Public Sculptor

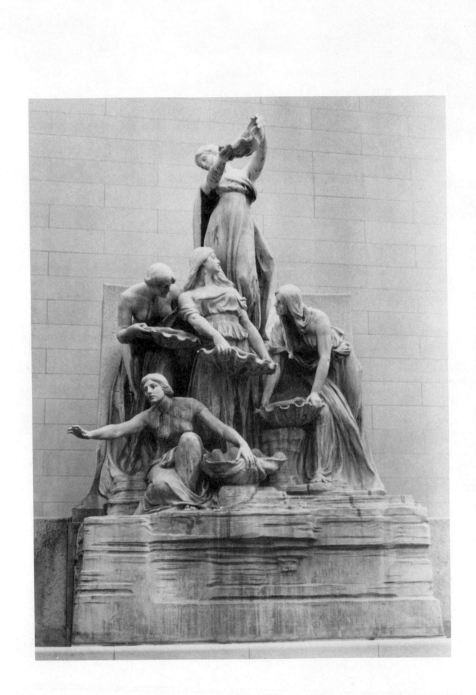

Public Sculptor

Lorado Taft and the Beautification of Chicago

Timothy J. Garvey

UNIVERSITY OF ILLINOIS PRESS

Urbana and Chicago

Publication of this work was supported in part by a grant from
Illinois Wesleyan University.

Library of Congress Cataloging-in-Publication Data

Garvey, Timothy J. (Timothy Joseph)
 Public sculptor : Lorado Taft and the beautification of Chicago /
Timothy J. Garvey.
 p. cm.
 Bibliography: p.
 Includes index.
 ISBN 0-252-01501-0 (alk. paper)
 1. Taft, Lorado, 1860–1936—Criticism and interpretation.
2. Public sculpture—Illinois—Chicago. 3. Urban beautification—
Illinois—Chicago. 4. Sculpture, American—Illinois—Chicago.
5. Sculpture, Modern—19th century—Illinois—Chicago.
6. Sculpture, Modern—20th century—Illinois—Chicago. 7. Chicago
(Illinois)—Buildings, structures, etc. I. Title.
NB237.T3G37 1988 87-24481
730'.92'4—dc19 CIP

For Paula

Contents

List of Figures

Acknowledgments

The following study of Lorado Taft and his circle was an enjoyable project through which virtually all went well and smoothly from the outset. Travel from my base in Bloomington, Illinois, involved relatively short trips to archival collections in Champaign-Urbana, Chicago, Ann Arbor, and Indianapolis—with a few more venturesome excursions to see individual works in smaller towns like Winchester, Indiana; Jackson, Michigan; and Elmwood, Illinois. Earlier research in Washington, D.C., New York, Philadelphia, Cleveland, and Detroit was also necessary, but more for background and comparison than to gather central information. In all such work, my efforts were supported by many individuals whose kind and generous assistance requires special mention.

My chief debt is to the librarians and archivists who made work in various collections both efficient and enjoyable. John Hoffmann, head of the Illinois Historical Survey at the University of Illinois Library, was especially valuable as both guide and friend. Together with his staff he provided much pertinent background information, and his personal interest in me and my project always made the prospect of work in that department more enjoyable. Likewise, Maynard Britchford and his colleagues in the University of Illinois Archives were quick to retrieve box after box of Taft Papers during my many visits, and made every effort to accommodate me and make me comfortable in various ways as I read, photographed, and otherwise consumed the documents in that collection.

Elsewhere, Archie Motley of the Chicago Historical Society is thanked in virtually every study published on a Chicago topic, and I must add my note of appreciation to the many others. Susan Glover Godlewski from the Ryerson Library at the Art Institute of Chicago assisted me in locating archival material in the Special Collections at that institution. At the Library of the Lorado Taft Field Campus (on the grounds of what was formerly the Eagle's Nest Artists' Colony near Oregon, Illinois) librarian Betsi McKay was a gracious and helpful contact who directed me through an important collection of photographs and took me on tours of the grounds during my visits. John Selch in the Newspaper Division of the Indiana Historical Society provided advice and helped locate special materials there. The American Academy and Institute of Arts and Letters kindly granted permission to use a restricted manuscript, and staff member Nancy Johnson provided helpful information about Taft works in their collection. Crucial at a later stage of my work was the opportunity to preview galleys of Allen S. Weller's *Lorado in Paris*, extended to me by Patt Tempel from the University of Illinois Press. Also valuable was the assistance received from staffs of the Newberry Library, Bentley Historical Library (University of Michigan), Hyde Park Historical Society, and Winchester Community Library. Assistance with photographs was provided by a range of sources including Tim Peterson of the Indiana Historical Society Library in Indianapolis, Janet Fuller of the Winchester, Indiana, *News-Gazette*, and the staffs of the Chicago Historical Society and Western Reserve Historical Society.

Individuals were also important for providing encouragement and comments through this study. Karal Ann Marling, longtime mentor at the University of Minnesota, was as usual also a supportive friend who helped me gain audiences for portions of the manuscript at various critical points and was enthusiastic and helpful in her own responses to the material. From the University of Illinois Allen Weller not only was important for the perspective provided by his own work on Taft, but took much time to read through the complete manuscript of my study, offering numerous helpful suggestions reflecting his special expertise. Others who read portions of the work at various points include Michael Sundell, Michael C. Steiner, Robert Silberman, M. Sue Kendall, and Michele Bogart.

Here at Illinois Wesleyan University I was also fortunate to find assistance and encouragement. My colleague Robert C. Bray not only read an early version of one of my chapters, but was kind enough to pass it on to the editor of the University of Illinois Press with recommendation that they consider the larger work. Several others were also instrumental in helping me gain a special university grant to offset certain publication costs. Provost Wendell Hess together with members of the Faculty Development Committee and Personnel Council proved very supportive, and the institution was generous in allowing funds improving the quality of the current book.

Finally, I owe my largest debt to my wife, Paula Aschim, who has been friend and partner through this as well as many other projects. She has provided and continues to provide a most necessary combination of encouragement, support, and diversion—in appropriate balance—and it is to her the present study is dedicated.

Introduction

When Lorado Taft wrote his survey "The Monuments of Chicago" in 1921, he did so with an authority born of long, careful study and broad personal experience.[1] As one of the most noted chroniclers of American sculpture well acquainted with the major figures in his field, Taft could reflect knowingly on the contributions of Augustus Saint-Gaudens, Daniel Chester French, and other nationally recognized artists who had placed works in the city. At the same time, because the majority of younger local sculptors had made their ways through his studios as assistants or students in years past, Taft was also fully prepared to offer special insight into the work of less well known individuals like Leonard Crunelle and Frederick Hibbard. But perhaps the most compelling of his many qualifications as an authority on Chicago's public sculpture was Taft's own direct experience in helping to shape the collection. Over the preceding three and a half decades he had been a passionately interested observer of the major commissions, unveilings, and dedications in the city—from the time of Saint-Gaudens's *Standing Lincoln* erected in Lincoln Park in 1887, to then current arrangements for Taft's own *Fountain of Time*, nearing completion even as he wrote. He had promoted and produced sculpture for his city, offered individual guidance to many younger sculptors as well as general instruction to the public, and experienced both encouragement and disappointment through a career dedicated to the sculptural beautification of Chicago.

Through this lengthy career, Taft developed a strong personal view of the roles and function of public sculpture. At the time of his writing in 1921, his assessment of Chicago's collection of monuments and fountains was predictably mixed. Works on view in the city ranged from the superb Saint-Gaudens *Lincoln*, an extraordinary portrait Taft claimed was in "perfect harmony with its surroundings," to Louis Rebisso's *Ulysses S. Grant Memorial* (1891), which he condemned as a "nondescript pile of masonry" surmounted by an equestrian portrait matching this unfortunate base in its "complete lack of artistic distinction."[2] Of certain members of the city's "petrified congress" of notables, Taft could only conclude with exasperation, "one asks in perplexity, 'Why are they here?'"[3] And such questions—as well as the works that raised them—were especially irksome to Taft, for in his estimation public sculpture represented some of the most telling of cultural records. Imposing, expensive objects requiring significant effort to create and fund, such sculpture eventually remained for future generations as an "unfailingly expressive" mark of cultural ideals. That so many of Chicago's monuments were of such questionable merit distressed Taft, suggesting vividly that "on these lines we have as yet no ideals at all."[4] While plans for new sculpture were promising, then, what he perceived as the city's lack of concern and its self-satisfied optimism with regard to sculptural beautification efforts frustrated and irritated the aging sculptor. Although he maintained great hopes for the future, Taft found little in the way of significant cultural record among the majority of monuments erected in his city by that time.

Yet among the works included in this survey of Chicago's public sculpture, one does stand out today in its capacity to carry broader cultural meaning. Taft's own *Fountain of the Great Lakes*, dedicated on the south side of the Art Institute of Chicago some eight years prior to the 1921 article, was arguably the most telling monument erected in the city to that point. The large bronze group consisting of five female figures spilling water from gracefully tilted shells offered a rather bland symbol of the nation's inland seas, but marked a crucial point in the community's cultural development. Taft certainly recognized it as a pivotal work in his personal career, the commission coming to encourage him after a lengthy period of struggle and marking a sudden opening of

new opportunities. And although he was too modest to do more than mention it in passing when discussing Chicago's sculpture in 1921, Taft's *Fountain of the Great Lakes* had also stimulated a great deal of interest and enthusiasm among others. Financed with money available from a new million-dollar public sculpture fund and dedicated as the first fruit of efforts calculated to introduce great improvements to the city's appearance and appeal, the fountain was heralded as both a wonderful object of great beauty and as a valuable example for a changing Chicago. It was with but slight exaggeration that one writer at the time of the dedication ceremonies in 1913 commented that the appearance of this new fountain marked "the proudest moment in the art history of Chicago."[5] This was indeed the monument providing exactly the cultural record Taft claimed was so sadly lacking in the city.

What made Taft's *Fountain of the Great Lakes* an especially strong record of the cultural climate of early twentieth-century Chicago was the extent and variety of interest it spawned. Wide discussion occurred early and continued throughout the development of the project. From the time of the initial announcement of the new Benjamin Franklin Ferguson Fund for public sculpture in 1905, through deliberations and negotiations leading to Taft's commission in late 1907, and then on to the dedication itself in September of 1913, newspapers and periodicals gave the entire matter considerable attention. Both the Ferguson Fund and the sculptor were subjects of many feature articles during those years, and by the time of the unveiling the volume of press coverage provides evidence of a perceptible rise of public interest in the entire question of such civic beautification. Editorials appeared to praise the donor, Taft was sought by interviewers from both local and national publications, and the success of the fountain was obvious to all. Immediately after its appearance the figures constituting the new work began to appear in everything from local advertisements and political cartoons to the "living sculpture" exercises undertaken by various physical education groups around the city and region. Like no other public sculpture in the city—and few others elsewhere in the country—this fountain captured the attention and imagination of a public for whom it represented the qualities and ideals believed important in such works.

Dedication ceremonies for Taft's fountain were appropriately

lavish. In June of 1913 Harriet Monroe had used one of her *Chicago Tribune* columns to call for an elaborate celebration combining song, dance, poetry, and oratory to provide a proper greeting for the long awaited fountain. Although her proposal that "all the arts" join to make the event memorable was not fully embraced, the schedule for the occasion still proved impressive.[6] Opening with prayer led by the Reverend Dr. Frank Gunsaulus of the Armour Institute, the ceremony extended through three major addresses punctuated by the Chicago Band with an assortment of marches, overtures, and, fanfares—concluding with Handel's "Hallelujah Chorus" breaking finally into the "Star Spangled Banner."[7] It was an important civic event honoring the donor, praising the sculptor, and celebrating the beautiful new product of their joint effort. Even more important, however, the addresses offered explanations regarding the meaning and value of the new fountain for the city.

The three speakers were all notable members of the cultural leadership of early twentieth-century Chicago. Taft, quite a celebrity by the time of the dedication, spoke first. Beginning with a brief explanation of the background and evolution of his idea for the bronze statuary, he soon progressed to a natural expression of gratitude for the commission and praise for the farsighted Ferguson, whose gift had made it all possible. Following Taft was Charles L. Hutchinson, a well-known local banker and prominent member of several civic groups and boards of trustees. It was in his capacity as trustee and president of the Art Institute that Hutchinson was on hand during these ceremonies, making the official presentation of this important new work to the city. Like Taft, Hutchinson began by offering background information regarding Ferguson's gift and its administration; he concluded by declaring the fountain an official memorial to the donor, offering it to the city as the *Ferguson Fountain of the Great Lakes*. Finally, sharing the dais with Taft and Hutchinson that afternoon was the Honorable John Barton Payne. A lawyer by profession, Payne also served as a member of Chicago's South Park Commission, elected president of that active body in 1911. In that capacity he had helped direct the development and management of the city's park system, and was called upon in 1913 to act as official recipient of the *Fountain of the Great Lakes* for Chicago. Payne spoke of the new public fountain as a symbol of broad civic accomplishment. Citing it as

a major cultural achievement, he claimed it as final evidence of Chicago's emergence as a city ranking with the most celebrated of Europe.

Upon closer scrutiny, however, the ideas expressed by these speakers offer far more than simple statements of gratitude, praise, and pride. The *Fountain of the Great Lakes* became a point of departure in all three addresses, allowing extension to issues of importance to the individual speakers and providing telling insights into their respective attitudes and goals. The speakers were not entirely united in their views that September afternoon as they addressed the crowds gathered along Michigan Avenue, but the issues raised by each reflected the opinions of substantial numbers of those assembled to hear them. Their perceptions and discussions of the fountain and its meaning for Chicago either echoed or were echoed by many others offering comment in other sources at the time. Yet in this case all achieved a focus. The fountain served as an image raising and clarifying opinions for the three participants, and they in turn expressed those opinions with precision and candor.

This, then, is the subject of the following study. In preparing it I have learned much of Lorado Taft and his contemporaries—but I have also learned a great deal *from* them. One of the most important of their lessons involves the potential significance of public sculpture as meaningful cultural record. The public monument, as Taft himself suggested time and again throughout his career, has the capacity to mark the ideas and ideals of those responsible for erecting it. Produced only through great effort and capable of remaining as a lasting presence once completed, it provides a means of gauging values communicated over extended periods of time. Moreover, as an essentially collaborative work requiring at least some measure of cooperation among artist, patron, and public, the monument is necessarily the voice of a group rather than an expression of a more personal, individual vision. Taft certainly intended that his *Fountain of the Great Lakes* be viewed in this light, and his fellow dedication speakers as well as the majority of their audience appreciated the new addition to their cultural landscape in just this way.

The only major difference between their perspective then and ours today is that Taft and many of his contemporaries believed

works like the new fountain would not only serve as records of ideals, but as a means of extending the ideals themselves into the future. They—and Taft in particular—viewed public sculpture as an effective way of establishing values and traditions in American culture, just as they believed those values and traditions of the past had been made permanent by the monuments of earlier cultural groups. Taft's own career proved the fallacy of this reasoning all too well. Changing attitudes toward the values represented by his sculpture had a strong impact on the sculptor's success, causing both his initial rise and subsequent decline in Chicago. The assessment of individual Taft works also ranged from rave reviews of the extraordinary beauty of his *Fountain of the Great Lakes* at the time of its initial exhibition as a study in 1906, to the identification of his later *Fountain of Time* as one of the city's major "atrocities" when unveiled on the Midway two decades later.[8] Likewise, subsequent scholarship on American sculpture has all but neglected Taft until recently in spite of his important contributions to the field earlier in the century.[9]

Still, regardless of its success or failure in extending ideals to the future, the *Fountain of the Great Lakes* is a superb record of the ideals that existed at that time. Perhaps more than Taft himself could ever realize, his fountain and the discussion it stimulated provide unparalleled insights into a range of issues occupying the sculptor, his circle of friends in the Chicago artistic community, and the cultural leadership of the city. And in this case, because of the timing of the commission, dedication, and subsequent discussion, such issues are thrown into higher relief as they occur against a backdrop of rapid cultural change. Because values were in the process of being questioned, challenged, and in many cases overturned, the static image of the fountain allows an understanding of the change afforded by few other cultural documents. It is as a measure of this change—change for Taft and change for Chicago—that his work is indeed "unfailingly expressive" of its time.

Patronage, Beautification, and Service

As one of the trustees responsible for determining appropriate uses for the Ferguson Fund, Hutchinson's role at the unveiling of the *Fountain of the Great Lakes* was to initiate the official transfer of Taft's new sculpture to public ownership. Preceded by an impressive Wagnerian fanfare, his opening comments were clearly intended to offer a frame of reference allowing the audience a better appreciation of the importance of the event. On the one hand, of course, was the significance of the new fountain as an "artistic development" for the city, marking the beginning of a new round of civic beautification beyond all imagination.[1] In the future, Hutchinson explained, the monuments following this first work would grow in number and greatly increase the pleasure and inspiration felt by thousands of Chicagoans and visitors as they viewed the city. At the same time, however, this fountain would symbolize the original gift and serve as a notable reminder and example for others. The generosity of the donor who made such splendid works possible would thus be constantly before the public, providing a "tangible illustration of the wisdom of a loyal and devoted citizen" who had turned personal fortune to use for the good of all.[2] Civic beautification was, in Hutchinson's view, not only an end, but the medium for a message of public service. Both were evidence of laudable values worthy of the recognition and careful consideration of Chicagoans.

The important gift was first made known to the public in 1905.

Benjamin Franklin Ferguson, a wealthy lumber dealer who spent most of his career in Chicago, died on April 10 of that year. Five days later when the disposition of his estate was made public, newspapers announced terms of the generous will by which he left most of his substantial personal fortune to the city for use in obtaining public sculpture. While small gifts were given to a niece, and small annuities to local charities and institutions such as the Illinois Humane Society, the Chicago Foundlings Home, the Newsboys' and Bootblacks' Association, and the Art Institute, the remainder totaling some one million dollars was set aside to form the special Ferguson Fund.[3] According to the will, capital in this fund was to remain intact, administered by the Northern Trust Company of Chicago, with interest income allocated for use in financing the erection of monuments. Trustees of the Art Institute were assigned responsibility for governing the annual use of the fund's income, charged only with the task of spending it for "the erection and maintenance of enduring statuary and monuments, in the whole or in part of stone, granite or bronze, in the parks, along the boulevards or in other public places, within the city of Chicago, Illinois, commemorating worthy men or women of America or important events of American history."[4]

Ferguson's gift appears to have been prompted by a variety of factors. Newton H. Carpenter, secretary of the Art Institute, noted at the time of the announcement that the will did not come as a total surprise to his office, for the donor had consulted Art Institute officials some years earlier regarding possible uses for a somewhat smaller bequest for public sculpture. According to Carpenter, Ferguson's interest had come about as a direct result of travel. Beginning in the early 1890s the semiretired lumberman spent increasing amounts of time touring the major cities of Europe, and the experience made him painfully aware of his own city's shortcomings. Especially disturbing to him, Carpenter pointed out, was Chicago's lack of the impressive monuments and fountains so common and enjoyable in the far more attractive Old World capitals. When he returned home and sought counsel at the Art Institute, it was with the intention of discussing a donation that might help remedy the situation and at the same time stimulate additional interest in beautification. Although nothing was immediately resolved as far as Carpenter and his colleagues

were aware, the inclination was clearly present, and Art Institute personnel did all they could to cultivate Ferguson's interest.[5]

Other local influences may well have been at least as important to Ferguson's decision in the matter. Eli Bates, another successful Chicago lumber merchant and certainly a figure well known to Ferguson, had earlier left some $35,000 to the city for similar beautification purposes at the time of his death in 1881.[6] Bates's gift, earmarked for a fountain and a commemorative statue of Abraham Lincoln for the newly developed Lincoln Park, had attracted considerable attention. Both the *Bates Fountain* and the *Standing Lincoln* were unveiled in 1887 to considerable publicity. Although the fountain, a collaborative effort by Saint-Gaudens and his protégé Frederick MacMonnies, raised eyebrows because of the nudity of the young fish-boys who splash about in the composition, the quietly contemplative, dignified figure of Lincoln was from the outset regarded as one of Saint-Gaudens's finest masterpieces.[7] The city was honored to have such impressive public art in its parks, and the honor naturally extended to the memory of Bates as well. Ferguson may have been appropriately awed and influenced by the experience of traveling through richly beautiful European cities as Carpenter and others claimed, but at the time of his death he was also a widower with no direct heirs. Bates's example could quite obviously have seemed both a commendable use of his fortune and an attractive means of perpetuating his memory. Indeed, as one editorial noted at the time Ferguson's bequest was announced, the donor "made his money in lumber," but insured perpetuation of his memory in "brass, marble, and other enduring materials."[8]

But Ferguson's interest in public sculpture was also stimulated by closer personal acquaintances like Hutchinson and Daniel H. Burnham. The latter, deeply involved in the development of his own plans for the beautification of Chicago around the turn of the century, is mentioned by later sources as a particularly influential friend of the donor.[9] It is not at all difficult to imagine the persuasive Burnham working to convince Ferguson of the merits of civic beautification just as he was bending the ears of others on the same topic; that such a gift fit perfectly with Burnham's intentions for the city is evidenced by the architect's comments referring specifically to the value of the new Ferguson Fund in his 1909 *Plan of Chicago*.[10] Hutchinson is also identified as one of the

lumberman's friends in the city, and he too appears to have played an important role in the matter.[11] In fact, Hutchinson collaborated earlier with Ferguson and others in a philanthropic venture that may well have been the most direct stimulus for the lumberman's final civic gesture. Traveling in Massachusetts in the late 1890s, Hutchinson had stopped at Chesterwood, the new studio of sculptor Daniel Chester French. Quite taken with an equestrian *George Washington* French was then modeling, Hutchinson returned to Chicago to solicit funds in order to obtain a copy for the city's Washington Park. Ferguson was one of several wealthy Chicagoans who agreed to contribute, and through their efforts the city did eventually unveil a casting of French's stately *George Washington* at the northwest corner of the park in 1904.[12] Whether manifestation of an existing interest or an important factor causing that interest, Ferguson's response to the influence of Hutchinson in this case proved a foretaste of his more substantial funding of similar sculpture later.

Although it has been suggested that Taft was also among those influential in guiding Ferguson's decision to leave his fortune for public monuments, the sculptor was not actually involved at that stage of developments.[13] In fact, at the time of the dedication of his *Fountain of the Great Lakes*, Taft pointed out that he never actually had the pleasure of knowing the donor to whom he owed so much.[14] Still, that Taft's name would be proposed as among those influential in such a situation provides some measure of his reputation for work on behalf of public art. After study at the Ecole des Beaux-Arts in the early 1880s, he had returned to the Midwest and opened a studio in Chicago by 1886. His early sculpture had been limited largely to portrait busts and an assortment of commercial modeling commissions, but by the time of preparations for the World's Columbian Exposition in the early 1890s he was sufficiently well known to receive an important assignment to produce sculpture for William Le Baron Jenney's Horticultural Building. This work, coupled with an assortment of commissions for Civil War monuments, a lengthy tenure as instructor at the Art Institute, and an increasing reputation as public lecturer and authoritative writer, established him as one of the foremost regional advocates of public sculpture by the turn of the century.

When Ferguson's will was made public in 1905, Taft was among

the first interviewed on the matter. Preceded only by those of Carpenter and Art Institute Director William M. R. French, Taft's comments published in the *Chicago Record-Herald* at the time of the announcement described the potential impact of the bequest by noting that it would both beautify the city and stimulate emerging young artists, causing Chicago to "gather impetus as an art center" of far-ranging importance.[15] To a *Tribune* reporter he explained that the Ferguson Fund seemed at long last to provide the basis for a "school of sculpture in Chicago," resulting in the creation of truly meaningful works of art.[16] This same theme was then expanded to broader speculation and counsel in an article Taft published two months later in the *World To-Day* where he offered several answers to the question, "How Shall Chicago Use the Ferguson Bequest?"[17] Cautioning his readers against what he viewed as less appropriate categories of public sculpture, Taft argued for fountains, allegorical statuary, discreetly placed portrait busts, and the adornment of bridges and park entrances. Such tasteful additions would create an enduring beauty appreciated by generations to come; coincidentally, these also happened to be the directions Taft was at the time pursuing in his own work, and represented the major concerns that would occupy him for the following three decades.

Yet if his interviews and article provided initial evidence of the sculptor's interest in the new Ferguson Fund, it became even more apparent by the fall of 1905 as Taft embarked on a program clearly designed to place himself all the more fully in line for an early commission. It was no doubt gratifying for him to find his name linked with the Ferguson Fund as early as September when one writer discussing Ferguson's sculpture bequest suggested that Chicago "already has at least one man, Lorado Taft, who is a national figure in that art," but Taft lost no time in pushing ahead to solidify his reputation as a specialist in the field.[18] In his classes at the Art Institute, public sculpture rapidly became a major issue. Taft had for several years devoted some portion of class time to one or two sculptural projects of more obviously public scale, but he redoubled efforts along these lines in 1905–6, having students work up models for several different fountains and sculptural groups in response to what he termed "the universal call for suitable park decorations."[19] In the meantime, in his own studio, the sculptor

began to refine and enlarge an earlier allegorical group he believed might prove attractive as a public fountain. The "Spirit of the Great Lakes" that Taft resumed work on that fall had originally been an assignment to students in a 1902 sculpture class at the Art Institute. In response to his compositional instructions that spring, five young women had each modeled one figure; they then joined them together in a tiered group in which the viewer was to imagine water flowing from the containers they held.[20] Continuing from this earlier concept for the group, Taft worked through the fall and early winter after the announcement of Ferguson's bequest to model and cast a plaster version of his own by mid-January 1906. Hutchinson, about to depart for France on January 17, stopped by Taft's studio to see the newly completed fountain group at the sculptor's invitation and wrote that he was delighted "not only in its conception but also in its execution."[21] While one newspaper reported at the time that Taft was working up his model in the general hope that it might "find a place in one of the larger cities of the country near the great lakes," it was quite clear that the sculptor had begun taking steps to secure a Chicago site for his work.[22]

By the end of the month Taft's fountain group was on view at the Art Institute as part of the annual exhibition of works by local Chicago artists. For four weeks his large plaster model dominated the show, and his cause gained considerable support. The "Spirit of the Great Lakes" loomed over all else on display, easily taking the Chicago Municipal Art League's prize for the best work of sculpture; together with two of the sculptor's portrait busts, the imposing figure group also helped bring him recognition as recipient of the Society of Chicago Artists' Medal for general excellence.[23] Observing the quality of his work, his success with the awards committees, and the fact that his sculpture was actually the centerpiece of an impressive array of work by many who were his former students, one newspaper noted that "few sculptors have ever appeared before a local public to a better advantage than does Mr. Taft at the present time."[24] When the same source concluded that Taft's "Spirit of the Great Lakes" seemed exactly the type of work that should be favored by those directing the use of the Ferguson Fund, it echoed precisely the thoughts of Mrs. William F. Grower, chairperson of the exhibition committee of the Municipal

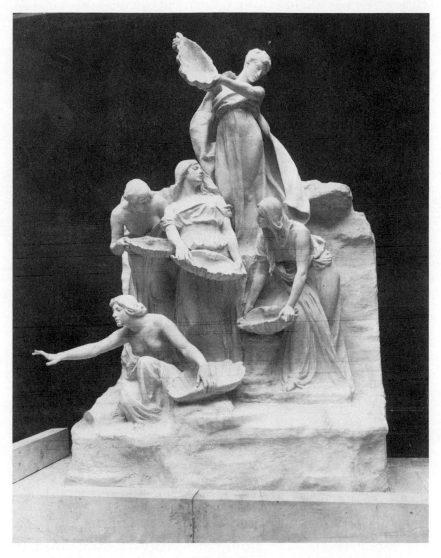

1. Lorado Taft's "Spirit of the Great Lakes" plaster study, 1906. Unlike the final version, the uppermost figure, "Lake Superior," here looks over her left shoulder. Lorado Taft Papers, Archives, University of Illinois.

Art League, who was sufficiently moved by the work to appoint a special subcommittee to convince Art Institute trustees of exactly that.[25]

Unfortunately, the efforts of Grower and others working on Taft's behalf were slow to take effect. Initial delays occurred when money for the fund was held up in probate court, but even after the will was legitimized and money released to the trustees on May 23, Taft's commission failed to materialize. Meetings held in June to discuss initial allocations met with no apparent success, for problems arose to make any decision very difficult. Initial conflict may well have emerged over the nature of the sculpture to be commissioned. This had been a matter of some disagreement since the announcement of Ferguson's bequest, and it remained a question in the minds of many a year later. One source indicated that the trustees were divided going into their meetings: some preferred use of the fund for the erection of beautiful and useful public fountains, while others wished to see Ferguson's money spent to honor individuals with commemorative portrait statues. Hutchinson himself was reported as "anxious" only that the first money from the fund go for a monument in some way honoring the donor.[26] While subsequent commissions could naturally have satisfied the desires of all sides in the debate, it is clear that expenditure of the initial allocation was deemed very significant.

Far more difficult, however, was the problem posed by an entirely different debate only marginally related to the Ferguson Fund and its possible uses. On October 25, the trustees voted to adopt a resolution accepting Hutchinson's suggestion that the first sculpture erected with the new money be "a monument or memorial" honoring Ferguson; yet at the same time they reported their decision to postpone any further action leading to definite plans at that time.[27] The problem was the conflict then raging over the future of Grant Park. Land reclaimed over several years as fill was dumped outside the infamous Illinois Central track perimeter on the lake side of the Loop, vastly extending the acreage of the old Lake Front Park. Shortly after the turn of the century plans were underway for increasingly elaborate development of the newly renamed Grant Park with extensive landscaping surrounding proposed civic buildings to include not only the existing Art Institute, but the future Crerar Library and Field Museum.[28] All had been

held up, however, by the efforts of A. Montgomery Ward. Respon-
sible for initiating proceedings to clear unsightly warehouses and
other shacks from the eastern side of Michigan Avenue in the
1890s, Ward was equally opposed to the introduction of new
buildings that would fill the precious new park space. His legal
actions to bring about the clearing of the park perimeter had been
successful earlier, and in 1906 it was as yet unclear what Ward's
continuing efforts to keep the land free of new development might
mean for beautification plans.[29] Although by no means bound to
use of Grant Park space for the first monument, the trustees of the
Ferguson Fund apparently hoped for a prestigious site in the beau-
tiful new downtown park and felt that the "unsettled conditions"
of deliberations over the future of building in Grant Park made it
unwise to pursue their project that year.[30]

If understandable under the circumstances, the delay obviously
displeased Taft. Regardless of the encouragement coming from
Hutchinson and the Municipal Art League, and despite his almost
certain knowledge of the reasons for the trustees' decision in 1906,
he began exerting slight pressure that year in order to encourage
more attention and serious interest. In July he published a view
of his Great Lakes group in the *Century Magazine*, apparently
following the advice of a friend who had recommended the prac-
tice as a means of gaining broader publicity some years earlier.[31]
In this instance he was rewarded by a rapid response from one
Francis Almy, a public-spirited citizen of Buffalo, New York. Almy
admitted that he wrote "wholly without authority from anyone,"
but his intention was to learn whether Taft might let the "Spirit
of the Great Lakes" be erected in Buffalo.[32] Taft's response indi-
cated that he wished to place the work in Chicago, but he also
sent along another photograph of the group, further stimulating
Almy's interest. The Buffalo merchant wrote again in October with
a long series of arguments and a description of possible sites for
the work, hoping either to change Taft's mind or strike a com-
promise whereby copies might be erected "both in an upper lake
and a lower lake city."[33] Although Taft was still quite obviously
intent upon a Chicago commission for his Great Lakes figures, the
trustees' decision to delay later that month must have caused him
to communicate his disappointment to Almy. The following Febru-
ary the *Buffalo Illustrated Times* published a full-page cover pho-

tograph of Taft's fountain model with a caption indicating that the
Beautifying Buffalo Society held out high hopes for obtaining the
work because even though originally intended for Chicago, "Delay
in Action There Makes Mr. Taft Willing to Let It Come Here."[34]

With the support of influential figures like Hutchinson, however,
Taft had little to worry about, and later that year the matter was
finally settled to his full satisfaction. Art Institute Director French,
a long-time colleague and friend of the sculptor, kept him informed
of developments as the commission was discussed in the trustees'
meetings. When a recommendation to acquire Taft's Great Lakes
group was reported out of the trustees' art committee as the first
official step in the procedure, French wrote to assure the sculp-
tor that "our plans are working well."[35] On October 31, 1907, the
board at long last voted to offer Taft the commission.[36] The con-
tract, dated December 16 and signed by Taft and Hutchinson with
Carpenter as witness, provided a sum of $38,000 to cover the costs
of creation, fabrication, and installation of the work, with payments
scheduled for specific points over the three years allotted for com-
pletion of the project.[37] It had been over two and a half years since
Ferguson's death, and nearly two years since Hutchinson had seen
the figural group for the first time in Taft's studio.

Some years later Taft explained to an interviewer the process
by which a sculptor conceives of a public work and proceeds to
gain support for it. The first step, he explained, was to discover an
appropriate empty site that appears to cry out for beautification.
This becomes the focal point demanding careful study and long
thought to determine what might best suit it both visually and
thematically. Then, after a period of incubation, the glimmer of an
idea occurs, eventually growing into full inspiration, and the sculp-
tor can begin working with clay to build a rough model to serve
as the basis for the piece. A satisfactory model achieved, the next
step should involve the development of a full-scale plaster model,
erected on the chosen site to attract attention and gauge public
response. Finally, the sculptor might approach "men of authority,"
requesting that they look at the plaster model in the hope that
"they will deem it beautiful and probably commission him to make
it permanent there in marble."[38] Of course Taft's experience with
the sequence of events leading to his commission for the *Fountain
of the Great Lakes* was nothing remotely like this. Stimulated by

news of money newly available for public sculpture in Chicago, he identified what he trusted would be a generally appropriate subject for the city and proceeded to gain support for the idea by a combination of studio showings, museum exhibition, and personal contacts.

Nor did the process draw any closer to his ideal scenario following Taft's receipt of the contract. The sculptor continued to work on his model over the next several months, refining and enlarging the group in preparation for its eventual casting in bronze, but the question of a precise location for the fountain remained unanswered for some time. In February 1908, Taft's friend and fellow Chicago artist, Charles Francis Browne, published a lengthy article on the sculptor in which he noted that although no site had been officially assigned the recently commissioned fountain, a Grant Park location would be preferable and erection before one of the blank walls at the south side of the Art Institute ideal.[39] Trustees of the Art Institute and commissioners of the South Park Board, however, remained wary of the litigation over use of Grant Park. It was noted in the institute's *Annual Report* that while the trustees had decided to offer Taft his contract, the future of the downtown lakefront park remained "so uncertain" that they felt it best to continue to postpone any plans for a site there.[40] In the meantime, Henry G. Foreman, then president of the board of South Park Commissioners, made public his own proposal that Taft's *Fountain of the Great Lakes* be installed in a special new park to be established on a vacant half-block at the intersection of Grand Boulevard and Thirty-fifth Street on the Near South Side. According to the drawing and specifications released by Foreman in February, Taft's fountain would be situated there within an elevated niche in a marble or granite wall forming a forty-foot vertical terminus for the boulevard.[41]

Browne's was the suggestion that eventually won out. In their 1909 *Annual Report*, Art Institute officials announced a proposal to erect a special sunken garden extending from their building south to Jackson Boulevard. Bounding the garden on the east was to be a substantial wall separating the new landscaping from unsightly Illinois Central tracks and providing a backdrop for the *Fountain of the Great Lakes*. With a lengthy pool collecting its water, the fountain was intended to function there as a focal point

eventually flanked by niches carrying additional sculpture and making the garden an attractively ornate addition to the Art Institute setting.[42] Unfortunately for their plans, it was at this point that litigation over the use of the park took a dramatic turn causing suspension of all such proposals. In their report for the fiscal year ending on February 28, 1910, the South Park Board of Commissioners expressed optimism regarding their efforts to overturn an Illinois Supreme Court ruling banning any further building in Grant Park, but eventually their suit went for naught.[43] Yet even before any final ruling in the matter, the site of the fountain had been changed once more. In mid-April, the *Chicago Daily News* noted that Taft's work was nearly completed and published a photograph of the south facade of the Art Institute with an *X* marking the spot against the wall of the building where the work was to be placed. Presumably such an addition virtually attached to the existing structure would be permissible to even the most adamant of open park space defenders—but it was noted that the absence of comment by lakefront watchdog Ward had nonetheless "occasioned surprise."[44]

Reasons for the long delay in completion and dedication of Taft's fountain after the spring of 1910 are unclear. One source mentioned only "various trifles" by way of explanation in early 1913, but whatever the case, the model was not sent to the foundry until that spring.[45] Taft had quite obviously turned to other things well before this. His colossal concrete statue of *Blackhawk* had been dedicated on its bluff overlooking the Rock River near Oregon, Illinois, on July 11, 1911; and the sculptor's *Columbus Fountain* was unveiled in the plaza before Daniel Burnham's Union Station in Washington, D.C., in June of the following year. In Chicago during the same period, Taft was busy in the promotion of new plans for additional public sculpture for his city, and the *Fountain of the Great Lakes* went unmentioned in several articles and interviews in which the sculptor aired his opinions and outlined plans. It was with rather surprising suddenness, then, that the announcement came in May 1913, that the fountain model had been disassembled and taken from Taft's Midway Studio to the West Lake Street foundry of Jules Berchem.[46] Once there, casting was accomplished rapidly and parts finally brought to the site at the Art Institute and

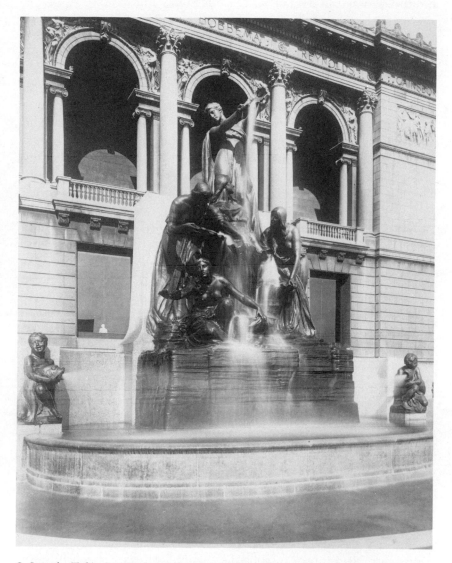

2. Lorado Taft's *Fountain of the Great Lakes*, 1913. Shown here in its original location on the south wall of the Art Institute of Chicago. Taft Papers, University of Illinois.

assembled in mid-August.[47] By the end of the month all was ready and the dedication date of September 9 was announced.

The day before the dedication of the new *Fountain of the Great Lakes*, a newspaper article previewed the upcoming event with enthusiasm. After explaining briefly the schedule for the following afternoon, the article pointed out that Taft's bronze group was important not only as the first work erected with money provided by the Ferguson Fund, but as "one of the first attempts to introduce the aesthetic in the new scheme for beautifying the city."[48] The new scheme referred to was of course Burnham's famous *Plan of Chicago*, published just four years earlier. In the intervening years the ideas outlined in Burnham's proposal had enjoyed considerable support in Chicago and attracted a good deal of interest beyond. Under the direction of Charles H. Wacker the Chicago Plan Commission had begun their work with the widening and general improvement of major city arteries like Twelfth Street and Michigan Avenue, and much else was scheduled for the next few years.[49] Yet the splendid watercolors and drawings Jules Guerin and Jules Janin produced to illustrate Burnham's planning document showed the widened boulevards of their future Chicago well populated by a significant volume of impressive monuments and fountains.[50] For many, the erection of Taft's *Fountain of the Great Lakes* immediately adjacent to Michigan Avenue represented the first step in fulfillment of the promise of those illustrations, perfectly complementing the efforts of those committed to the beautification of the city.

This was certainly apparent in Hutchinson's address, where the issue received considerable emphasis. This fountain was, after all, but one of a long series of wonderful works to be added to the city with money from the special new Ferguson Fund. Beautiful in itself, the banker pointed out, the work also stimulated thoughts of "all that will be accomplished in the course of a hundred years," and in that respect seemed the beginning of a glorious realization of Burnham's dream.[51] Moreover, in Hutchinson's account the donor typified the force behind the beautification movement: more than a mere businessman, Ferguson was described as a worker with a purpose and goals that went well beyond his daily commercial enterprise. The donor was in Hutchinson's words a "dreamer of dreams" with "visions of a City Beau-

tiful and a strong desire to aid in the upbuilding of such a city."[52] Indeed, to emphasize the strength of Ferguson's commitment, the speaker went on to outline in general terms the sacrifice it took to ensure that the bequest be sufficient for the desired ends. Identifying as his target the sum of one million dollars, Hutchinson explained, the lumberman had initially found his estate "considerably less than the desired amount" and so waited patiently for his holdings to grow to an adequate level before making his gift.[53] Although Hutchinson made no direct claim that the wait entailed any substantial material sacrifice on the part of the donor, his implication was clear.

To some extent this emphasis on the promotion of City Beautiful ideals in his address may be attributed to Hutchinson's personal interest in the matter. While Ferguson is the one most often credited with the sentiment, Hutchinson too had observed an unfortunate discrepancy between beautiful European cities and his own Chicago.[54] It was this that had caused him to solicit funds from wealthy friends not only for the development of the Art Institute's collections, but for public monuments like the equestrian *George Washington*. Likewise, it prompted him to an active participation in various organizations attempting to achieve broad improvements in the appearance of the city. In 1899 he was one of the founding members of the Municipal Art League of Chicago, a group dedicated to the promotion of "artistic efforts" in all areas of civic development.[55] As a member of the board of South Park Commissioners from 1907, he was among those most active in attempting to transform Grant Park into a beautiful urban gateway with museums and statuary, simultaneously donating his salary as board auditor to fund public art for other parks in the system.[56] And when Wacker's Chicago Plan Commission was named by Mayor Fred Busse in 1909, Hutchinson was a natural addition to the list—ultimately one reported to have contributed "his untiring labors for the greater and more beautiful Chicago" that commission sought to build.[57]

Yet Hutchinson's was but one of many voices raised in support of civic beautification on both the local and national levels during these years. Large professional organizations like the National Sculpture Society (1893), the Society of Beaux-Arts Architects (1894), and the National Society of Mural Painters (1895) were

formed in part to encourage municipalities to work harder in their efforts to beautify, and major expositions like those held in Chicago, Buffalo, and St. Louis proved striking and popular demonstrations of the potential for such efforts. When Chicago's Municipal Art League was announced in 1899, the only organization cited as precedent was the successful group founded in New York in 1893; just six months after Hutchinson and his colleagues banded together in Chicago, however, they were invited to attend a conference in Baltimore including several more municipal art associations already formed in other cities as well, drawn together to discuss strategies for furthering interest in civic art and similar improvements.[58] Indeed, as Charles Mulford Robinson prepared his series on "Improvement in City Life" for *Atlantic Monthly* in the late 1890s, his investigations of "aesthetic progress" uncovered numerous examples of urban beautification undertaken by a variety of civic organizations turning increasing attention to such matters at the time.[59]

Chicagoans believed these beautification efforts to have special significance in their case. From the early nineties when preparations for the Columbian Exposition began attracting new attention to the city, Chicago drew criticism for a cultural development lagging sadly behind its material achievements. Even though writers like Lucy Monroe and William Morton Payne attempted to tell the nation of the promising future for art and literature in their city, such accounts described foundations on which little had as yet been built.[60] When Franklin H. Head assembled a lengthy article describing the "Heart of Chicago" in 1892, he spoke primarily of a business heart in terms of square miles, square feet, and real-estate values; he cited the role of investors and explained the nature and volume of the city's products; and he created an image of a towering business core flanked by busy commercial and industrial activity all surrounded by productive farm land. Yet the specific visual character at the heart of Head's Chicago remained anything but attractive. He noted that the commercial core of the Loop could boast "twelve hundred tall chimneys and over two thousand steam boilers," but "few even of the latest buildings have any architectural features of excellence"; and surrounding the commercial center was a "veritable *terra incognita*" of wholesalers, railroad yards, and general traffic, creating what seemed at times an "inter-

minable confusion and endless hurly-burly."[61] It is little wonder that William Dean Howells's "Altrurian traveller" could dismiss the city as "only a Newer York, an ultimated Manhattan" in which the vivid Old World beauty of the White City appeared all the more unreal in 1893.[62]

Some offered critics like Howells an answer explaining the city's raw ugliness as a direct result of its youth. Founded in the 1830s and burned in the 1870s, they argued, Chicago had not enjoyed a long enough period of development to allow for much beyond a practical building toward material prosperity. In an 1892 editorial entitled "Chicago's Higher Evolution," the *Dial* articulated just this position, claiming the city's lack of beauty and culture was attributable to the fact that Chicago was as yet only a healthy young adolescent. The half century of "evolution" to that point involved significant commitment of civic energy to "the development of a material body which is magnificent in its functional structure and health," but such commitment through its youth had allowed little growth of "the higher powers [that] unfold later in all normal life."[63] The editorial went on to point out, however, that the stage had finally been reached where this line of growth would slow as the city attained a new level of maturity. As the *Dial* explained, "Already the signs are clear that the season of mere physical life is over, and that the life of the soul calls for exercise and nourishment," which was certain to "transform the grossness of our hitherto material life."[64] Nor was the *Dial* alone in expressing this sentiment. Monroe, Payne, Head, and many others pointed—at times with a wistful undercurrent of hope—to similar changes they perceived as the city appeared to come of age in the nineties. Even the usually cynical Henry Blake Fuller could note in 1897 that while a mere six decades earlier "the Pottawatomies held their last war-dance within a few steps of the site of Chicago's city hall," the metropolis had by the 1890s finally won full material prosperity and established a base from which growth toward "higher cultural status seems assured."[65]

For some, however, this excuse of youth wore thin over the decade. Those supporting the development of public beautification became especially critical of that rationale as it was sounded with increasing frequency by the turn of the century. When the Municipal Art League was formed in 1899, the collection of artists,

architects, and cultural leaders assembled for the first meeting agreed that the demands of rapid growth and expansion in a young city simply did not constitute sufficient excuse for a lack of high ideals, and Chicago must abandon its plea of youth as explanation for neglect of public art.[66] Even more skeptical was Taft, who lampooned the foolishness and exaggeration he perceived in claims that the young city was somehow still struggling for its very survival: "We say that our city is only fifty years old, which was true awhile back. We talk still of the 'necessities of life,' of clearing forests and struggling with nature, and, for aught I know, of fighting Indians; but now, 'honest,' don't you think that this is getting to be an old story? Who of Chicago's population has seen a red-man skulking about excepting in wild-west shows? Where are the stumps of your clearings?"[67]

Of greater importance for other writers, however, was a strong economic argument against neglect of the city's appearance. Among the many proponents of civic beautification through the nineties, several began to advance the theory that it might be regarded as a thoroughly practical action. *Municipal Affairs*, a quarterly journal published by the Reform Club of New York City, carried several articles on aesthetic improvement, a number of which argued exactly this point. Frederick S. Lamb, for example, explained that beautification could increase the competitive edge of a city at a time when there was "a competition of cities just as there is a competition of individuals."[68] In his view, increasing a city's beauty naturally increased its attractiveness and in the end proved profitable. Taking this one step further, Brooks Adams claimed beautification of American cities could actually have meaningful impact on economic competition between the United States and Europe. Citing Greek culture as a model, Adams explained that if cultural genius could only be exercised as fully as entrepreneurial genius in this country, it would soon be possible to stem the annual tide of an estimated hundred million dollars (an amount "not far from the net earnings of the United States Steel Company") spent by Americans traveling abroad to enjoy the attractive cities of Europe.[69]

As proponents of City Beautiful ideals in a major established metropolis like New York could point to the value of public art as a means of attracting visitors, Chicagoans recognized a more

pressing incentive in their simple desire to keep wealthy residents from leaving. Burnham argued for his beautification scheme by citing the depressingly large amount of money "made here in Chicago and expended elsewhere," but he was just one of many detecting the same basic problem.[70] In his general discussion of civic beautification, Robinson too outlined the economic arguments, describing the difference between Chicago and cities like New Orleans and San Francisco as a case in point. The latter two cities, possessing unique qualities due to locations and histories, could easily develop as charming resorts; civic leaders and promotional groups in those cities devoted their efforts to enhancement of the attractiveness of their communities in the hope that tourism might eventually create an income "as important as that derived from the trade of the city."[71] Chicago, on the other hand, was according to Robinson a city not only incapable of attracting new visitors, but actually losing even those whose fortunes had been made in the prosperity of the community's booming youth. He granted that its orchestra, libraries, Art Institute, and park system signaled the beginning of a change occurring in Chicago, but Robinson nonetheless felt compelled to encourage further work with the reminder that "once a start is well made, the wealth that is attracted, or kept at home, will be spent on the very objects that increase the attractiveness of cities. To the city that hath, more shall be given."[72] And it was at the same time and in the same spirit that Wallace Heckman, a wealthy local lawyer speaking before the Chicago Art Association, called for immediate civic beautification with the warning that the "bigness and business of a city will take men to it, but will not keep them there so long, or take them so often, as if other things contributed to the invitation—a continuing fascination."[73]

In such a climate, then, efforts toward beautification were pushed steadily forward in Chicago. The Municipal Art League played an active part after its formation in 1899, but it was only one of several organizations involved at the time. Two years before that group was founded, the Commercial Club of Chicago had devoted a meeting to the question "What can be done to make Chicago more attractive?"[74] Burnham was the principle speaker at that meeting, and then again the next week, when his topic was the same in an address before the Merchants' Club of the

city. These and other Chicago clubs considered the question with and without Burnham's direct prompting over the following years. In the fall of 1905 when businessmen provided Chicago Mayor Edward P. Dunne with their assessment of the "City's Needs in a Nutshell," one of their stated objectives was the "Adoption of a plan of municipal beautification, far-seeing—costly perhaps—and enchanting."[75] The following year support had built to the point where the formerly competing Merchants' and Commercial clubs merged in order to offer more effective joint backing for Burnham's ideas.[76] Under these circumstances, it was little wonder that the announcement of Ferguson's bequest had caused such a stir among Chicagoans already bent upon the physical enhancement of their city.

Through his writing, public speaking, and participation in organizations like the Municipal Art League, Taft made significant contributions to this rising interest in civic beautification as well. But attracting even greater notice was a special project he directed in 1899, calculated to draw attention to the specific issue of public sculpture. On the morning of June 16, the day immediately following announcement of the formation of Chicago's Municipal Art League, rush-hour traffic along Michigan Avenue was greeted by the appearance of ten over-life-size figures corraled in a rough fountain enclosure on the lawn south of the Art Institute. The figure group, entitled the "Nymph Fountain" at the time, was the work of ten young women from the sculpture class Taft taught at the Art Institute. Working through the night they had assembled their composition of figures, encircled them with a low plaster perimeter wall, and arranged rudimentary plumbing providing a modest spray of water—all in time for the crowds returning to work in the Loop that morning. Taft later explained at considerable length that the group was by no means a secret intended to surprise those who encountered it that day; he had actually described the student project in an article published in one of the local newspapers the previous month, and others had also noted the progress of the figures as they were underway in Art Institute studios that spring.[77] Indeed, he expressed some surprise himself over the claims of those who charged that he had intended to shock viewers with the sudden appearance of the group. For the sculptor and his students it had been a lengthy project involving

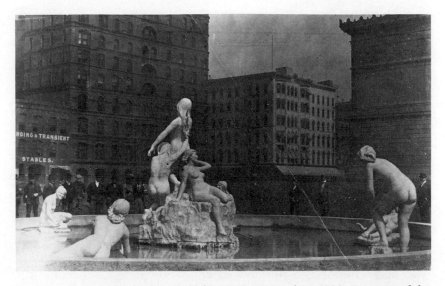

3. "Nymph Fountain" by Lorado Taft's Art Institute class, 1899. A corner of the Art Institute is seen at the far right; the large building across Michigan Avenue is the Pullman building (1884), still seeming massive because not yet flanked by Orchestra Hall (built in 1904) or the towering People's Gas Company (built in 1911). Taft Papers, University of Illinois.

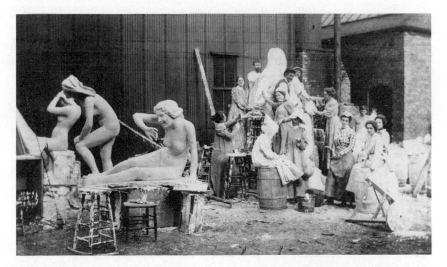

4. Taft's Art Institute class working on figures for the "Nymph Fountain," 1899. Taft, in his white smock, stands highest in the group, working just to the left of the large mold under construction. Taft Papers, University of Illinois.

considerable labor carried out in full public view in their open studios that spring. Based on his recollections of friends enjoying the water during summer months of camping along the shores of Bass Lake in Northern Indiana, Taft had planned the composition of splashing maidens, determined the poses, and assigned individual figures to each of the students who participated in the modeling. The young artists possessed varying skill and different degrees of life class experience, but each worked up a small scale model of her assigned nymph, enlarged it, and then had an opportunity to see it joined with the others in the completed fountain group.[78] It was obviously an ambitious undertaking and, scheduled to appear in conjunction with the annual spring student exhibition and commencement exercises at the Art Institute, it served as a memorable final project for those involved.

Yet beyond its value as a student project, the "Nymph Fountain" was also intended to provide an educational experience for the Chicago public. Interviewed on the day it appeared, both Taft and Art Institute Director French pointed out that their goal was to generate response from the public and "wake them up" with regard to the possibilities for such work.[79] The Municipal Art League also reported to be watching eagerly for signs of interest; just embarking on their new beautification program, they hoped the fountain would not only stimulate interest, but also provide a clearer indication of what they might have to contend with in the course of their own enterprise.[80] The project no doubt exceeded all expectations on this level. Accounts of the first day describe crowds of people six deep ringing the composition by nine o'clock that morning, and newspapers sought opinions from cultural leaders, city authorities, moral watchdogs, and even the police soon stationed to control the crowds. Within two days the *Tribune* called the new sculptural group "the town talk," and while a handful of local ministers and representatives from the Women's Christian Temperance Union and the Social Purity Committee of the Civic Federation voiced objections regarding the appearance of nude figures in a public fountain, theirs was the minority opinion.[81] Far more important were the favorable views expressed by notables like Hutchinson and Mayor Carter Harrison, and their opinions were echoed in editorials praising the efforts of Taft and his students.[82] Even the cop on the beat, noting he had been stationed

in the vicinity of the Art Institute long enough to know some-
thing about art ("both nude and nudeless"), dubbed it "the best
that ever came this way" and censured those who would criticize
the work by adding that, after all, "it's art, and if everybody goes
around taking a wallop at art where'd we be?"[83]

Although perhaps agreeing with the constable in general prin-
ciple, Taft was quick to admit that the fountain produced by his
students was by no means perfect. The limits of their experience
showed up in a degree of awkwardness apparent in both anatomy
and expression of individual figures, and use of soft plaster made
it necessary to moderate the play of water to prevent damage.
Most troublesome to Taft, however, was the unfortunate location.
Noting that original plans had involved placing the group in a
courtyard within the Art Institute, he explained that they had been
forced to change tactics and move the fountain out to the lawn be-
cause of unanticipated interference from preparations for the new
Ryerson Library then under construction. While the courtyard
would have provided a more intimate setting, the nude bathers
seemed altogether too implausible a subject for such a public
place on the lawn alongside busy Michigan Avenue, and the back-
drop of smoke from locomotives on the nearby Illinois Central
Railroad tracks was "a poor substitute for shrubbery."[84] The highly
public location had, of course, provided far more attention than
an appropriately secluded courtyard, but the sculptor promised a
more fitting match of subject to site in future projects.

The specific aesthetic accomplishment of the "Nymph Foun-
tain", then, was limited. Taft answered all who suggested that the
group be made over in permanent materials by explaining that
this was merely an exercise and was "never intended for any-
thing more than a full-size sketch, to give the general effect of the
scheme."[85] If the public desired a fountain, he noted, it would be
possible with proper funding and time to create a truly beautiful
work, far superior to the plaster figures on display beside the Art
Institute. Yet however modest the artistic quality of the work, the
contribution to public interest in civic beautification represented
by the students' "Nymph Fountain" was important. Drawing atten-
tion and initiating discussion, it raised the matter of civic statuary
in exceedingly dramatic fashion at exactly the moment Heckman
and others were calling the most crucial juncture in the cultural

life of the city.[86] And that it brought together Taft, City Beautiful ideals, and that particular plot of real estate on the south side of the Art Institute made the event even more intriguingly prophetic.

In light of these interests, it was little wonder that Ferguson's gift and the sequence of events it initiated brought about such an enthusiastic response among Chicagoans. It was not only a matter of the amount of the generous bequest, or the surprise it caused many observers at the time of the 1905 announcement; it was that the very appearance of a gift providing for the long-term funding of public sculpture seemed an especially happy coincidence at that point. Organizations were working to improve the appearance and image of the city, Burnham's ideas were receiving more and more support and encouragement among several groups, and an appetite for public art had been whetted by individuals like Taft. Indeed, the Ferguson Fund seemed to fill out the equation perfectly, promising what Illinois State Senator Francis W. Parker explained would be the full flowering of Chicago with "magnificent public and private buildings, statues, fountains, boulevards, public places and decorative features."[87]

When Hutchinson spoke of the importance of the *Fountain of the Great Lakes* in his dedication address, however, his enthusiasm was prompted by more than its beauty. Beyond the obvious role of such a fountain in City Beautiful schemes was its importance as evidence of the value of individual public service. As he explained, future generations contemplating this and other products created as a result of Ferguson's bequest "will wonder at the far-sighted wisdom of this man, who loved his fellow-men and sought to be of service to them—sought not only to minister to their esthetic sense, but to arouse their patriotism as well."[88] The *Fountain of the Great Lakes* thus served as a means of both embellishing its site and exciting public pride in a beautiful city. More important, Ferguson's service in providing money for this and other public sculpture offered a lesson proving the value of service itself. In Hutchinson's estimation, however crucial the improvement of the physical city, broader encouragement of civic responsibility demanded at least as much attention in the early years of the century. In an "age of steam and electricity, when the affairs of the world seem to be controlled by corporations and run by machinery,"

Hutchinson believed that the individual's contribution to society was in danger of becoming seriously undervalued.[89] Ferguson's gift, on the other hand, provided exactly the remedy needed to right the situation, demonstrating that individual action was important and could still have meaningful effect. The *Fountain of the Great Lakes* stood as strong material evidence, then, offering a convincing lesson on the potential for public service.

Of course such a lesson had long been taught in American culture. Public service was expected of the American business leadership almost from the outset by orthodox Puritans. Writing in 1701, for example, Cotton Mather advised that in addition to a Christian's general calling to serve God, each individual had a personal calling to a life occupation on earth. He described these dual responsibilities as oars on a boat, both necessary to maintain a true course: devotion to God should be complemented by occupational diligence, which would result in "Usefulness" within the "Sociable" world God had wrought.[90] And although secularized over the following decades, this concept of usefulness rapidly blossomed into a service ethic put forward as justification for increasingly aggressive personal enterprise. In the later nineteenth century with American business leadership grown large and powerful, and captains of industry scrutinized more closely than ever before, "service" became a watchword of considerable importance. As one source points out, by the turn of the century apologists for many suspiciously successful entrepreneurs and corporate leaders came to portray their subjects as individuals possessing an energetic love of work and power—but also motivated by an underlying desire to serve others by their efforts.[91]

The service provided by these wealthy American businessmen was described as something occurring on at least two levels. On the one hand, their enterprise was seen as action benefiting the entire country. The development of natural resources and the building of railroads, industry, and cities contributed to the public good and offered the most obvious evidence of a financier's service. As Theodore Roosevelt explained in 1901, without the nation's industrial and commercial leaders, "the material progress of which we are so justly proud could never have taken place."[92] Writing the following year, Andrew Carnegie, often cited as one of the prime examples of the type, stated the same thing rather more

quaintly: "It will be a great mistake for the community to shoot the millionaires, for they are the bees that make the most honey, and contribute most to the hive even after they have gorged themselves full. . . . Under our present conditions the millionaire who toils on is the cheapest article which the community secures at the price it pays for him."[93] Recognition of "gorging" as the price to be paid is interesting, but the implication of meaningful service is still quite apparent.

Beyond such entrepreneurial service, on the other hand, was the role of the American businessman as useful example, serving as a model that might be emulated by others. If some had reservations regarding the means by which wealthy business leaders had acquired their fortunes in certain instances, many others could answer as the Reverend William Lawrence that such acquisition must certainly be the will of God. Natural resources were, after all, available equally to all citizens in a democracy like the United States, and "it is only to the man of morality that wealth comes."[94] Coupled with an increasing belief in the idea that success or failure was largely a function of the individual's own ability and worth, arguments like Lawrence's seemed to offer a good rationale for "gospel of success" advocates who recommended that the young look to the lives of business leaders to find modern heroic models.[95] Even those who understood the darker side of the industrial titan, however, conceded his usefulness as an example of one special form of modern genius. In his trilogy on the career of Frank Cowperwood, Theodore Dreiser described a man given to treachery, deceit, and lawlessness; but the three novels were at the same time a celebration of the businessman as a modern hero possessing strength, self-confidence, and keenness of mind. In Dreiser's estimation, figures like his fictional Cowperwood represented "the coldest, the most selfish, and the most useful of all living phenomena."[96]

Among the many avenues for public service open to such leaders in the later nineteenth century, cultural philanthropy was one of the most attractive. Throughout the period libraries, museums, college and university buildings, park space and similar gifts were donated to the public by wealthy citizens in several American cities; many more contributed generously to special funds established for the purpose of expanding library or museum collections, underwriting beautification planning, or maintaining

civic orchestras and opera. Many of the donors naturally benefited from their own gifts. Enjoyment of cultural institutions coupled with an understanding of the economic arguments behind civic beautification and cultural improvement made such philanthropy very popular among the wealthy. At the same time, however, a substantial number of the gifts were posthumous bequests like Ferguson's, and in all cases the concept of public service was never far from the minds of either benefactors or recipients. Helen Lefkowitz Horowitz has noted that this general interest in cultural philanthropy was in fact due to a growing belief in the value of such contributions as a means of strengthening the broader public spirit. Wealthy, successful civic leaders, spurred on by a "sense of superior wisdom" in many instances, attempted to develop the minds and offer nourishment to the souls of common citizens in a genuine effort to elevate the entire population.[97]

Yet many also perceived another distinctly practical value in the mental and spiritual nourishment offered by cultural philanthropy. In addition to those offering their resources out of a pure, high-minded generosity were others motivated by a belief in the potential for a more practical social reform resulting from philanthropic efforts that might raise the cultural standards of the public. A population able to select from and enjoy a wider variety of cultural amenities would be a happier population—not only enriched but contented. In his account of civic improvements near the turn of the century, this was exactly the sort of social argument Robinson put forward following his economic argument for civic beautification: "There is a sociological value in the larger happiness of great masses of people, whose only fields are park meadows, whose only walks are city streets, whose statues stand in public places, whose paintings hang where all may see, whose books and curios, whose drives and music, are first the city's where they live. The happier people of the rising City Beautiful will grow in love for it, in pride in it. They will be better citizens, because better instructed, more artistic, and filled with civic pride."[98] The cultural philanthropist, then, had an opportunity to offer a greater measure of internal harmony to his city by allowing the broader population more comfort and enjoyment as well as pride in the life of their community. That achieved, many of the troubling signs of social disharmony becoming increasingly apparent in later nineteenth-

century American cities would disappear and life could become more agreeable for all.

In Chicago, cultural philanthropy was especially popular among the city's wealthy. Jane Addams's Hull House may well have received the lion's share of attention, but more funding typically went toward institutions like the Field Museum, the Crerar and Newberry libraries, the Art Institute, and the University of Chicago. Kathleen D. McCarthy estimates that from the city's founding until the early 1920s, nearly two-thirds of the money donated for public service in Chicago went for cultural enterprises of one sort or another; during the first decade of the twentieth century, Ferguson's substantial bequest of a million dollars represented less than a tenth of the amount given to promote cultural enterprises in the city.[99] Not all found this an appropriate direction for generosity. At the dedication of a new day nursery he had donated to Hull House in 1907, industrialist Richard T. Crane was outspoken in his criticism of City Beautiful benefactors, claiming that they "see charms in plans for street statuary, artistic bridges, and extensive boulevards, but overlook the necessity for clean and comfortable homes and tenements, clean and well paved streets, clean back yards and alleys, where the poorer classes live."[100] Yet for every business leader like Crane who donated money to Hull House and the Chicago Relief and Aid Society while refusing requests that he "contribute $80,000 toward equipping an expedition to go to the South Pacific islands to gather material for the Field Columbian museum," there were others perfectly willing to turn their fortunes to funding public statuary, civic orchestras, and anthropological expeditions.[101]

No doubt this drive to fund the development of cultural institutions in Chicago was in large part a response to the criticisms so often leveled at the city by residents and outsiders alike. Despite the momentary optimism of his 1897 description of the city's "upward movement," for example, native Chicagoan Fuller more commonly expressed the belief that the youthful grasping for material prosperity had left an unmistakable mark on the new metropolis. In his first major Chicago novel, *The Cliff-Dwellers* (1893), one of Fuller's chief characters reflected the author's opinion when observing that the very intensity of the commercial striving that had built the city appeared to have "drugged" all sense of civic

responsibility, leaving "the base scaffolding of materialism" utterly devoid of "the graces and draperies of culture."[102] While Fuller's may have been an exaggerated view based as much on his personal dissatisfactions as anything else, newcomer Ralph Clarkson voiced a similar concern very shortly after arriving in Chicago. An accomplished painter lured to the city by hopes (and certain promises) of a brilliant career among wealthy patrons in the thriving new western metropolis, Clarkson's early experiences of the city left him with no real grounds for personal complaint on that score. Yet as he explained in an 1898 article, his observations regarding the city's broader insensitivity toward the arts were disturbing indeed. Finding a complacency characterized by the Chicagoan's claim that "when we take up art we will dispose of it as quickly as we have other things," Clarkson worried that the city would never amount to anything more than "a gigantic commercial center" with little or no cultural life.[103] In such a city—an enormous commercial skeleton lacking the flesh and blood of culture—it seemed to writers like these that the refinement and amenities seen elsewhere were inconceivable.

It was in this climate that people like Hutchinson placed such a premium on public service in general and cultural philanthropy specifically. When he spoke of the service value of Ferguson's bequest during the dedication ceremonies, Hutchinson's observations were actually those of a man who was himself a devoted servant of Chicago. In an appreciation written shortly after his death, Hutchinson was described as a man active in over seventy organizations working for "the advancement of human welfare."[104] His interests ranged from local to international causes and included charities, religious concerns, and cultural projects. It was in this last area, however, that Hutchinson made his greatest mark. Long-time president of the Art Institute, he was also an officer or board member of the University of Chicago, the Chicago Symphony Orchestra, the Field Columbian Museum, the Municipal Art League, and several other organizations and institutions. To this work he contributed both his untiring effort and his own fortune.[105] As Taft pointed out in an address delivered at the banker's memorial service in 1924, Hutchinson's devotion to such work was unstinting because it was based on an ability to "look beyond the dirt and disorder and see the city to come—the city of des-

tiny." [106] Like Ferguson, then, Hutchinson stood as both a significant contributor to the cultural development of Chicago and an example for others to follow.

And it was certainly his own preoccupation with public service that made Ferguson's contribution to the city even more personally important to Hutchinson. Committed to what one source termed "duty in the service of art," the opportunity to promote such concerns was seized immediately and gratefully in his 1913 dedicatory address. [107] On the specific level, of course, Hutchinson could praise the new fountain Taft had created as an important addition to a Chicago improvement program toward which he himself had long worked. More generally, he could also cite Ferguson as a potent example: *this* individual proving the importance of *the* individual as a meaningful force in the enhancement of modern life. And to underscore his message, one small addition was made to the new work being dedicated that day. Just a month before the ceremony, it was announced that a modest plaque would be added to the back of the large granite slab forming the rear wall of the fountain. [108] Carrying a relief portrait of the donor and a statement explaining his role as a contributor to the beautification of Chicago, the plaque thus formed a small but important shrine attached to what was then officially renamed the *Ferguson Fountain of the Great Lakes*. [109] It was a natural expression of gratitude, honoring the man by commemorating him and his notable gift; yet as it honored the public servant, elevating that servant to the level of cultural hero, it proclaimed the value of the service ethic in this modern world.

CHAPTER

2

Realized Ambition

When Taft spoke at the 1913 dedication ceremony, his address began with predictable expressions of gratitude. He thanked the trustees of the Ferguson Fund for the opportunity represented by this first commission; he thanked his bronze founder, Jules Berchem, who had produced such a successful casting; he thanked the architects of the firm of Shepley, Rutan and Coolidge for their contribution in designing the base for his fountain group; and he thanked the Municipal Art League "who kept me encouraged through so many wistful years, assuring me that Chicago should have the *Fountain of the Great Lakes*, if they had to beg money on the street corners."[1] It was this last expression of thanks to the league that set the tone for the remainder of his address that afternoon. The sculptor described the commission, received after long, dismal years, as a turning point in his career. As Taft explained to his audience, there had been "a long dreary period after the World's Fair, a hopeless eternity of depression and longing" during which opportunities were few and slight.[2] Upon receipt of the Ferguson Fund commission, however, the situation appeared to change. Increased publicity, additional commissions, and a growing feeling that his public work was gaining a measure of recognition in the community revived Taft's commitment, giving him the necessary encouragement to continue.

Taft's descriptions of his career and new possibilities were as accurate as he could have been at that point in 1913. Looking back

over nearly three decades of professional experience in Chicago, he no doubt saw a rather clear pattern of personal optimism and private encouragement followed by repeated public disappoint-ment for some twenty years of that period. There were both high and low points during those years—times of frenzied activity followed by virtual inactivity—finally concluding with his major commission from the trustees of the new Ferguson Fund. If his perception of himself as a successful artist in 1913 was still some-what uncertain (and ultimately short-lived), there was little ques-tion that the relative success and stability of the years between his receipt of the commission and the dedication of the fountain were great indeed.

The career Taft described in his address had started very op-timistically in the mid-1880s. Returning to the Midwest in 1885 after four years of study in Paris—three at the prestigious Ecole des Beaux-Arts—the sculptor had settled in Chicago in the belief that the city held many possibilities for an ambitious young artist. This was of course natural for a young man who had grown up in downstate Elmwood and Champaign; the metropolis emerging to the north during his childhood stood out as an important center for Taft just as it did for so many other hopeful youths described later in the novels of Dreiser, Willa Cather, and Hamlin Garland. Making it all the more attractive to the sculptor, however, was the early encouragement he received from wealthy individuals like Chicago real-estate magnate Simeon B. Williams. Taft met Williams while still a student in Paris, where he impressed the older busi-nessman sufficiently to win his active, enthusiastic support.[3] When the sculptor arrived in Chicago to establish his studio, Williams was on hand to offer advice, introductions, a modest degree of financial support, and the encouragement that "Chicago is des-tined to be headquarters in art sculpture."[4] The result was what Taft later described as a continued naive hopefulness and belief on his part that opportunities for him in Chicago were excellent.[5] In letters home to family, he styled himself a "rising artist" and from the very first gave notice of "prospects" already "accumulating at a terrible rate."[6]

These "prospects" varied considerably. On the level of the pure potboiler were assorted commercial projects involving the mod-eling of decorative trim, firebacks, grates, and similar devices or-

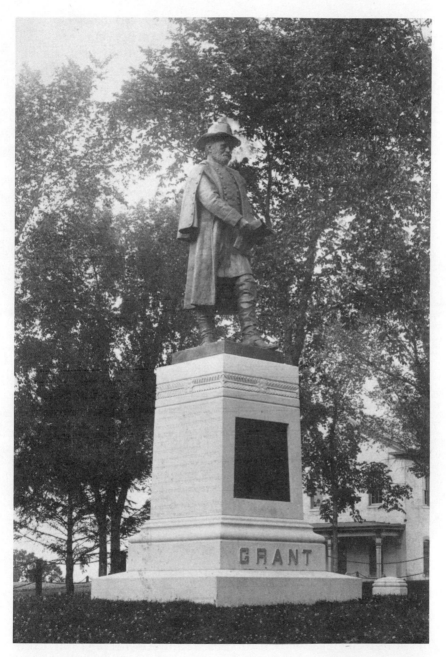

5. Lorado Taft's *Ulysses S. Grant*, 1889, Leavenworth, Kans. Taft Papers, University of Illinois.

dered by local foundries; there was even an occasional call for but-
ter sculpture for restaurants and fairs in the early years.[7] Although
not really to his liking, such work allowed Taft to maintain his
studio and even attracted some public interest from time to time.[8]
Far more rewarding—financially and aesthetically—were opportu-
nities for public statuary. Very shortly after his arrival in Chicago,
Taft found commissions for commemorative figures appearing
with increasing frequency. Among his first tasks was modeling a
statue of the *Marquis de Lafayette* for Lafayette, Indiana, in 1886.
He complained to his parents that this first project actually de-
manded only a copy of the well-known statue by French sculptor
Frédéric Auguste Bartholdi presented to New York City ten years
earlier, but he was shortly given other opportunities to create com-
memorative statues of his own design.[9] His *Schuyler Colfax* (1887)
was commissioned for the city of Indianapolis, and his *General
Ulysses S. Grant* (1889) was done for Leavenworth, Kansas. At
the same time, contacts with monument companies and foundries
brought additional subcontracting work. When Arthur A. McKain,
a versatile Indianapolis businessman whose many concerns in-
cluded a company called Monumental Work, obtained the order
for the *Randolph County Soldiers and Sailors Monument* (1892)
for Winchester, Indiana, he hired Taft to produce the figures and
reliefs required for the huge memorial.[10] In fact, so active was
Taft's studio by 1890 that the sculptor could write his mother
with pride of no less than "*ten* soldiers growing up like the harvest
of dragon's teeth all over my studio" and destined for towns and
cities from Morris, Illinois, to Yonkers, New York.[11]

In addition to public statuary, Taft also received frequent orders
for portrait busts. Beginning during his student days in Paris he
worked to master portraiture, eventually learning to fashion like-
nesses of remarkable sensitivity.[12] Later, whether carving butter
portraits for regional fairs, modeling features of civic or govern-
ment leaders for institutional clients, or demonstrating his ability
to render facial expression and character in his famous "clay talk"
lectures, Taft continued to display a great facility for such work
throughout his early career and a steady stream of portrait com-
missions came his way. Many of these required working from death
masks or photographs of recently deceased notables. Early after his
arrival in Chicago, for example, Taft was contacted to take a death

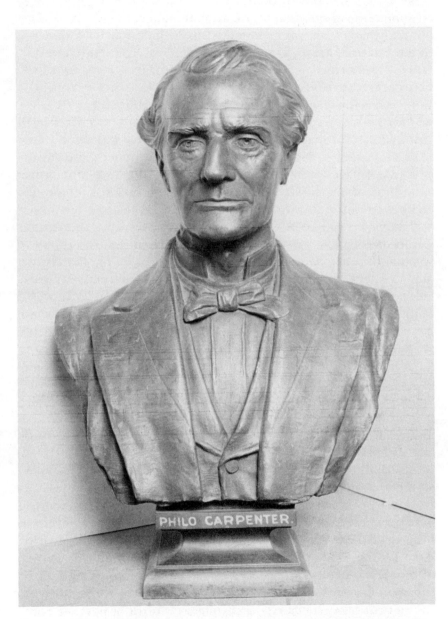

6. Lorado Taft's *Philo Carpenter*, 1888. Courtesy of the Chicago Historical Society.

mask of the well-known abolitionist and promoter of early Chicago religious organizations, Philo Carpenter; shortly thereafter, Carpenter's daughter commissioned a bust, which was then donated to the Chicago Historical Society in 1888.[13] In 1890 another important portrait of the late John Crerar—this time from photographs— was ordered by the Chicago Literary Club for placement in the new library his generous bequest made possible.[14] In between— and for some years to come—many more busts were done of both distinguished individuals and virtual unknowns. Indeed, so substantial was the volume of portraiture Taft produced during the first two decades of his career in Chicago that in 1908 one writer noted that the sculptor's studio had actually "been given largely to portrait busts" through those years.[15]

Taft viewed all such work as effort necessary to establish his career in the city. It not only brought in revenue allowing him to maintain and expand his studio, but it brought increasing reputation. Visitors turned up to see work in progress from very early on; portraiture helped circulate further word and evidence of his skill and thus draw more interest.[16] He did have certain reservations regarding the ultimate merit of such work. It was no doubt as much for his own peace of mind when he wrote his mother to reassure her he would not remain forever content with orders for soldiers and busts, claiming to be actively "composing ideal works all the time," many "much stronger and more artistic than I ever dreamed of in the student days."[17] Yet he realized too that his career was just beginning in the late 1880s, and the very bustle and energy of the active studio was in itself enough to give him pleasure and pride in the early Chicago years when all appearances signaled growing success.

In the spring of 1891 Taft found even better evidence of this when he received "flattering encouragement from the various Chicago architects who are to design buildings for the World's fair."[18] What had been a general interest in his adopted city's struggle to gain the honor of hosting the Columbian Exposition quickly turned into a personal hope that some of the important decorative work at the new fairgrounds might eventually come his way.[19] As construction commenced at Jackson Park, Taft's dreams came true. His initial assignment was to work with William Le Baron Jenney, producing sculpture to grace the architect's Horticultural

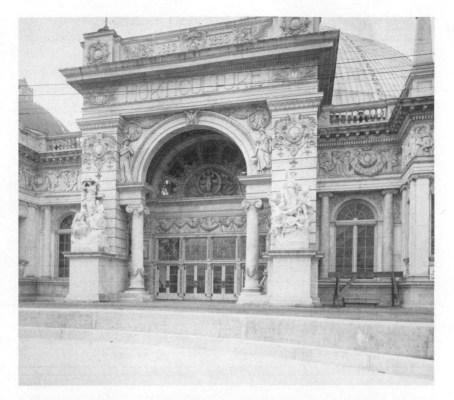

7. William Le Baron Jenney's Horticultural Building (detail of entrance), World's Columbian Exposition. Flanking the archway in this view are Taft's *Sleep of Flowers* (left) and *Awakening of Flowers* (right); the frieze of children above the cornice line is likewise Taft's work. When completed, this large building also served as the site of a workshop in which Taft directed one of the crews enlarging staff sculpture for other locations at the exposition. Taft Papers, University of Illinois.

Building. For two important positions flanking the main entrance, Taft designed large allegorical groups of classical figures entitled *The Sleep of Flowers* and *The Awakening of Flowers*; additional figures were designed for other locations, including heroic statues of *Flora* and *Pomona* in the vestibule and a long frieze of garlanded children completely encircling the exterior.[20] But beyond his decorative work for the Horticultural Building, Taft was retained to serve as a shop foreman to guide enlargement of other sculpture in a temporary studio established within that building. Directing an assortment of younger sculptors and other assistants,

he operated what one of his crew later jokingly termed an "art sweat shop," transforming small models into larger staff sculpture for buildings, bridges, and other locations around the grounds.[21] It was a time-consuming process that eventually took him entirely away from his own studio work, but it also represented what he recalled as a welcome change from "death masks and soldier monuments."[22] It was an opportunity to turn his hand toward something he regarded as more challenging and creative, and to do so in a stimulating environment.

In fact, the enthusiasm felt by the sculptor was due in large part to his perception of the atmosphere that developed with preparations for the Columbian Exposition. In Taft's memory the work there always stood out as one of the brightest moments of his career—a benchmark even many years later. In reminiscence he rather grandly likened the 1892 spirit emerging at the fairgrounds to that which built the Parthenon, recalling it as a time when for at least a moment "America's greatest artists were all walking the streets of Woodlawn."[23] The experience proved a tremendous boon to his sense of professional identity, for in addition to working with Jenney, Burnham, and other important Chicagoans, he became more closely acquainted with many of the established and rising American talents in his own field. The presence of Saint-Gaudens, recognized even then as an equal by the major planners of the exposition, brought about what Taft described as an "unusual quickening" of excitement at Jackson Park, but between Saint-Gaudens's visits many others were on hand to create an impression of vital creativity about the place.[24] French was at work on his colossal *Republic* in the Agricultural Hall, with Charles Lopez foreman of a team like Taft's in that building; Karl Bitter and Philip Martiny had veritable armies enlarging their work in the Forestry Building at the same time; and Taft's immediate neighbor in the Horticultural Building was Alexander Phimister Proctor, whose crew worked alongside Taft's. A camaraderie grew during the months of preparations, ultimately strengthened by the sense of accomplishment felt by all when the task was over and the White City complete.[25]

Yet if Chicago became headquarters for a large number of artists during the months of construction in Jackson Park, their ranks swelled once the fair was underway. Eager to see the highly touted

exposition and investigate the rising midwestern metropolis spon-
soring it, many more artistic and literary figures arrived and re-
mained for extended visits during the summer of 1893. Hamlin
Garland, soon to be one of Taft's closest personal friends in the
city, provides an excellent example. Returning from the East to
observe the fair and participate in the Literary Congress held in
the newly completed Art Institute building that summer, Garland
later recalled being greatly impressed by the swarms of artists,
colonies of writers, and ambitious young publishers whose pres-
ence seemed to suggest that Chicago was "entering upon an era
of swift and shining development."[26] Despite the hostility of press
reports following his debate with Mary Hartwell Catherwood at
the Literary Congress during a panel discussion on "Aspects of
Modern Fiction," Garland's experience of Chicago was in fact im-
pressive enough to lead him to an important decision. The cultural
leadership was strong, promising well for the future of institu-
tional support for the arts in the city, and Garland concluded that
writers like himself could contribute to the proper fulfillment of
that promise. When the exposition closed he settled his affairs in
Boston and returned to take up permanent residence in Chicago.[27]

While the exhilarating presence of so many active artists in the
early nineties gave way as most departed during or soon after the
exposition, an important nucleus did remain in the city. New ar-
rivals like Garland and new acquaintances like Fuller soon gave
Taft a broader circle of colleagues increasingly valued as stu-
dio companions through the decade. Clubs initially ranging from
short-lived experiments like the Attic Club and light-hearted Wise
Diners group eventually gave way to more permanent organiza-
tions like the well-known Little Room, providing a stronger base
for the studio life Taft enjoyed; friendships formed in those groups
were then carried over to summer vacations at Bass Lake, Indi-
ana, and the famous Eagle's Nest camp overlooking the Rock River
in northern Illinois.[28] If this group never actually recreated the
vital artistic atmosphere of Jackson Park, at least Taft's circle grew
more reliably stable over the years. By the turn of the century visi-
tors expressed surprise when encountering such an active cultural
community thriving in studios of the city best known to outsiders
as a busy commercial hub.[29]

At the same time, the artists participated not only in the social

activities of club meetings and summer vacation outings, but in more serious dialog regarding the nature and direction of contemporary art. Garland's introduction to the city with the Catherwood episode at the Literary Congress, for example, was but the first of his efforts to gain a hearing for his views on modern literature. Although richly satirical, Fuller's thinly disguised portrait of his friend Garland as Abner Joyce in *Under the Skylights* (1901) later presented a man prone to long and impassioned discussion of his views. And while his own Chicago fiction of the period seems reasonably close to the "veritism" Garland advocated, Fuller's more refined personality and love of established cultural values provided a striking foil for his friend's iconoclastic proclamations and calls for an "era of reorganization" in the arts.[30] For his part, Taft could side with either—depending upon the issue under discussion. A firm believer in the importance of traditions in the arts, he also recognized the need for some adjustment to modern circumstances. To Fuller, the sculptor undoubtedly represented someone equally enamored of European civilization and well able to discuss the great cultural heritage of the past; Taft's studio gradually became a favorite refuge for the quiet writer, an artistic haven in the bustling city. Garland, on the other hand, appreciated Taft as an active collaborator in the Central Arts Association and other efforts to bring greater awareness of contemporary art to the broader public; together they worked on a variety of enterprises calculated to circulate exhibitions and critical literature.[31] The diversity of these personalities and others in the group prevented much real agreement, and consensus was reached only on the belief that much local work was meaningful and important. Yet the stimulation provided by good-natured dialog and debate made the community appear even more viable to those who participated.

Augmenting this development of his artistic circle was the increased recognition coming to Taft from "official" sources during these early years. His initial ideas about the possibility of gaining additional income by offering modeling classes for "young ladies who have nothing to do" were rapidly put aside when Director French of the Art Institute invited him to assume a position as instructor and head of the sculpture department at that institution in 1886.[32] That connection and others soon led to more and more opportunities for public appearances over the next few years, and

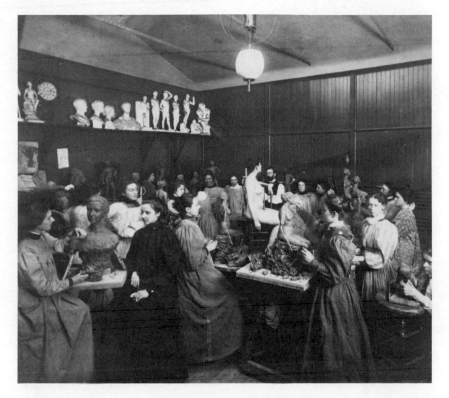

8. Taft's sculpture class, School of the Art Institute of Chicago, c. 1890. Taft is behind and slightly to the right of the nude model. Taft Papers, University of Illinois.

by the early nineties Taft was so much in demand as a lecturer that multiple bookings at times forced him to send others in his place.[33] Moreover, the Chicago press, also kind to the sculptor from the outset, gave him increasingly broad coverage as preparations for the Columbian Exposition brought him to the fore. When the *Chicago Inter Ocean* introduced its new Illustrated Supplement in 1892, Taft was one of the leading subjects, featured in a full front-page color illustration showing him at work in a studio crowded with his sculpture.[34]

This increased prominence led to new social opportunities beyond his immediate circle as well. Taft was a gregarious man, and the club life of the city held special appeal for him. While the Chicago Arts Club was a natural choice for the sculptor, he was

also an active participant in the Congregational Club, the Chicago Archaeological Society, and the Chicago Literary Club during his early years in the city. In these organizations he met many of the important cultural leaders of the city and became an increasingly welcome member of their groups. The Literary Club was Taft's special favorite. Formed in 1874 as a genteel association providing relaxation for the city's business leaders, it had become a gathering of some of the most influential figures in Chicago by the time Taft was elected to membership in 1889. The meetings consisted of polite readings and mild discussion; club rules prohibited members from venturing opinions on religious, political, social, or economic issues, so presentations tended toward surveys of historical periods and literary themes.[35] In addition to formal meetings, however, Taft soon discovered small groups often continuing private chats on topics of interest late into the night, and accounts provided later to his family indicate he enjoyed these informal sessions as much as the meetings of the full club.[36] And as club life rapidly provided Taft access to an ever wider range of the city's cultural elite, the artist proved himself a gentleman well worthy of their interest and trust. By the early nineties, meetings were frequently mixed with dinners and receptions at some of the more prestigious homes in the city, Taft assuming such high visibility at such events that he was eventually taken to be one of the primary representatives of the Chicago art community. In one case when the visiting painter Gari Melchers and friends were feted in Chicago in 1890, Taft was invited to dinners at the Hutchinson residence and then again at the home of Frederick W. Gookins—in each case as the sole Chicago artist on hand to help entertain the special guests.[37]

Perhaps the most striking and regular sign of his growing acceptance in the early years, however, was the attention Taft received in his own studio. Very soon after establishing himself in Chicago, the sculptor began to benefit from the popular public practice of studio visiting. These visits were, of course, common in virtually any American city large enough to support a population of artists in the later nineteenth century. Neil Harris explains that formal receptions at artists' studios in New York became fully established as an important part of that city's cultural and social life in the 1850s; many artists eventually even altered the very character of

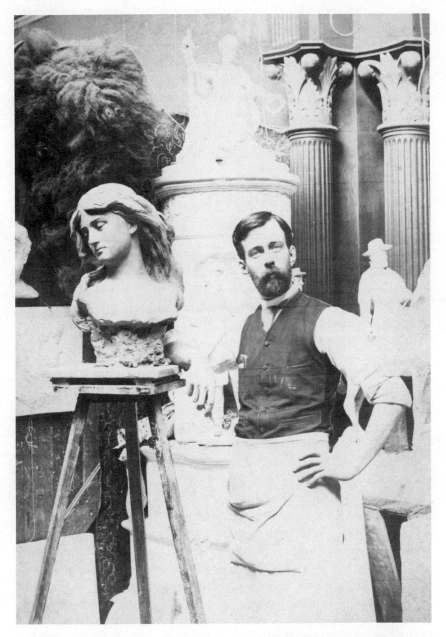

9. Taft in his studio, 1887. Items of note serving to embellish the studio include a buffalo head, classical temple facade, and much statuary. Taft Papers, University of Illinois.

their studios, taking space in more prestigious locations and intro-
ducing lavish collections of exotica as decorations calculated to
impress lay visitors with the unique personality of their host.[38] Taft
recognized the importance of the studio from the opening of his
career in Chicago. As early as 1886 he signed a lease on an attrac-
tive new studio atop a Loop business tower, knowing full well that
the rent was more than he could comfortably afford, but believ-
ing it essential that he cultivate an image as "one of the swellest
artists in town."[39] Over the next twelve years he moved three more
times, in each case to larger, more expensive penthouse studios in
order to appear, as he later explained, "as prosperous as possible,
because, as you know, people like to patronize . . . a man who has
the approval of the crowd, and pass upon one who is obviously
down at the heel and out of favor."[40] And in these bright, spacious
studios, Taft assembled his own unique collection of decorative
attractions, including several plaster studies and casts arranged
above and around a large model of a classical temple facade.[41] If
Fuller's later satirical account of pink shaded candles, jewelled
censers, and peppermints arranged on silver trays beside amply
cushioned carved pews was a bit far-fetched, there can be little
doubt that the sculptor's lair was more a tasteful den than a dingy
workroom.[42]

Stepping into this artistic sanctuary was intended to give the
visitor an illusion of having been transported far beyond the tumul-
tuous, pressing activity of noisy Chicago to a quiet world of grace
and beauty—and Taft's efforts to establish this unique atmosphere
were almost too successful. Lured by the attraction of watching
the sensitive creative genius at work in his tasteful surroundings,
many more than Fuller rode the elevators to the doors of Taft's suc-
cession of Chicago studios. The sculptor's early correspondence
made frequent mention of visiting parties stopping to watch him
at work; after one such group included the wealthy manufacturer
and civic leader Eliphalet Wickes Blatchford in early 1886, Taft
was so jubilant he wrote his parents of the coup, concluding that
he doubted "a young artist ever set out with a more flattering out-
look."[43] His enthusiasm for the traffic flowing through his studio
waned a bit as time went on and he found the sheer volume of
spectators overwhelming, but even as he added partitions and a

separate visitors' room, his reports to the family suggest a pride in the position he had created for himself in Chicago society.[44]

The speed with which the sculptor attained that position also seemed to Taft and his friends to bode well for the future. On April 25, 1890, just four days short of his thirtieth birthday, Taft's early patron and advisor Simeon Williams wrote to congratulate the sculptor on receiving the Literary Club's commission for the Crerar portrait bust, noting that it was precisely the type of project that promised important connections and future successes: "It paves the way for something of greater cost. As an introduction to the money bags; to the Elite; to the literati; to the philanthropic; to everybody who fancies that they know true art when they see it, and who will readily echo what the public judges [of the Literary Club] pronounce good; unique; beautiful; lifelike;—it is about as good a commission as you could desire for that purpose."[45] There appeared no limit to the promise of support available to Taft in Chicago.

In spite of such appearances, however, Taft's experience over the following years was far less positive than he hoped; the promise of his initial period in Chicago remained largely unfulfilled. However strong the interest and encouragement coming from friends and colleagues, however exciting the activities of their Jackson Park camaraderie and downtown studio life, it gradually came to Taft that real success continued to elude his circle of Chicago artists. In his 1913 dedication address he characterized the postfair years as a discouraging time of "pent-up emotions" when his hopes for important sculptural commissions languished; while his efforts remained dominated by "lecture trips, and writing, and teaching, and 'death-masquerading,'" his "beautiful dreams" for meaningful sculpture were pursued only on the side and went largely unrealized.[46]

To a certain extent this should have been predictable, for it was apparent even at the time that some of the interest shown Taft and his colleagues was actually rather shallow. The public's studio visits, for example, were popular more as social outings by the curious than pilgrimages to witness the creation of great works of art. In his 1895 novel, *With the Procession*, Fuller char-

acterized society's encouragement of local artists as something reaching only "the extent of seeing how the thing was done," and rapidly "exhausted with an understanding of certain mechanical processes."[47] Later, his matronly Eudoxia Pence of the *Under the Skylights* stories typified the wealthy visitor who stopped by studios for quiet half-hour breaks from shopping crowds in the Loop. Eudoxia was at times given to "gentle patronage" and "dilittante comments and criticism," yet it was the tea, biscuits, and comfortable leather-covered settle at the heart of the artist's relaxing salon-studio that most attracted.[48] Even Joe Moss, a fictional Chicago sculptor in Garland's *Money Magic* (1907), maintained a tea table and entertained guests—in spite of his claim to produce art in a very down-to-earth fashion and preference for work on "real stuff" like mantelpieces and andirons.[49] Studio entertainment had little apparent role in the businesslike Moss workshop Garland described, yet the author could not ignore the extent to which such entertainment had become a large part of the lives of virtually all artists in the city. In fact, Anna Morgan later recalled that by the time the Fine Arts Building opened to provide studio space right on busy Michigan Avenue in the late 1890s, this social dimension of the artists' routine had reached such a stage that it seemed at times "almost a continuous party."[50] That the party had little direct connection with the art being created made no apparent difference to those enjoying the artists' hospitality.

Moreover, opportunities for mingling with the wealthy at dinners and receptions were frequent but often unsatisfying. In many cases artists were introduced into such social settings less as equal contributors to enlightened conversation than as curiosities providing a measure of diversion for other guests. In his 1895 novel, *Rose of Dutcher's Coolly*, Garland described an evening gathering where two artists enter the party with snappy cultural debate only after dinner guests emerge from the table; the heroine found their entertaining discussions "illuminating and epoch-making" and was glad one of the pair twisted his mustache "devilishly" upward in Parisian fashion.[51] Even more to the point were episodes from a thinly fictionalized serial entitled "The Russells in Chicago" in which Emily Wheaton described the city for *Ladies' Home Journal* readers in 1901-2. Wheaton's discussion of club life, for exam-

ple, offered an especially telling account of a social gathering of the "Cercle Francaise" [*sic*] to which local musicians were invited as "volunteer" performers. For the musicians, the evening turned out to be one long humiliation: left to find their own ways to the home of the wealthy hostess, they were embarrassed by servants, segregated from other guests prior to performance, whisked away to a hurried meal in a remote upstairs room after their program, and then dismissed "so they could get home early" after eating.[52] When they gave the impression of being insulted by such treatment, the hostess grew immediately indignant that after her kindness in allowing them "to play in my house and have my friends hear them" they were unable to display an appropriate gratitude.[53] And even at the weekly salon gatherings Wheaton described elsewhere, although artists apparently joined other guests at dinner, the drawing-room socializing that followed was not a time for "interchange of ideas and brilliant conversation," but a veritable vaudeville with each of the artists in attendance requested to "do something" for the enjoyment of the group.[54]

Nor was Taft oblivious to shortcomings in both the level and quality of interest represented by studio visitors and social invitations. Despite the sculptor's obvious pride in attracting attention at his studio, he expressed an increasing discomfort over the distractions resulting from visitors who "come in to look around and then are off again."[55] In several cases he complained to his family of having to stop in the midst of casting or other activities to visit with uninvited guests; at times the buzz of people wandering through his studio caused him to lose his train of thought altogether. And if interruptions from individuals like Hutchinson, Williams, or Blatchford were welcomed for the possible support those men might later provide, many others were obviously neither particularly influential nor likely to be clients in the future. Outside the studio Taft's artist-gentleman role also wore thin as he recognized that he was at times called upon to serve as a source of entertainment for others. After one evening's affair he wrote his mother of the event with humorous candor: "Friday night I played the society man fast and furiously. I went to the Hutchinsons' first where was held a reception to [*sic*] the Chicago Society of Artists. Mrs. H. was lovely as before and made me acquainted with various interesting

ladies who were there to see the 'animals.' We took great plea-
sure in being exhibited and struck graceful attitudes and looked
as artistic as possible." [56]

When critic Aline Gorren described the problem of the artist's
role in society in 1899, she faulted both parties for reducing
the artist to mere entertainer in this fashion. Polite society, she
explained, did find the artist "a picturesque lion" capable of stimu-
lating interest and excitement when properly positioned in a
drawing-room doorway; yet "it is not an entirely disagreeable posi-
tion for the lion," for artists were typically attracted by luxurious
surroundings and an atmosphere of affluence and gentle manners. [57]
And both sides did benefit to a degree. In Wheaton's account
of the "Cercle Francaise," for example, it is arguable that while
the hostess obtained a virtually free performance to entertain her
guests, the musicians gained valuable exposure. Likewise, Taft cer-
tainly benefited from his ability to adapt to the expected role at
Hutchinson's reception, and his hostess and her friends were no
doubt charmed as ever by the sculptor's efforts.

Nonetheless, both sides were also hurt by the growing barriers
thrown up as a result of this unnatural social situation. Although
both hostess and musicians received some benefit from the brief
and unsatisfying contact Wheaton described, each side emerged
from the experience with a pronounced sense of hostility toward
the other. Unflattering treatment by the society matron whose
guests they entertained caused the musicians to feel misused and
undervalued; perceiving their resentment, the hostess was in turn
insulted by what she perceived as an ungracious response to
the promotional opportunity she provided. Under such circum-
stances, mistrust easily developed on both sides. Wheaton's hostess
clearly expressed her discouragement, claiming that the "queer
and erratic" behavior so often exhibited by artists made them very
difficult to deal with. [58] While their opinions went unrecorded in
the story, her musicians presumably held an equally unfavorable
view of those they felt used them so poorly. In Taft's case the
sculptor's social grace no doubt kept him from showing his hand
at the Hutchinson reception, but the sarcasm of his later account
demonstrates what was by then a growing disillusionment.

Making the situation even more insidious, however, was the fact
that all fascination with the artist as a unique personality apart

from more "normal" society led to further alienation between Taft's circle and the city's cultural and social elite. When commenting on the growing interest in the presence of the creative individual in 1899, for example, Fuller bitterly observed that such interest was very shallow—limited to the study of his character with "little heed to his ideas, and less to his expression of them." [59] Unfortunately, by the end of the century Chicago artists had much to support their claims of frustration over a felt inability to exert influence on the cultural affairs of their city. As early as 1879 control of the major art organization of Chicago had been wrested from the hands of professional artists when a group of civic leaders found debts of the old Chicago Academy of Design grown too large, forced dissolution of the academy, and founded the Art Institute under the leadership of lay personnel like Hutchinson. [60] Subsequent efforts to establish other artists' groups achieved only limited success; organizations like the Chicago Society of Artists lacked prestigious support and always remained in the shadow of the more dominant Art Institute. When assessing cultural developments in the city on the eve of the Columbian Exposition, Lucy B. Monroe was forced to the conclusion that artists had receded well into the background: "Curiously enough, the history of the encouragement of art in Chicago must deal with the business-man of the community rather than with the artists. . . . And it is safe to say that whatever has been accomplished in building up art schools, and exhibitions, and collections, and in fostering an interest in art in the community at large, is due to the men of affairs, who have thrown into this work the same energy that has built the city and made it famous." [61] And in the wake of the fair the situation remained largely the same. While local artists played an increasingly important role as teachers at the Art Institute and as members of organizations like the Municipal Art League, most of the actual decisions regarding acquisitions of art for local collections and general civic beautification were made by the city's wealthy lay leadership.

Yet Taft's discouragement over his role in general cultural matters was far overshadowed by his disappointment in the lack of worthwhile commissions coming to him as his career progressed through the nineties. However certain Williams had been that opportunities like that with the *Crerar* bust would lead to bigger

and better things for his young sculptor friend, the reality of the sitation was quite different. Following the bright promise of the Columbian Exposition, the return to old routines was depressing. Taft was tired of the soldier statues and other commercial work even before the fair. If a nice indication of financial success early on, such work seemed a betrayal of his Paris training, and his enjoyment in creating the enormous ideal figures for the Horticultural Building made Civil War uniforms and accessories less and less acceptable. Portrait busts were even more objectionable—especially when based on death masks, as was frequently the case. Lamenting this side of his career in 1899, Taft described his studio as a veritable morgue of death masks taken of people under a wide range of circumstances, most of them appalling. Despite his objections, he grumbled, he was called to deathbeds so many times he came to feel like "a Siberian convict chained to a corpse."[62]

It was not that attractive commissions and patronage opportunities never surfaced in Chicago—they were simply seldom available to Chicago artists. Writing in 1908, James Spencer Dickerson could claim that local patronage of Chicago artists was improving significantly, but the earlier situation had long been one in which art was "valued in inverse ratio to the distance of the artist's studio from its purchaser's home."[63] The Columbian Exposition certainly provided opportunities and stimulation for local artists like Taft in the early nineties, but even then the most prestigious assignments at Jackson Park were awarded to easterners like French and Americans working abroad like Frederick MacMonnies.[64] Likewise, the Art Institute performed invaluable services in the encouragement, assistance, and education of local artists, but the collection that grew there toward the end of the century showed a marked preference for the established work of foreign masters. The same may also be said of most important private collections in the city; whether drawn to old masters or more contemporary artists, wealthy Chicagoans like Bertha Honore Palmer, Sara Hallowell, Martin A. Ryerson, and Charles T. Yerkes virtually always favored the work of Europeans and eastern artists when amassing their personal collections.[65]

For Taft these circumstances resulted in double disappointment: not only did he fail to gain much beyond the odious death masks and boring soldier monuments, but his financial picture remained

relatively bleak for some years. Naturally, this was in part related to general conditions during the severe nationwide economic depression of the nineties; as the economy declined, Taft was but one of thousands whose fortunes dropped with it. Yet the problem was significantly compounded in Taft's case by his decision to remain and work in Chicago. Few of the other sculptors and painters who participated in the creation of the White City ultimately found sufficient local interest outside Jackson Park to warrant extending their time in Chicago long beyond the end of the fair. From the major figures like Saint-Gaudens and French to young hopefuls like Janet Scudder, Lee Lawrie, and Andrew O'Connor, most simply finished their work and departed for more supportive environs.

Those who remained found existence difficult after their assignments at the exposition were completed. When Fuller published his satirical account of his circle of artist friends in 1901, his humorous description of a Chicago artistic community scraping by on dreams of commissions—and scrambling for even the most remote possibility of realizing those dreams—contained an unfortunate element of truth. Taft and the others may have been amused by Fuller's characterization of good-hearted but ineffectual artists bumbling along after commissions that evaporated as they drew near, but their laughter was undoubtedly uneasy as they recognized themselves in the portrait.[66] The sculptor, for example, his death masks notwithstanding, was at times living a virtual hand-to-mouth existence through the mid-nineties. On one occasion when scheduled to lecture before a group in downstate Normal, Illinois, Taft was forced to turn to French at the Art Institute for a loan when unable to come up with enough for the round-trip train fare; in another instance he wrote French from Indiana requesting a loan of ten dollars to pay a studio assistant because a certain payment Taft expected from another source was delayed.[67] Under such circumstances, it is little wonder that he recalled the period as one of hopeless "depression and longing."[68]

Finally, the effect of his situation began to tell on Taft. By the end of the decade the strain of contradictory feelings was increasingly apparent in both his work and writing. On the one hand, prompted no doubt by an impression of his general acceptance by the cultural leadership of Chicago, Taft often sounded an opti-

mistic note. In reviews of exhibitions, for example, he expressed much hope for the new developments in his field. Although he noted that sculpture still "clings coyly to the radiators or disputes space with unwilling picture frames" in many exhibits, and the general public "shows ever an unerring instinct for bad statuary" when seeking public monuments, he believed the changes of the previous quarter century had been great and boded well for the near future.[69] Likewise, when considering the broader question of American taste and cultural inclinations, Taft posited an emphatic *no* to the query "Are Americans Inartistic?" Raising the issue in one of a series of newspaper articles he published in 1899, the sculptor cited the inappropriate frequency of claims by people like Fuller, Lillian Bell, and Sidney Lanier that modern American society was simply unreceptive to art and would remain so because of an innate national inability to elevate aesthetic over materialistic concerns. On the contrary, Taft objected, if art was not yet a dominant element in American culture, a growing public hunger for beauty convinced him that "there never was a time when people were so ready for it." After describing several examples of American artists gaining support among their countrymen, his conclusion was optimistic in the extreme: "These are some of the reasons why I said that there never was such an opportunity for real artists as now. Happy the man who lives in his own time and who is of his own people! Thrice happy the artist who finds things worth doing and who, full of his message, speaks with heart and soul to his fellowmen in a language which they can understand."[70]

At the same time, however, the sculptor displayed a deep pessimism in various ways. Less than three months after chiding those who would criticize the lack of artistic sensitivity among Americans, for example, Taft changed his position sufficiently to assume the role of cultural critic himself in another newspaper article. "While I cannot agree with Henry Fuller that our race is hopelessly inartistic," Taft explained, "I do feel that our city life is fast becoming so. The aesthetic side of our nature is almost completely atrophied. Artists cannot develop amid such surroundings."[71] In his own case, he felt that this atrophy of public taste had proven especially damaging, promoting the dismal patronage climate in which he was forced to labor. In one instance Taft wrote a brief

third-person summary of his career as a series of naive hopes and subsequent disappointments. His account told of early fantasies of being welcomed home from Paris "by leading citizens of New York and Chicago, Champaign and Urbana," who gathered with bands and cheering crowds of well-wishers; later, the story continued, even when he had given up such youthful dreams of "brass bands and hoarse huzzas," he continued for some time to cling to the belief that the "hurrying people of the street must want his wares" and "would soon be crowding his studio and disputing for his rare creations."[72] Yet after years of struggle, Taft ruefully admitted that those gathered in his studio displayed little interest in the work he considered most important. With death masks, portraits, and soldier statues dominating his *oeuvre,* the sculptor could only conclude with sorrow that this "was not the profession which he thought he had chosen."[73]

And for Taft, lack of professional success of the sort he envisioned equaled failure. To many of his colleagues, he appeared quite successful in those early years. Teaching at the Art Institute, active in preparations for the Columbian Exposition, gaining some commissions, and hobnobbing with the likes of Hutchinson, Williams, and Blatchford, Taft was perceived as a figure whose career was blossoming in the early nineties.[74] Yet for the sculptor failure loomed large on two levels. His artistic goals were not met with the kind of commissions he received after the fair; by his own account, Taft became increasingly disheartened when the work he was called upon to produce "was not the kind of 'art' he had bargained for."[75] Making this all the more disturbing, however, was the fact that his very association with successful civic leaders from other walks of life must certainly have forced Taft to be even more acutely aware of his relative lack of progress in his chosen field. As a member of many of their elite clubs and organizations and a visitor at their splendid homes, the sculptor could hardly have ignored the vast difference between his situation and theirs. Had he been able to measure his success in terms of the kind and quality of sculpture he was commissioned to produce, his lack of material reward would certainly have meant less; had his standard of living more nearly approached that of leaders in other fields, perhaps his disappointment in the work of the later nineties would not have

been so great. Under the circumstances, however, it is apparent that both the sculptor and the artist-gentleman in him found the period bleak.

Taft's response was to adopt a new attitude and approach to his career. As he explained to the audience during his 1913 dedication address, the dreariness of the postfair years disheartened and discouraged, but did not cause him to abandon hope. Instead, he simply changed tactics. "It came over me gradually," the sculptor recalled, "that the coy attitude of our artists, like a girl waiting to be proposed to, was not a success. That while our public needed sculpture, it did not know it and never would guess it unless someone showed it what it wanted!"[76] Recognizing the limits of public awareness in this matter, then, Taft decided to find the means of expanding that awareness. To a public knowing and therefore appreciating only portraits and soldier statues, he resolved to bring a new sensitivity to ideal sculpture; to a city and region convinced that art of high quality was necessarily produced elsewhere, he determined to prove the ability of local talent. It was an ambitious project on both levels, requiring Taft's strongest efforts on behalf of himself, his ideas, and his colleagues. Yet as he stood before the impressive bronze *Fountain of the Great Lakes* addressing a large audience of his fellow Chicagoans that September afternoon, Taft's achievement as a cultural promoter was obvious.

Part of Taft's success as a promoter was due to sheer force of will and tireless effort; but also contributing to the campaign he waged were the sculptor's unique personal abilities and careful strategies. Certainly among his most widely respected talents during his lifetime was Taft's ability as a public speaker. Perceived from the opening of his career in Chicago as an attractive, personable young man, the sculptor very early began an extensive lecture schedule. At the time of her 1892 assessment of cultural Chicago, Lucy Monroe characterized him as a modeler of portraits and soldier figures, but noted as well that Taft was "extremely popular with his pupils and the public" as a "fluent and entertaining lecturer."[77] There can be no doubt that the sculptor enjoyed talking about art, and he took special pride in the long and widespread popularity of the famous "clay talks" in which he demonstrated modeling clay busts while providing his audience with entertaining insights into the

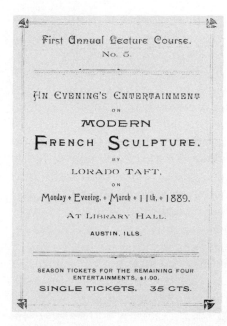

10. Advertisement for Taft's lecture at Austin, Ill., 1889. Taft Papers, University of Illinois.

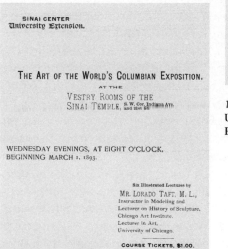

12. Advertisement for Taft's lectures at Sinai Temple, Chicago, 1893. Taft Papers, University of Illinois.

11. Advertisement for Taft's lectures at Union Park Church, Chicago [1893]. Taft Papers, University of Illinois.

process.[78] Yet in many respects such work was less opportunity than necessity with him. One writer tactfully pointed out that the "exigencies of his location" in Chicago had virtually forced the sculptor to "become an evangelist as well as a creator," preaching the gospel of art.[79] Taft stated it much more bluntly: "I soon discovered that no one wanted my work but, strangely enough, the women's clubs liked to hear me talk about sculpture!"[80] In any case, his bookings increased with amazing speed in the early years, and by the turn of the century he was a well-known figure on the lecture circuit through the entire region. And as he pursued his mission encouraging greater public interest in art, he also served his own cause by proving himself not only a handsome, entertaining young artist, but one who knew a great deal about his field.

Taft's success as an author reinforced this positive image. A prolific writer from his youth, he began to perceive distinct advantages in publishing very soon after his arrival in Chicago. In the early days after his arrival in the city, he viewed writing as a means of increasing a meager income. In 1889 he wrote his family of attempts to place transcripts of his lectures in the *Tribune*, and went on to describe plans to write of his Paris experience and training for the *Inland Architect*. In each case it was clear he intended to turn his literary talent to good practical use: he chose the *Tribune* over other local papers at the time because they had the reputation for paying the highest rates to free-lance authors; and he obtained a promise of per-column rates from the architectural journal before even considering the work for them.[81] Yet very shortly he recognized a potential for personal publicity in such work. He wrote his father in 1890 that he had recently started writing synopses of his lectures for the *Chicago Inter Ocean* as a means of attracting more attention. He explained that Harriet Monroe was providing accounts in her *Tribune* column already, and his anonymous contributions to the competing *Inter Ocean* were intended to stimulate continued notice. As he pointed out, the effort was well worthwhile, for "press reports have done more towards giving me reputation here than all my 'muddling.' I think I shall have to do something or other for pretty Miss Monroe. Her reports—though she does get things fearfully jumbled—are worth dollars to me."[82] Eventually, such modest efforts blossomed just as

his lectures did. By the turn of the century he was a regular con-
tributor to the local art journal *Brush and Pencil*, he had written
a regular column for a time in the *Chicago Record*, and his con-
tributions appeared in several other newspapers and journals as
well. When the Macmillan Company sought a manuscript survey-
ing American sculpture for their History of American Art series,
Taft was well suited to produce this first comprehensive analy-
sis of his field, and the resulting *History of American Sculpture*
published in 1903 confirmed his position as one of the foremost
authorities and most cogent writers on American art.

Garland later noted of Taft that his contribution to the rise of
cultural awareness in the Midwest was greatly enhanced by the
fact that he wrote and spoke so "well, wisely, and wittily," reach-
ing a broad audience very effectively as a result.[83] Yet beyond
those skills was the sculptor's diligence as a collaborator in groups
dedicated to other promotional efforts. Feeling called upon, as
Garland pointed out, "to do everything within reason for art in a
land of trade," Taft emerged as one of the leading spirits in such
organizations as the Central Arts Association, the Society of West-
ern Artists, and the Chicago Society of Artists.[84] The major goal
of these promotional organizations was to challenge the prevail-
ing sentiment that placed midwestern artists at the bottom of any
conceivable artistic hierarchy entertained by local patrons and in-
stitutions. The Central Arts Association was of special importance
because it was the most frankly promotional of the lot. Founded
in 1894 by Garland, Taft, and a handful of others, its purpose was
to stimulate and spread the interest in the arts spawned earlier
by the Columbian Exposition. Garland described It as "a sort of
Chautauqua-system for the study of art," broadened to encourage
exhibitions and collecting of regional art.[85] Taft naturally served
as one of the lecturers conducting classes in various locations
on behalf of the association; he also worked with Garland and
the painter Charles Francis Browne to publish pamphlets of criti-
cism and other materials offering instruction to interested groups
throughout the region.[86] At the same time, he served as one of
the officers who kept the organization functioning on a daily basis.
During the early years of the association's existence, Taft's studio
was reportedly used as distribution center for exhibitions and gen-
eral clearinghouse for information and scheduling—the sculptor

donating his considerable "executive ability" to the direction of all such activity.[87] If some, like Fuller, were somewhat disdainful of the art "propaganda" resulting from these efforts, Taft believed the work an important duty of the "artist-citizen" responsible not only for making but for encouraging interest in his cultural product.[88]

The exhibitions of the association were widely circulated through the efforts of Taft and his fellow "artist-citizens." Cities as distant as Minneapolis, Minnesota, and Lincoln, Nebraska, and towns as close as Janesville, Wisconsin, and Aurora, Illinois, called upon the services of the organization, obtaining shows of varying size. Hung in unused hotel lobbies, vacant storefronts, or any other available space, the exhibits were frequently complemented by a lecture or even lecture series provided by Taft or another of the association's speakers. Although generally modest in scope, such combinations of works and lectures provided what was for many of the small towns throughout the region the first local experience of original art and professional artists. In the meantime, the association also promoted its cause in Chicago, organizing exhibitions and other activities to focus greater attention on regional talent. Within the first six months of his organization's existence, Garland reported, the city had been treated to a large show of works by the "Hoosier group" as well as a substantial two-person exhibition.[89] These and other shows, publicized and reviewed in local journals like the association's own organ, *Arts for America*, and the closely affiliated *Brush and Pencil*, were soon augmented by artists' festivals and art education congresses in Chicago, bringing even greater attention to regional art and artists.[90]

Yet while those efforts helped promote midwestern art in a general fashion, Taft was also intent upon finding ways to draw more direct attention to his real love—public sculpture. A good deal of his writing naturally addressed the role and value of sculpture in the city, and his participation in the Municipal Art League was certainly prompted in part by a desire to encourage use of statuary and fountains in the beautification of Chicago. The "Nymph Fountain" and subsequent student projects Taft assigned and directed were also calculated to provide suggestion by example. But in addition to offering guidance and encouragement, the sculptor also demonstrated his ideas in more tangible form as opportunities presented themselves.

Most notable was the case of his work for Chicago's Autumn Festival in 1899. No doubt stimulated by the example of elaborate decorations then being prepared by members of the National Sculpture Society as their contribution for New York's welcome of Admiral George Dewey returning from his victory in the Philippines, Taft collaborated with his chief Art Institute assistant, Charles Mulligan, and the architect James Gamble Rogers to produce a special State Street "Court of Honor" in time for the annual autumn celebrations scheduled for Chicago's Loop. The sculptural decorations in New York were in many ways more noteworthy— and certainly more extensive, with twenty-five artists donating their services in the creation of allegorical groups, portraits of Dewey's staff, and an assortment of reliefs and medallions arranged over the enormous "Dewey Arch and Colonnade."[91] Although Rogers designed a similar configuration of pylons leading to a triumphal arch for Chicago's festival, the amount and sophistication of applied decoration was significantly limited by the fact that Taft and Mulligan were the only sculptors participating in the project. Mulligan's contribution was a pair of allegorical groups representing "Education" and "Industry" placed on either side of the arch; Taft produced a comparable set of figures representing "Peace" and "Prosperity" for the two stout pylons marking the opposite end of the court.[92] If theirs was a more modest effort, however, it was no less impressive to the Chicago press. Newspaper accounts heralded the State Street Court of Honor as an extremely impressive ceremonial space for the upcoming festivities, and views of the sculpture prepared by Taft and Mulligan were compared favorably with that done for New York's Dewey celebration.[93] More important, while both New York and Chicago decorations were temporary, made of staff, and thrown up on remarkably short order, each showcased local artists and demonstrated the potential for civic sculpture. "Such object lessons," one source concluded, "do more for public art than volumes of printed matter or hours of oratory. A beginning has been made, and improvement all along the line is what we may expect in the future."[94]

Finally, with the happy occurrence of the Ferguson bequest, all Taft's long promotional effort climaxed in success. After the sculptor was awarded his contract for the *Fountain of the Great Lakes* as the first work commissioned with money from the new

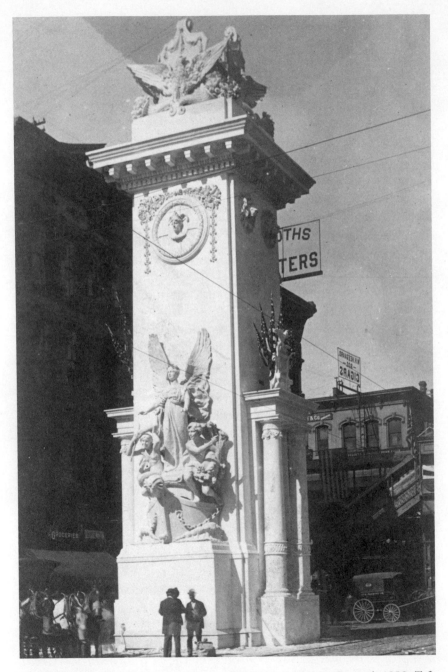

13. Taft's *Peace Pylon*, Court of Honor, State Street Autumn Festival, 1899. Taft Papers, University of Illinois.

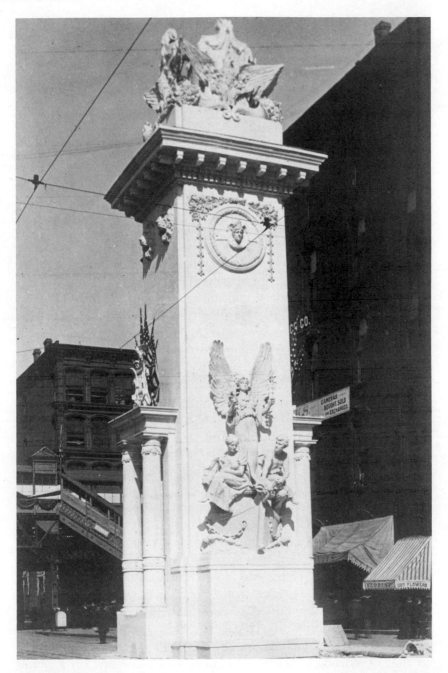

14. Taft's *Prosperity Pylon*, Court of Honor, State Street Autumn Festival, 1899.
Taft Papers, University of Illinois.

fund, one editorial in a Milwaukee newspaper complained that like so much else in Chicago, Taft's assignment had come about as a direct result of "pull."[95] In fact a more obvious statement of the circumstances could hardly have been made at the time. Taft never denied conscious cultivation of an image and connections affording exactly the leverage required to gain an advantage in just this sort of situation. That he had done so effectively and carried away the prize of his labors with this commission represented an outstanding achievement in his estimation: it proved fulfillment of his duties as "artist-citizen," and he accepted the commission as reward for activities in which he felt an unconcealed and justifiable pride.

The commission immediately opened what appeared to many an entirely new role for the sculptor as well. At the dedication Taft recalled his early feelings of pride when granted the opportunity to make a positive contribution to the heritage of the city, but others perceived his initial commission as something of an opening wedge signaling the beginning of meaningful public support for the sculptor and his ideas in Chicago. Fuller, writing to congratulate his friend when news of the commission was first announced in late 1907, suggested that the "profits and honors" of this first award were but the initial round of what would certainly be much more of the same in years to come: "I think your whole future is now splendidly assured. Official action counts—even in America; one thing will lead to another and opportunities will propagate almost spontaneously. The 'people,' as we say, will understand. This first significant 'endorsement'—odious word!—will easily justify itself with everybody: the simple will comprehend, and the knowing find plenty to admire."[96] Indeed, to observers like Fuller, Taft's long struggle for recognition seemed over at last, allowing him renewed confidence that his efforts would now be appreciated, his ideas valued, and his work appropriately rewarded.

And immediately there was a perceptible shift in the focus of Taft's effort. Still a staunch advocate of civic beautification, he was prompted by his new confidence to make more frequent and specific his recommendations regarding the location and nature of public art for Chicago. He spoke of his as a position comparable to that of Burnham, offering beautification schemes on a grand scale just as the architect offered his vast city plans.[97] At one point

Taft noted that his new position was similar to that of a physician prescribing remedies for the improvement of public health, or a lawyer proposing new legislation to benefit his fellow citizens.[98] And over the following years, Taft's prescriptions and proposals did receive more attention. Press coverage of his ideas broadened, others began paying more heed to his plans and offering comment in response, and eventually additional commissions came his way. The climax occurred in 1913. Not only did he finally see his *Fountain of the Great Lakes* cast and erected on the south facade of the Art Institute that fall, but earlier in the year he received a second major commission from the Ferguson Fund. Awarded to the sculptor to help finance preparatory work for a second, larger fountain, this new commission seemed to bode well for a vast plan of sculptural beautification Taft proposed for the city's Midway parkway connecting Jackson and Washington Parks and running immediately in front of his own studio. If the first Ferguson commission signaled initial acceptance, this second favor appeared to verify beyond any doubt his position in the community. It is little wonder he could regard himself a "stockholder" in Chicago at the time of the 1913 dedication address—his long investment of work was bringing dividends at last.[99]

Commemoration without Representation

When Hutchinson opened his comments at the dedication cere-
monies to note that the fountain being presented to Chicago that
afternoon was the *Ferguson Fountain of the Great Lakes*, his slight
addition to the name of the work was obviously calculated to
honor the donor whose bequest meant so much to beautification
efforts in the city. Yet the new name and bronze memorial plaque
attached to the fountain also constituted a response to one of the
most notable requirements of Ferguson's will. Beyond stipulating
terms of the management of the sculpture fund he was establish-
ing, Ferguson inserted a specific charge that his gift be used to
erect works "commemorating worthy men or women of America
or important events of American history."[1] Title and plaque were
a direct response to that requirement.

This clause in the will drew the immediate attention of many
when Ferguson's bequest was made public in 1905. Art Institute
Director French observed that his office was flooded with sug-
gestions regarding commemoration of Chicago's "notable dead"
within an hour of the first public announcement; by the following
day the *Tribune* reported "every artist or civic beauty enthusiast
who ever undertook to sketch a picture of Chicago as 'the city
beautiful'" coming forward with some kind of suggestion for com-
memorating one or another individual or event.[2] Major proposals
outlined in the press included ideas ranging from predictable com-
memoration of events like the Chicago Fire and individuals like

the popular conductor Theodore Thomas, to rather more vague commemorative conceptions involving such amazing notions as a Chicago "Colossus of Rhodes" to guard the harbor entrance.[3] While all suggestions were received graciously, it appears officials decided early to reserve the first commission for a work commemorating the donor. When the trustees of the Art Institute made it official with their adoption of a recommendation to that effect in 1906, their action seemed a simple reflection of what was by then the general consensus on the matter.[4] Indeed, an editorial appearing the day after Ferguson's will was publicized predicted such action when it wryly pointed out that the donor had insured a place in history by an act of generosity certain to "put his memory" in durable metals and stone.[5]

That Taft's *Fountain of the Great Lakes* was selected as the means of commemoration in this instance was due to both general and specific qualities it was felt to possess. In the first place, the composition was intended to present a distinctly American subject. In his dedication address Taft explained how his idea for the Great Lakes theme actually originated with Burnham. On a commuter train bringing them home to Evanston one evening "soon after the World's Fair," Taft recalled, Burnham originally posed his advice as a gentle scolding. Claiming sculptors often overlooked wonderful subjects at their own doorsteps, the architect cited the example of the lake beside them as a rich American theme a sculptor might do well to consider.[6] Taft explained to his 1913 audience that other commitments kept him from working with the idea for some time after that, but the theme excited his imagination from the beginning. Eventually he gave the subject more serious thought, developed models, assigned it as a project for one of his sculpture classes at the Art Institute, and finally worked up the version that went on view in 1906.

It was not at all unusual that Taft failed to consider the lakes as a potential theme in his work prior to Burnham's suggestion; more remarkable was the fact that the architect recognized any possibilities in the subject. For all its importance in the city's history, Lake Michigan was by no means a dominant image for Chicagoans at the turn of the century. Rail lines along its edge had for years cut significant portions of the city off from the water, the barrier causing the lake to seem quite distinct from the metropolis ex-

panding out from its shore. Likewise, rail transportation helped further diminish the importance of the lake by the turn of the century as overland shipping by rail grew at the expense of lake shipment.[7] And in spite of all efforts to create greater opportunity for lakeshore use with the development of new public facilities like Grant Park, Fuller pointed out in 1901 that "the great majority of Chicagoans know the lake only through the bulletins of the daily papers, which tell them whether its water is 'bad' or 'usable.'"[8] Moreover, the majority of Chicago novelists—Fuller among them—were relatively uninterested in the lake as a major image in their novels of the city. Carl Smith has recently explained that while the skyscraper, railroad, and stockyards were all frequently employed as compelling literary images in the Chicago novel, writers in what was billed as the "Queen City of the Lake" virtually ignored the enormous body of water beside them.[9] Both daily life and imagination, Smith suggests, seem to have been oriented away from the lake.

Nonetheless, once the subject was brought to the fore with Taft's fountain many immediately embraced it as an appropriate and attractive American image. Fuller, for example, praised Taft for having "drawn, with admirable felicity, from his own proper environment," a subject so appropriate it seemed all but "inevitable."[10] In his assessment of the work, Browne cited the *Fountain of the Great Lakes* as an especially potent regional image, noting that this quality would be enhanced if the sculptor were commissioned to create as its companion a group "having the 'Prairie' as a motive" for an adjacent space.[11] But most telling was the favorable response of Garland. The novelist of the "middle border" was one of the most outspoken advocates of a national art, especially among the "Western" artists and writers he championed. Noting that "mere beauty no longer suffices" and warning his contemporaries to reject "the tyranny of the classic," Garland called for art responsive to the themes of American life.[12] When looking back to his early Chicago days in *A Daughter of the Middle Border* (1921), he remembered Taft as not at first receptive to such ideas. Garland characterized the sculptor as an essentially conservative "worshiper of the Greek" in those days, but explained that as a "counter-irritant" he kept Taft "wholesomely stirred up" over the issue of American art, ultimately convincing him "that the Modern could not be

entirely expressed by the Ancient, that America might sometime grow to the dignity of having an art of its own," and that it was the responsibility of the artist to progress in that direction.[13] And for Garland, too, the *Fountain of the Great Lakes* seemed a strong indication of such progress—evidence of "Old World conventions" replaced by a commendable American theme developed by Taft on the basis of "the forms and faces which surrounded him."[14]

Ferguson's personal connections with this particular American subject also reportedly contributed to the decision to use Taft's *Fountain of the Great Lakes* as an appropriate commemorative monument. During his dedication address, Hutchinson took pains to characterize the donor as a man whose reputation was bound inextricably to the nation's inland seas. Although he was born in southeastern Pennsylvania in 1839 and worked initially at his father's lumberyard in the town of Columbia along the Susquehanna River, Ferguson came to Chicago immediately after the Civil War and entered the lumber trade as it began to boom in the old Northwest. By 1867 he was in business for himself, working through a series of partnerships as he expanded his concerns first in the lumber district along the south branch of the Chicago River, then near the opposite end of the Great Lakes at Tonawanda, New York. With his large yards thus strategically positioned at key points on lake shipping routes, his business flourished well into the nineties. By the time he decided to reduce his commercial activity and scale down to partial retirement in the mid-nineties, Ferguson's holdings had been expanded to include enterprises in the South as well, but his reputation and fortune had been built in the Great Lakes lumber trade.[15]

It was this background Hutchinson evoked at the dedication when he described the donor as one who "spent many years of his life in traversing the waters" of the lakes, and noted Ferguson's reputation as a familiar figure "always held in high esteem" in the many lumber ports where his business often took him. In this regard, then, Hutchinson found the fountain a perfect commemorative monument, recalling not only the generosity of Ferguson's civic gesture but the very life of the man it honored. Naturally, Hutchinson admitted, the trustees of the Art Institute made no claim to have set out to find such an ideal memorial image, but the sudden availability of Taft's *Fountain of the Great Lakes* struck

them as so fortuitous it appeared immediately as "one of those happy circumstances or unexpected coincidences, so appropriate that men of faith sometimes call them special providences." Moreover, having once made the decision, Hutchinson informed his audience, the trustees were especially gratified to receive a commendation from one of Ferguson's "intimate friends," who wrote to confirm that "no better selection could have been made to commemorate the activities of the donor, in his chosen business, the lumber trade. Fitting it is that this field of his operation should be given expression in so unique a manner."[16] The decision thus supported by circumstances as well as testimony, Taft's fountain seemed apt on this score as well. The portrait plaque was added to further cement the connection between fountain and donor, but it was considered only reinforcement and clarification of an existing relationship.

Yet the very fact that the trustees felt compelled to add clarification by means of a portrait plaque and inscription points to what was surely one of the more surprising qualities of this monument: the *Ferguson Fountain of the Great Lakes* was intended to commemorate the donor without actually representing the man whose memory it purported to honor. The plaque carrying its likeness of Ferguson together with its message stating unequivocally that "This Fountain is a Memorial to Benjamin Franklin Ferguson" was actually an afterthought, added to make more immediate and direct the connection between man and monument in order to forestall any problems or confusion that may otherwise have arisen on this question. Ferguson's call for sculpture commemorating "worthy men or women of America," after all, had been quite precise, and the resulting suggestions for monuments to Chicago's "notable dead" typically included as central features likenesses of those honored. Ranging from simple statues of people like Theodore Thomas and George Howland to far more elaborate memorials "of the type erected in Edinburgh to Sir Walter Scott," the proposals made when Ferguson's will was first announced clearly took it for granted that the portrait was the most effective vehicle for proper commemoration.[17]

When it came to awarding the first commission, however, it was equally clear the trustees held a rather different opinion in the matter. In fact, French provided signs of this very early when noting he

and other officials of the Art Institute intended to administer the Ferguson Fund with a view to obtaining "fine art objects" rather than statues on pedestals. "Prince Albert coat" statues, as French and his colleagues came to term public portraits, were "emphatically" opposed by those directing the new fund.[18] To avoid such objects, the trustees elected to interpret portions of the will in a manner allowing them the greatest possible latitude when selecting works to be commissioned. Taft best defined key terms of what became the official position in a 1905 article informing readers it was "fortunate indeed that the far-sighted donor did not say 'representing' instead of 'commemorating'" when describing the nature of the public sculpture his bequest would fund.[19] The distinction was fine, but necessary. According to the consensus among Taft and his friends, "representation" required a likeness or some comparable description, while an individual or event could in their estimation "be fitly and beautifully commemorated by means of an ideal group or a fountain, an object of beauty in itself."[20] Commemoration and beauty could in that way go hand in hand.

Such an interpretation, then, was adopted in order to legitimize use of the Ferguson Fund for public sculpture of the highest available quality. If it caused a certain degree of difficulty or awkwardness when the subject to be honored was only marginally associated with the means of commemoration, such problems were not sufficient to dissuade those who directed the fund and believed the advantages far greater than any possible confusion. In fact, for them the introduction of Taft's *Fountain of the Great Lakes* as an object commemorating the philanthropic lumberman was a clear aesthetic statement. More than a memorial, it served as an answer—a critique of practices and attitudes Taft and his supporters had become increasingly opposed to by the turn of the century. For sculptor and trustees alike the fountain was a veritable symbol of what might be achieved under optimum circumstances with the appropriate combination of adequate funding, proper talent, and enlightened guidance toward wise objectives.

On one level, the critique implicit in Taft's *Fountain of the Great Lakes* was largely a response to the general state of American public sculpture in the later nineteenth century. Especially following the Civil War, bronze and stone portrait statuary emerged as the

dominant form of public art in the nation's towns and cities. One 1895 account of public sculpture in New York City, for example, cited twenty-three major works in progress, noting proudly that such sculpture "has taken a great bound forward" in the city with plans to spend "at least a million dollars" on this collection of projects over the following two years.[21] All but two of these projects, however, involved portraits of specific notables ranging from actor Edwin Booth to reformer Samuel J. Tilden. If exceptional in its ambitious scale and complexity, the planned monument to Irish patriots described at the time indicates the general direction of such work: "The design calls for a fourteen-foot figure, in bronze, of Daniel O'Connell at the top of the monument. On the base, which is an octagon, are bronze figures of Robert Emmet, Grattan, and Curran, each ten feet high. On brackets on the four corners of the die, which rests on a second base, also an octagon in shape, are the statues of Burke, Sheridan, Moore, Father Mathew, Smith O'Brien, Wolf Tone, Dr. Francis Meagher, and John Mitchel, and on the sub-base four colossal Irish wolf dogs in place of the usual decorative lion."[22] Replacing the unpalatably British lion with the rangy Irish wolfhound certainly indicated a consideration of other sorts of imagery, but the major values held by the Irish-American community promoting such a monument in New York were clearly to be found in the identities of the men represented. Portraits honored and carried important meaning, and this was the rule for the vast majority of commemorative monuments.

Yet in those cases where such specific identity was not provided, more generalized portraits still served as key ingredients in public sculpture produced during the period. Even before the Civil War was decided, monuments were undertaken to honor local and regional soldiers fallen in battle. Randolph Rogers's *The Sentinel*, commissioned for Cincinnati's Spring Grove Cemetery in 1863, was probably the earliest in a long line of Civil War monuments featuring anonymous but carefully detailed soldiers and sailors honoring the war dead.[23] Although the rugged, bearded features of Rogers's soldier were anonymous, the slouch hat, great coat, heavy boots, and musket of the figure were accessories making the subject one of the heroic defenders of the Union. Very soon solitary figures in bronze or stone appeared in other cemeteries as well as in city parks and courthouse lawns of both northern

and southern communities wishing to commemorate the efforts of their lost sons.

Moreover, the generalized memorial portrait became increasingly elaborate as time went on. Martin Milmore, a Boston sculptor who was also producing anonymous Civil War figures by the later 1860s, designed a more substantial and complex *Civil War Memorial* that served as a model for many others after its dedication on the Boston Common in 1874. Including a range of figures situated on and around a broad base with towering cylindrical shaft, the memorial in Boston employed generalized soldier portraits in combination with allegorical figures in a manner quickly adopted elsewhere.[24] Twenty years later, Cleveland erected what was perhaps the best known and most overdeveloped of these memorials: *The Cuyahoga County Soldiers and Sailors Monument*, designed by one Captain Levi T. Scofield. The figure of *Armed Liberty* atop the shaft of Scofield's monument is in this case in command of four complete squads of men representing infantry, artillery, cavalry, and navy; not only are the men of Scofield's groups accessorized to the point of allowing viewers to distinguish rank, they appear actively involved in military actions characteristic of their respective branches of the service.[25] Anonymity in these cases allowed the image—whether single figures or groups—to serve as evocation of all fallen warriors, yet the specificity of detail lent credibility and accessibility akin to that found in an individual portrait.

Like other cities, Chicago could boast examples of public portraiture by the turn of the century. Leonard W. Volk, one of the pioneer sculptors of the Midwest, is today best known for his life-mask portraits of Abraham Lincoln, but his long career in Chicago also yielded public monuments featuring both generalized types and specific likenesses. Shortly after the Civil War, for example, Volk produced a memorial to Chicago's war dead that actually seems a step between Rogers's solitary figure and Milmore's complex grouping. *Our Heroes*, unveiled in the city's Rosehill Cemetery in 1870, emerges from a substantial granite base with bronze relief plaques depicting representatives of the four major branches of Civil War forces; above the base rises a square granite shaft topped by a large marble figure of an anonymous Union standard-bearer, posed with flag and bugle as he surveys the graves of fallen comrades buried nearby.[26] At the same time, Volk was busy planning

15. Captain Levi T. Scofield's *Cuyahoga County Soldiers and Sailors Monument*, Cleveland, Ohio, 1894. Courtesy of the Western Reserve Historical Society.

his towering *Stephen A. Douglas Memorial* for the city. A distant relative of the famous Illinois Democrat, Volk produced several portraits of the man and was working on plans for a commemorative monument when the Chicago Fire of 1871 postponed the project. Finally unveiled a decade later, the memorial includes a mausoleum, allegorical figures referring to the virtues of the man, and bronze relief panels charting the rise of western civilization. The crucial element, however, is the over-life-size portrait of Douglas himself standing grandly atop a forty-six-foot cylindrical shaft positioned over the crypt. If the distance to the top of his column perch makes it somewhat difficult to see all details of this likeness, it is nonetheless quite clear that the statue is a portrait—especially when compared with the allegorical figures ringing the base.[27]

Volk's example with such monuments was widely followed as other commemorative works were erected in the city in years following. Complementing his memorial to fallen Union soldiers was the equally impressive *Confederate Mound Monument* designed by former Confederate General John C. Underwood and dedicated at the Oak Woods Cemetery in 1895. Some six thousand Confederate prisoners who died of diseases ravaging Chicago's Camp Douglas prison were buried at Oak Woods during the war, and Underwood's unarmed soldier standing at the top of the tall granite shaft overlooking their unmarked graves appears an appropriately sorrowful figure, reflecting on the fate of his unfortunate comrades interred below.[28] Elsewhere in the city portraits of specific Civil War heroes like Generals Grant and Logan, national leaders like Washington and Lincoln, important local figures like Michael Reese and Charles Hull, and the special heroes of various national groups like Johann von Schiller, Carl von Linné, Giuseppe Garibaldi, and Leif Ericsson represented the other category of more specific public portraiture by the turn of the century.[29] In all such work detail helped establish both general and specific identity. Underwood's young Confederate in Oak Woods has the uniform and kit bag of the soldier, while his bare bowed head with heavy drooping mustache helps convey the sense of mourning so important to the memorial. The alert-seeming portrait of Charles J. Hull near the main entrance to Rosehill Cemetery is not only clothed in appropriately contemporary dress, but in replicas of Hull's own suit and boots, provided by Jane Addams herself. Whether Addams was

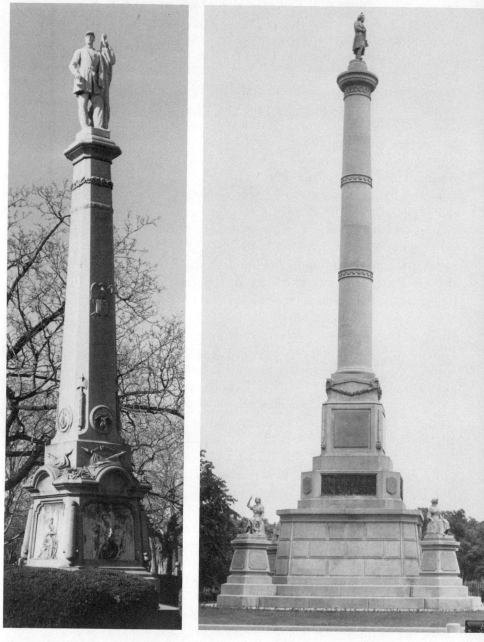

16. Leonard Volk's *Our Heroes: Civil War Monument*, Rosehill Cemetery, Chicago, 1869–70.

17. Leonard Volk's *Stephen A. Douglas Memorial*, Chicago 1881.

serious or not when she requested that sculptor Richard Henry Park take care to leave the old mud caked on Hull's boots, it is clear that even the smallest details of garments, accessories, and facial features were elements enhancing meaning and value in these works.[30]

While public portraiture remained popular through the turn of the century, however, critical assessment grew increasingly negative. Naturally, there were some commemorative statues that remained very highly regarded. In a series of articles on public sculpture in *Leslie's Weekly* in 1893, for example, Saint-Gaudens's *Admiral David Farragut Memorial* (1881) in New York City and *Standing Lincoln* (1887) in Chicago were cited as truly outstanding public statues—an opinion broadly shared at the time.[31] Yet in the article introducing this series, *Leslie's* pointed out that in spite of the quality of some works, the country was unfortunately "being covered with monuments to those who fell in the Civil War or who have otherwise achieved a place in the affectionate regard of their countrymen, which are, in many cases, absolute deformities, designed in utter defiance of every principle of good taste, and lacking every element of appropriateness."[32] It was the hope of the editors that the newly formed New York Municipal Art Society might better control the quality of future public sculpture placed in the city, and to aid that organization in its task, *Leslie's* kindly published a list and photographs of eight of the city's worst "Deformities in Sculpture" as examples of misguided enthusiasm and unfortunate taste.[33]

A good deal of the criticism of this sculpture was leveled at the siting of the work. When sculptor Charles Lopez described the character and quality of New York's public statuary in a 1901 article for *Municipal Affairs*, he explained that problems so frequently identified in the appearance of many works could be eliminated or at least made less apparent by more careful siting. "With nearly all of our statuary," Lopez wrote, "this defect of placing is deplorable; the statues are scattered without the slightest thought of their surroundings. A large figure is placed where a smaller one would be better; a standing statue where a seated one would prove more harmonious; and some statues where it would be better to have none."[34] Such comments on placement, scale, and general type of statuary, together with discussion of the need for closer

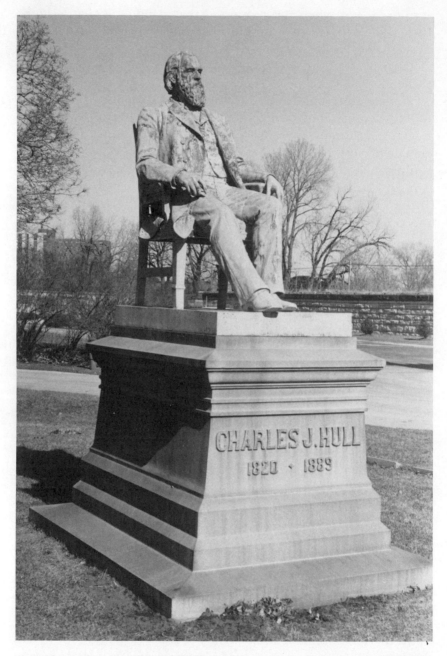

18. Richard Henry Park's *Charles J. Hull Monument*, Rosehill Cemetery, Chicago, c. 1891.

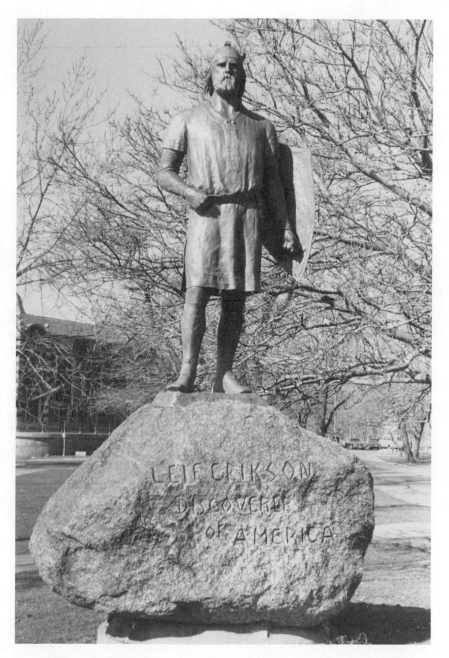

19. Sigvald Asbjornsen's *Leif Ericsson*, Humboldt Park, Chicago, 1901.

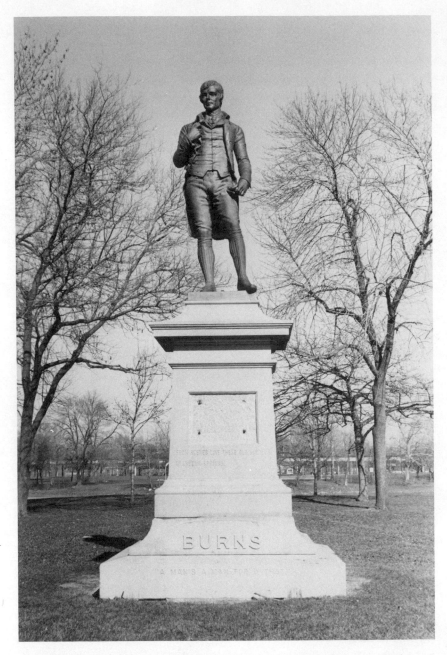

20. W. Grant Stevenson's *Robert Burns*, Garfield Park, Chicago, 1906.

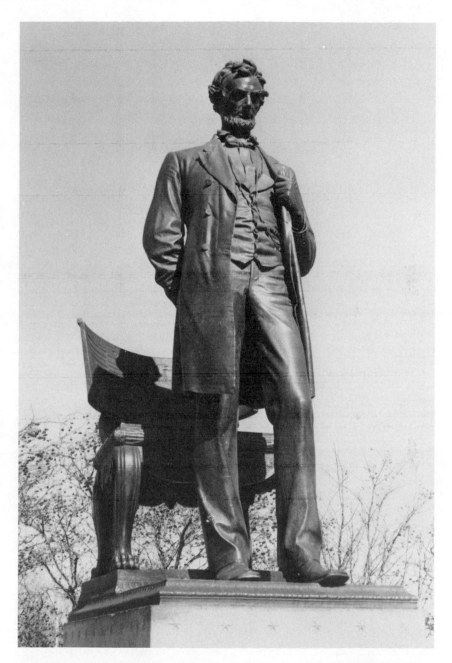

21. Augustus Saint-Gaudens's *Standing Lincoln*, Lincoln Park, Chicago, 1881.

integration of sculpture, architecture, and landscape, reflected the concerns of many members of the National Sculpture Society in their efforts to promote proper use of sculpture in civic beautification. Others had similar comments to offer in their own analyses of the role of public sculpture in the city, and in December 1899 the organization held a special symposium on the subject.[35] Eleven speakers addressed the issue, describing sites from the Battery to Harlem and proposing appropriate—and often elaborate—sculptural projects, always with a concern for the overall character of the location and surrounding buildings.[36] Sculptor Charles E. Bissell's general comments to the open session were typical. Citing the need for more open space in the city, Bissell recommended the introduction of sculpture islands at the center of busy intersections; the sculpture would beautify, but routing traffic around the new islands would also demand carving back portions of surrounding buildings, opening more space, and incidentally creating new opportunities for further embellishment of new facades.[37]

Yet Lopez's last observation about "statues where it would be better to have none" raised another issue drawing increasing attention in the later years of the century—especially when the site in question was the urban park. Proprietors and defenders of city park systems had long been critical of any attempt to introduce "granite pantalooned remembrances of dead musicians and soldiers and statesmen" to their natural havens.[38] Since refuges like New York's Central Park and Chicago's Lincoln Park were originally established in order to provide a calming natural space to which harried city residents might repair for rest and recuperation, many argued against the introduction of any overt signs of civilization. Indeed, for some the quality of the sculpture was never at issue. Charles S. Sargent, editor of *Garden and Forest*, insisted that even "high merit in a statue does not always justify its admission to a park; that such a work ought not only to be worthy in itself, but worthy as an ornament to the park." [39] Especially odious to these critics, however, were the "effigies" that threatened to turn parks into leafy pantheons; Germans wishing to install their Schillers and Goethes, Italians with a Columbus or Garibaldi, and Scots with their ubiquitous "Bobby Burnses" posed what several found to be among the greatest threats to the natural beauty of the urban park.[40] In his 1897 account of cultural Chicago, for

example, Fuller noted that since the only real attraction his city would ever possess was its extensive park system, special care should be taken in the protection of that public land—even to the point of condemning and removing some of the more abominable statuary that had already been foisted upon it.[41]

For Taft this question of siting ranked among the most important of those occupying the professional sculptor. In his 1921 survey of Chicago public monuments, he assessed existing works not only on the basis of sculptural quality, but in terms of their appearance at their site. Volk's *Douglas Memorial*, for example, was historically important, in Taft's estimation, but the figure of the senator was altogether too inaccessible atop its towering shaft. As he advised a Denver man inquiring about pedestals shortly after the turn of the century, such compositions were problematic, for there was "always the query in one's mind—How did he get up there? and, what is he doing up there?"[42] Conversely, the impact of Saint-Gaudens's *Standing Lincoln* was greatly enhanced for Taft by the fact that the broad, low platform base designed by architect Stanford White fit with both statue and site in "perfect taste and perfect harmony," achieving a stable, monumental presence at the convergence of the broad avenues of its location.[43]

Yet even this famous *Lincoln* violated one of Taft's most crucial siting rules: "metal coats and trousers" should simply never be allowed to disturb the natural beauty of "flowers and trees."[44] Formal bronze and stone portrait monuments were in Taft's view best restricted to more formal locations along boulevards and before buildings, while the precious nature of urban parks was reserved for more appropriately natural subjects. Located as it was near the outer edge of its park, the *Standing Lincoln* was not a serious violation, but in other cases the effect could conceivably be disastrous for both park and sculpture. By the early 1920s Taft dismissed the parks of Chicago's West Side as virtual lost causes in this regard. Statues of Alexander von Humboldt, Thaddeus Kosciuszko, Leif Ericsson, Fritz Reuter, Robert Burns, and Karel Havlicek utterly destroyed the "sylvan beauty" originally intended, creating instead a "petrified congress of nations, a sculptural card-index of the peoples represented in Chicago's mighty melting pot."[45]

Nor were the figures thus gathered together always honored as well as original sponsors might have wished. In response to a

series of suggestions for public statues in the late 1890s, Taft wrote a humorous article explaining the possible problems of combining commemorative monuments in unlikely groups. Frances E. Willard, he pointed out, was certainly one worthy of a proper memorial in the Chicago area, but the suggestion that a likeness of the temperance leader be erected in the new Grant Park gave rise to the unsettling prospect of placing her with only Generals Shields and Logan for company:

> It is true that she might be joined soon by Dewey and Aguinaldo, Confucius, Moses and Richard Harding Davis, and ultimately—who knows?—by Ald. Coughlin and Johnny Powers; but a crowd is not always company, and even well-executed statues raised by an admiring constituency may not suffice to make a public place seem homelike. Miss Willard was as much beloved for her sense of humor as for her brave battle with what she considered earth's greatest evils, and one can imagine her deprecatory smile at the proposition. It is like inviting a friend to dine with a group of strangers carefully selected on a basis of ignorance of each other and lack of sympathy in each other's work.[46]

Better that such a portrait of Willard be erected near her home in Evanston, Taft explained, and that other commemorative statuary find sites in equally apt locations around the city. Then, if the public still desired sculpture for the city's parks, images of Indians, wood nymphs, wild animals, and other "apparitions which one does not resent amid the shrubbery and trees" might be introduced.[47]

Even when all questions of site were satisfactorily answered, however, Taft and other critics of existing trends in public statuary realized that the quality of the sculpture itself posed a serious problem in many cases. In the *Leslie's Weekly* series, critic Philip Poindexter was not referring to siting when he identified Scofield's *Cuyahoga County Soldiers and Sailors Monument* as one of the major sculptural atrocities in the country. The location of the enormous memorial in its square at the heart of Cleveland's business district was fine—it was the overelaborate character of the mass of sculpture constituting the work that the critic found objectionable.[48] Nor was Poindexter alone in his opinion of Civil War monuments at the time. A few years later Karl Bitter lamented the fact that such monuments were the only contact many Americans

living outside major cities had with sculpture. As Bitter explained, viewing "the customary column with its equally customary soldier" not only did little to excite public enthusiasm for the art, but caused further damage by creating unfortunately limited expectations regarding the appearance of public sculpture.[49] So firmly had the pattern been established that the meaningless sameness of the figures was increasingly expected by many; the only variety occurred in the minor details provided when firms in the monument trade advertised "sets of buttons and accoutrements ready to be attached to suit the regiment requiring the memorial."[50] Under the circumstances, it is little wonder that when one more sensitive to the issue like General Rush C. Hawkins wrote the editor of the *New York Times* to protest plans for yet another Civil War monument for the city, he condemned as insufficient and wasteful works so "inharmonious and trifling" in design and reminiscent only of "ornate window confectionary" in detail.[51]

Residents of larger cities with access to a relatively greater number and variety of monuments were in Bitter's estimation only slightly better off for the experience. Other commemorative works complemented Civil War memorials in urban centers like New York and Chicago, but many felt these equally unsatisfying as examples of public art. Bitter found the majority to consist of ungainly figures perched on awkward pedestals; likenesses were attempted, but there was very little to provide special insight into the nature of the subject portrayed. Although these works were often well intended, presenting images of individuals of local or national importance to serve as models or sources of inspiration for the public, most viewers came away from the figures "with no more vivid recollection than that the man was stout or slender, that he held a book or scroll in his hand, or that he was wrapped about with the folds of a voluminous cloak."[52] During the *Leslie's Weekly* flap over quality in New York City monuments, one source complained that such bad statuary could actually have serious impact on the future of public sculpture in the city, confusing the young and setting bad precedent for all:

> There is a serious side to permitting statues like these to remain. They vitiate people's taste, particularly in the case of young persons who are forming ideas of what is fine and the reverse. Naturally,

they suppose that so conspicuous a place and so much money expended on a given monstrosity mean that the object is beautiful. But furthermore, these statues keep the gates open for other bad sculpture. It is hard to meet the argument, or rather the apology for an argument, which consists in saying that a piece of sculpture knocking for admission to the public parks is better than certain pieces already admitted. The late Poet Laureate of England has spoken of the power of precedent as the means to establishing laws. The precedent of inferior sculpture is certain to be invoked while a single bad statue is left on which to hang the plea.[53]

Sculptor Frederick Wellington Ruckstuhl may have slightly overstated his case when claiming the following year that fully half the existing statues in New York were bad, but his exaggeration reflected the growing concern over quality and the future of public sculpture.[54]

Taft was also distressed by the low quality he perceived in much public statuary. In an 1896 article on the state of American sculpture, he pointed out that any progress in the field was made in spite of conditions: "Natural man," Taft claimed, persisted in showing "an unerring instinct for bad statuary" in this country.[55] This had affected Taft's own work early on, causing him to participate in projects resulting in works very like those he and others eventually criticized. His collaboration with Indianapolis businessman Arthur McKain to produce the *Randolph County Soldiers and Sailors Monument* in 1890, for example, yielded a classic Civil War memorial. Taking obvious inspiration from the likes of Milmore, their memorial on the courthouse lawn in Winchester, Indiana, fits the pattern perfectly: the base is a substantial fortress-like block guarded by uniformed figures representing the four branches of the armed services; an elaborate bronze frieze showing troops in battle encircles a drum above the square base; and a towering granite shaft rises from the drum to a height of fifty-three feet where another uniformed standard-bearer serves as terminus. Figures here are replete with "window confectionary" detail ranging from sabers and rifles to insignia, stirrups, buckles, and even buttonholes. Likewise, Taft's *Schuyler Colfax* in Indianapolis qualifies as precisely the sort of ungainly figure Bitter and others objected to. Although obviously presented in a manner intended to make him seem somewhat animated, Taft's *Col-*

fax appears wooden and unnatural. The gesture of his extended right hand can mean little to the viewer, the scroll held in his left hand nothing at all; a conventional contrapposto pose has been so obscured by layers of clothing that the forward position of the *spielbein* appears a stride about to propel the poor man off his perch atop the squat shaft of the pedestal.[56] Taft was later by no means proud of these early works. While pleased to receive the commissions at the time, in years to come he expressed embarrassment over having produced such "effigies" and satisfaction that he had not captured all the commissions he sought.[57] Reflecting on his early career many years later, he judged most of the early figures "hideous" and was only happy to recall he never actually signed many of them.[58]

By the turn of the century much of Taft's more vehement criticism was leveled at what he perceived as the most objectionable characteristic of recent public statuary: the popular practice of emphasizing details of contemporary dress. City parks, according to the sculptor, were becoming mere showcases for bronze "clothing dummies" offering nothing more meaningful than "examples of modern tailoring."[59] Taft was quick to point out that a handful of sculptors like Saint-Gaudens had produced extraordinary works representing modern figures like Lincoln, but added that he "would not care for another standing contemporary even from [Saint-Gaudens]. One pair of bronze trousers is not very much more interesting than another pair."[60] Yet the issue was ultimately less a question of monotony than of beauty, for in Taft's opinion modern clothing styles posed an unprecedented problem for modern sculptors simply because of the ugliness of contemporary dress. "What could a Phidias do with a procession of our time?" Taft asked. "How many ward politicians in frock coats and silk hats would it require to make the aggregate impressive and beautiful? These clothes of ours, the ugliest that the world has ever seen, are simply impossible to sculpture."[61]

Moreover, in addition to its ugliness, contemporary clothing was also unduly restrictive. Taft claimed modern styles "shrouded" the figure in a decidedly unnatural manner: "Millet's peasants were too poor to have even a fold in their garments; now conditions are changed, and it is the well to do who cannot afford a wrinkle or crease other than the graceful one down each leg. The hand

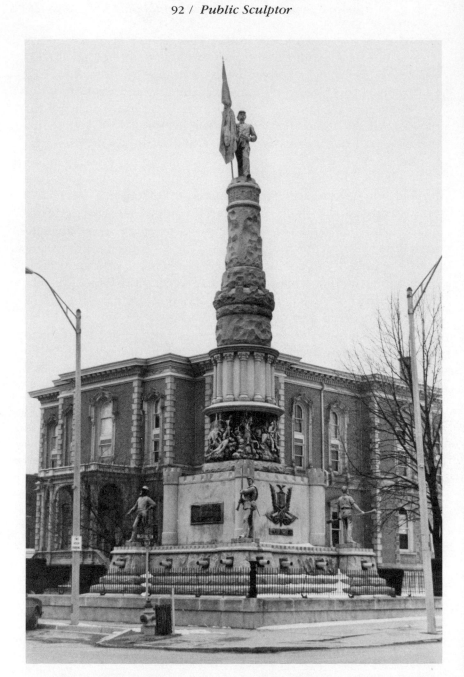

22. Taft's *Randolph County Soldiers and Sailors Monument*, Winchester, Ind., 1890. Courtesy of Janet Fuller, *Winchester News-Gazette*.

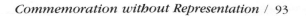

23. *Artilleryman.* Detail from Taft's *Randolph County Soldiers and Sailors Monument.* Courtesy of Janet Fuller, *Winchester News-Gazette.*

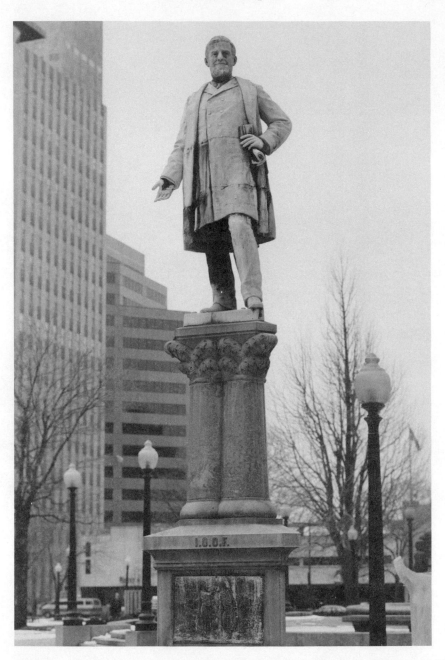

24. Taft's *Schuyler Colfax*. Indianapolis, 1887. Courtesy of the Indiana Historical Society.

protrudes from a shiny cylinder serving the purpose of a brass ferrule. The neck is held fast by another rigid cylinder, and on each head, if it should be stylish, yet another cylinder is carefully balanced."[62] This geometric rigidity was less pronounced in the case of women's styles of the day, but Taft found their clothing even more drastically restrictive: "Women never think of lifting their arms when they have their 'good clothes' on. They get out of the habit of it and need a maid to comb their hair. We grieve over the cripple [*sic*] feet of China, but, with the exception of a few athletic women and golf-players, our fashionable women are crippled all over, paralyzed in body and limbs, cramped by costume and convention. They might as well be in plaster casts. They cannot run; they cannot jump; they cannot climb stairs with any grace or freedom."[63] The result, then, was that when sculptors attempted to produce works featuring figures attired in modern dress, their efforts yielded only statuary unattractive in detail and unnatural in pose and gesture.

This was especially troubling to someone like Taft, trained as he was to regard the human figure as the primary focus of the artist's attention and major stimulus to his imagination. As a student at the Ecole des Beaux-Arts, he experienced a course of study directed exclusively toward mastery of the anatomy, a "beautiful mechanism" he and his fellow students came to consider as "the artist's single theme."[64] Hours of working from plaster casts and models were complemented by more hours studying masterworks in the museums and public spaces of major European cities—activities reinforcing the students' conviction that the figure was the basis for all accomplishment in the history of sculpture. Yet in American culture, Taft sensed a disturbing reluctance to accept the human figure as a beautiful object. Art students trained in American institutions were rarely made sufficiently aware of the figure or its importance; the public seemed either indifferent or hostile toward figurative art; and the popular trend in public statuary perfectly reflected the situation by placing more emphasis upon creases, buttons, and lapels than the graceful forms of the figures obscured by those surface features. It was little wonder, then, that Taft grew increasingly critical of the public sculpture erected in so many urban parks by the later nineteenth century. When measured against the standards he was trained to embrace, most of the

figures created for commemorative monuments were visually offensive, representing some of the major weaknesses in prevailing American attitudes toward art.

But even more problematic was the fact that most public statuary was *merely* contemporary. Specific period dress, Taft explained, is only an "accident of time and place" and of little real consequence in its own right.[65] Sculptors who worked too closely with details of clothing and accessories, however, often failed to recognize this and were therefore altogether too liable to become mired in the commonplace, loosing sight of larger, universal issues that should more rightly concern them. Taft's solution—and the solution of many others sharing his views at the time—was to call for an "ideal" art capable of transcending both period and location. Ideal art was by definition essentialized, intended to combine physical beauty with messages regarding time-honored values and virtues; it was an art capable of carrying "force to the soul as well as beauty to the eyes."[66] Specifics of identity, event, or place were viewed as incidental to the higher, universal message of the ideal statement, and were therefore avoided in the interest of directness and clarity.

Under the circumstances, then, Taft's criticism of public statuary sporting cavalry boots, Sam Browne belts, Prince Albert coats, and stovepipe hats was even more understandable. Such details were introduced in order to establish more concretely the identity of the subject commemorated in a public statue, but in Taft's view the specificity they created could only reduce any sense of timelessness or universality, thereby significantly limiting the meaning of the work. And for Taft, breadth of meaning was especially important. He spoke of the artist as one communicating not only with his contemporaries, but with those of other times as well. Much of this had to do with what he termed the "awfully permanent" nature of his medium, and the fact that the durability of sculpture made it necessary to contemplate the distinct possibility that most of the work made in bronze and stone during an artist's lifetime would extend its message "on adown the shadowy years to those who are to follow."[67] Yet more than that, he pointed out that ideal art was part of an artistic tradition—a heritage one of his contemporaries described as "slowly worked out by the universal process of evolution, generation after generation working out the

same problem" as the meaning of their messages was adjusted and refined.[68] Artists aware of this aspect of the ideal, Taft concluded, "bind together the generations of men; they give solidarity to the race."[69]

The *Fountain of the Great Lakes* was clearly intended as an example of this ideal art. Browne may have been more enthusiastic than accurate when he termed it the "first large and purely ideal group erected in America," but there can be no doubt it met the basic requirements of the ideal.[70] Nonspecific figures were presented as objects of beauty rather than images to be identified as individuals or types in this fountain: drapery here consists of gracefully flowing linear folds suggesting fabric neither obscuring the figural forms nor establishing unnecessary ties to time or place. The composition was calculated to lead the viewer's eye from one figure to another; poses, gestures, drapery lines, and the positions of the large shells held by each of the women create an easy movement from the top along a series of diagonals to the base. Content was also important, but in an equally unrestrictive fashion with meaning more implicit than explicit. Given the title and the presence of five figures, reference to Lakes Superior, Michigan, Huron, Erie, and Ontario is clear, but the relationship among them is only suggested rather than described. Taft took the connectedness of the system of Great Lakes as a point of departure, refined the idea to an essential notion of water flowing through five natural stages, and presented this essence as image. And in its timelessness, he sincerely believed his fountain achieved universal meaning. "It bears its message through the ages," Taft explained during his dedication address, "reaching a hand in either direction, binding together as it were the generations of men. On mouldering stone and corroded bronze we read the aspirations of a vanished race. In the same materials we send our greetings to myriads of souls unborn."[71]

Even beyond all question of beauty and discussion of the relative integrity of portraiture and the ideal as public statements, Taft's rejection of descriptive commemoration in favor of timeless beauty and universal meaning reflects the artist's more general inclination to distance both himself and his art from the contemporary world. It is true that on several occasions the sculptor counseled his fellow artists to remain in close contact with contemporary

society. In an early article discussing uses for the Ferguson be-
quest, for example, Taft claimed that the "important thing" was
that the artist commissioned should strive to become "part of the
life about him"; to achieve success with such a commission, he
explained, the contemporary artist should "speak no alien tongue
but must follow the vernacular of his day" in the work he pro-
duces.[72] There may well have been a good measure of Garland's
"veritist" influence behind that advice, yet if the novelist's ideas
had impact from time to time, Taft was never entirely swayed by
them on a permanent basis. His work certainly demonstrates this,
as does his criticism of sculpture he took to be too cluttered with
descriptive detail. But even more telling are the ideas he expressed
in other contexts—especially when his views were more directly
related to the place of the artist in society and the possible effect
of modern pressures on the artist's work.

In a series of 1899 newspaper articles for the *Chicago Record*,
such issues were the sculptor's primary concerns. Taft wrote of
several related problems through the series, but in a piece entitled
"The Artist and the City," he most directly addressed social roles,
and the problem of the artist unable to march in step with the rest
of society in a complex modern world. As the sculptor explained
it, artists were essentially simpler, more childlike beings than most
of their contemporaries, "in love with nature, in love with trees
and flowers and beautiful forms, content to make 'pretty things,' to
stipple with a pencil, to nibble with a modeling tool, to tickle with
a brush," but to remain all the while well outside the mainstream
of modern society.[73] Yet as time passed, he warned, the complexi-
ties of society took their toll on these special individuals. That
minority possessing the most artistic souls, Taft complained, often
became lost in the confusion of modernity; misunderstood, they
went their own way bravely but with little possibility of making
any perceptible impact. Others like himself, he ruefully admitted,
were even less fortunate. Unable to resist temptation, they were
quickly swept up in the "intricacy and complexity of life," attempt-
ing to make their way and leave their mark in a social context ulti-
mately so foreign as to prove disastrous: "We try to adapt ourselves
to our environment, to serve two masters. Hopeless competition
it is, but we want good clothes! We want carriages, too; we want
fine houses and all the trappings and belongings of the wealthy,

who devote themselves to this sort of thing. It is the hopeless race of a farmer's dog with a railway train. He falls panting in the ditch at the end of the field, and the train sweeps on."[74]

What Taft lamented in this passage was something fretting many of his contemporaries as well: modern artists were coming to seem altogether too intent upon achieving present success at the expense of future glory. There was actually no little basis for their concern. As one recent source has noted, it is only necessary to consult lists or photographs of guests at exclusive dinners and other social events of the period to discover architects, painters, and sculptors appearing with increasing frequency among the wealthy cultural elite usually making up those groups.[75] Certain observers, like *Craftsman* editor Gustav Stickley, found this growing friendliness a good sign, boding well for future support of American art.[76] Some, however, were rather suspicious of the situation. Aside from the fact that many like Fuller and Wheaton worried about misunderstandings and hostility, others shared Taft's view that fraternization with the wealthy might lead to misdirected ambition among artists thus favored. Far from feeling such patronage an invigorating influence, for example, Gorren called it the "vulgarization of artists," claiming it could only lead to a creative emasculation.[77] Likewise, sculptor William Ordway Partridge warned at the time of "dangers which are very ominous" blocking the paths of artists who would allow their work to suffer by pursuing it for social status or material gain rather than pure love of art; according to Partridge, artists as well as any others in society were susceptible to "the death-dealing influence of luxury" and would be well advised to take special care to "seek a simple and genuine life."[78]

And as Fuller suggested in his satirical story, "The Downfall of Abner Joyce," all artists were at peril. In the opening pages of Fuller's story, the central figure, a staunchly democratic young writer fiercely opposed to all signs of aristocratic luxury, is given to creating rugged tales exposing the plight of the rural poor. After a series of enticements and encouragements, however, Joyce turns completely about, transformed to an author offering apology for the urban wealthy while enjoying their splendid hospitality. "The pomp and luxury of plutocracy inwrapped him," Fuller concluded, "and he had a sudden sweet shuddering vision of himself dining

with still others of the wealthy just because they *were* wealthy, and prominent, and successful. Yet, Abner had made his compromise with the world. He had conformed. He had reached an understanding with the children of Mammon. He—a great, original genius—had become just like other people. His downfall was complete."[79] If the "downfall" was in this case a burlesque, humorous at the expense of his friend Garland, the terms and direction of the fall made it a timely story indeed.

To avoid losing sight of his primary mission as an artist required Taft's special attention and sustained effort. Achieving his goal, as the sculptor pointed out, demanded that he find ways to elude the numerous and complex pitfalls of modern life, ignoring or otherwise escaping temptation as thoroughly as possible while pursuing the higher life of the artist. Willpower and self-awareness were certainly in order for this task, but Taft and his colleagues also did their best to create something of a buffer between themselves and the potential sources of distraction surrounding them. Although never intended as a complete or permanent barrier between themselves and the outside world, the establishment of a discrete artistic community accomplished their desired ends quite well. In some respects this was simply a psychological distinction arising from their cultivation of a collective professional identity in the studio life of the city; in a few instances it involved the development of a more clearly defined physical separateness by means of exclusive social groups in which artists were better able to express their unique values and personalities independent of influence from outsiders. Regardless of the case, however, the combination brought about a degree of distancing that Taft and his circle felt better allowed them to maintain their artistic integrity.

This distancing began in the studio. In spite of the popularity of Chicago studios with the general public, they remained very much artists' special havens. Taft wrote his parents very early after arriving in Chicago that his new studio was already "a kind of headquarters and rendezvous" for young artists in the city—a situation that continued as he moved into more attractive spaces over the following years.[80] The Athenaeum Building, the Masonic Temple, the Tree Studio Building, and others each contained small but cohesive colonies of artists who established and maintained community identities based on both professional and social ties. Far

overshadowing all other studio centers, however, was the Fine Arts Building opened on Michigan Avenue in 1898. The structure was originally known as the Studebaker Building, housing that company's carriage assembly plant and display center from 1885 to 1896; but when Studebaker decided to relocate to other quarters in Chicago, the owners decided to renovate the original building to accommodate artists, musicians, and various compatible groups. Changes were extensive and impressive: shops and two music halls were created on the ground floor with nine stories of soundproof and fireproof studios rising above them; a substantial light well was carved through the center of the structure beginning at the fourth floor to make space away from the street brighter and more attractive; and the tenth-floor ceilings were pushed up to a height of twenty-three feet and outfitted with skylights to provide more space and light for artists requiring special conditions.[81] Near both the Auditorium Building and the Art Institute and across from what was then still known as Lake Front Park, the structure proved immediately attractive and successful in drawing the most important of the city's creative population together in one location. As Anna Morgan recalled, it was here that the "blending of the social with the artistic life" flourished for several years, artists forming lifetime friendships both personally and professionally satisfying.[82]

Moreover, within this special artists' tower, much was done to enhance the distinctive flavor of the renovation by providing tasteful interior decor. Solon S. Beman, the original architect of the structure, was also charged with responsibility for remodeling in the mid-nineties, and he gave careful consideration to special cosmetic improvements as well as major alterations. The base of his new central light shaft was transformed into a "Venetian court" complete with terra-cotta ornament, a fountain, and planters; the lobby was made sumptuous with attractive marble facing and cases for changing displays by residents; and carved wood doors and trim, often combined with leaded glass partitions, made upper floors appear equally elegant. Manager Charles S. Curtiss then complemented these special appointments with ornate hall furniture, statuary, paintings, and potted ferns and palms. The tenth floor was the province of the major artists of the building, however, and there Taft and his colleagues added a good deal more than was standard on floors below. Not only were their individual studios

elaborately decorated according to individual taste, but several of the tenants collaborated to adorn the open public space of the floor with eight substantial murals near stairwells and elevators.[83] It was claimed that the "Tenth Floor" became known throughout Chicago as the artistic pulse of the city; important figures were stationed there, and the social life of the prestigious Fine Arts Building centered there.[84] As cartoonist John T. McCutcheon later recalled, "the atmosphere became thicker" as a visitor rose to that prominent uppermost level.[85]

Several Chicago novelists recognized the distinctive artistic atmosphere of the Tenth Floor and its predecessors in other buildings, often using these special spaces as foils against which to present the gritty reality of busy Chicago. Differences between their fictional artists' tasteful studios and the crowded city streets were developed for assorted reasons and with varying emphases, but what emerges is a strong impression of combined physical and psychological distancing achieved by artists in their remote work havens. Garland's Joe Moss of *Money Magic*, for example, frankly explains that he selected his studio atop the "Wisconsin Block" because he wished to be "in the midst of trade, but above it." [86] There in his tower-top studio Moss is industrious in producing utilitarian objects like door knockers, andirons, and mantelpieces—but only if permitted, as he puts it, to "do it my way." [87] Hobart C. Chatfield-Taylor, another of Taft's circle, provides an even clearer impression of studio isolation in *Two Women and a Fool* (1895). Within forty-eight hours of his arrival in Chicago, Chatfield-Taylor's protagonist, Guy Wharton, found the "nervous air" of the city impelling him to search for a studio in which to continue his artistic career; yet however overwhelmed with the anxious desire to begin work in this bustling city of workers, the young artist was equally anxious to "be away from the droning, toiling multitude" of the streets.[88] After considering spaces in various buildings, he finally located what was described by his Parisian friend d'Argenteuil as a "fourteenth story paradox" offering the "pure air of art" in striking relief after the "fetid atmosphere" found all around in the city below.[89]

Furthermore, specific descriptions of ascent reinforce the remote distinction of penthouse studio spaces in these novels. D'Argenteuil's reference to the "fetid atmosphere" of Chicago is

graphically explained by his account of the process necessary to gain access to Wharton's peaceful loft: "I come to the door in one of those clanging, jerking cable cars; I jump off because the pig of a conductor won't stop for me; I splash mud all over my boots; I stumble over a heap of garbage; I slip on a banana skin; I am jostled by a throng of embryo millionaires; I rush into a vestibule where glistening tiles and gilded arabesques are jumbled into one glaring apotheosis of bad taste, and after being jammed into an iron cage where my toes are trodden upon and my nose inflicted with a dozen human smells, I am shot up into space, and landed opposite the door of this art-haven."[90] His response, then, is to both physical and psychological unpleasantness; Chicago is a dirty, smelly, and crowded place, but making it even worse for a cultured man like d'Argenteuil are the sins of boorishness and poor taste encountered on all sides. By comparison, the quiet beauty of Wharton's studio strikes the Parisian as "fourteen stories nearer paradise."[91] Likewise, Garland's *Money Magic* heroine, Bertha Haney, was struck by the tremendous distance between street and studio in Chicago—and for this unspoiled western woman, the best measure of this distance was found in a natural image. "To go from the crash and roar of the savage streets into this studio," Bertha mused at one point, "was like climbing from the level of the water in the Black Cañon to the sunlit, grassy peaks where the Indian pink blossoms in silence."[92] While the idea of comparing architectural Chicago with the cliffs and canyons of the West obviously originated with his friend Fuller, Garland has here made good use of it again as a means of establishing more vividly the unique quality of the artist's space; the crash and roar of waters in a "black" canyon is an image offering strong contrast to the sunny, silent peaks with flourishing crops of grass and pink flowers, underscoring the striking distance between studio and city.

Within these special spaces, equally special social activities added to the sense of distinction cultivated by the artistic community. Annual artists' costume balls were held on the top floor of the Fine Arts Building, for example, and accounts indicate that participants went out of their way to create unique impressions with elaborate, often colorful attire.[93] At other times when notable figures like Henry James, Israel Zangwill, or Isadora Duncan visited Chicago, the community's social wheels were again set in motion

as the celebrities were whisked up to be feted in Tenth Floor studios.[94] But the most regular and important of the studio group's social activities were the weekly meetings of the Little Room. The exact beginnings of this studio club are not clear; sources conflict as to the date and location of its origin, agreeing only that it was first organized in the early nineties and rapidly found a home in the studio of Ralph Clarkson.[95]

From the beginning, members viewed the Little Room as an exclusive organization consisting of creative individuals of like temperament joined together for relaxation. Architect Irving Kane Pond, one of the original members, recalled that the group was first formed as the Attic Club, but upon finding an undesirable element among their number, the majority simply agreed among themselves to disband, forming again later without the objectionable party and naming the new club the Little Room.[96] Once established, new membership was permitted, but on a very limited basis, and only after candidates were carefully screened by an anonymous but highly selective "starchamber" careful to see that "no uncongenial spirit entered into the inner sanctum."[97] Moreover, behavior of those who gathered was unofficially but effectively controlled during their Friday afternoon social hours to prevent professional concerns from impinging upon the convivial atmosphere they cultivated. As one early source explained, "while achievement is the passport to the doors of the Little Room, once within all evidence of toil and talent must be hidden: the clay is covered, the easel draped, the desk closed, the piano locked; and hospitality rules."[98]

Even the name of their club was a subject of no little interest and discussion, adding to the sense of distinction enjoyed by the group. In his 1906 novel, *The Charlatans*, Bert Leston Taylor poked gentle fun at the mysteriousness maintained over the club's name, creating a strikingly similar fictional organization he called the Pekoe Club boasting a "seriousness of purpose" its members refused to explain to "Philistia."[99] If participants in the real club were somewhat less reticent, Pond later recalled Little Room a name many fancied as "fraught with mystic meaning" only fully sensed by "a devoted member of the order."[100] In fact, the club's name was adopted directly from a story by the same title, written by another of the charter members, Madelene Yale Wynne.

The initial tale in *The Little Room and Other Stories* (1895) centered around a mysterious chamber in a small rural house owned by two elderly ladies; appearing and disappearing throughout the story, the room was visible and accessible to some while others could neither see it nor enter. Naturally, the occasional nature of Wynne's fictional room coupled with the exclusiveness implicit in the image of a sanctum only few could perceive made her title fit the club quite well. Details from her story also offered striking parallels with the circumstances of the club: the location of the mysterious house, nearly a mile from the nearest neighbor and high atop "Stony Hill," seemed to match the physical separation of the Tenth Floor from the public street below; and even the imported fabrics, leather-bound books, brass candlesticks, tea set, and other carefully described contents of the elusive room Wynne created were reminiscent of the range of tasteful studio accessories normally found in Tenth Floor havens like Clarkson's.[101] Yet the most important similarity lay in the fact that the room was unquestionably real for those capable of seeing it, regardless of the opinions of others. Wynne's heroine, Margaret Grant, could see the room even though her husband, Roger, could not; yet after some initial problems, he came to accept the idea of it "as something not to be scoffed away, not to be treated as a poor joke, but to be put aside as something inexplicable on any ordinary theory."[102] In their cultural retreat over the commercial city, Little Roomers held tenaciously to a similar belief, aware of the extraordinary nature of the enterprise. Their club created an illusion of even greater distance than the ten flights might indicate, and they insisted the distance was meaningful indeed.

To support their insistence, members also cultivated an image of temperate but obvious eccentricity in their club activities. To be sure, many Friday meetings were simply times of relaxation among friends gathered around the samovar. Yet on some occasions, the group organized fanciful entertainments reported as quite out of the ordinary. Vaudeville evenings, for example, were occasions when members stepped down from their "pedestal of high art" to cut up with magic tricks, dialect jokes, and ghost stories; one account claimed that when the normally refined Clarkson performed a cakewalk during one such session, even the portraits lining his studio walls were roused to inquire "What has

become of his reserve and dignity?"[103] More elaborate were the burlesque theatricals staged by the group from time to time. Employing substantial props, costumes, and even programs, the "unparalleled Stock Company of the Little Room" staged—for their own amusement—a "moral play" entitled "Little Room" in 1903, and a "Stupendous Tragedy" called "Cap. Fry's Birthday Party" in 1904.[104] On other occasions they parodied novels by members, as when George Barr McCutcheon's *Beverly of Graustark* (1904) was given as "Revelry in Graustark," or Chatfield-Taylor's war story, *The Crimson Wing* (1902), was adapted as "The Crimson Wig" with Roswell Field and Irving Pond playing roles of the French and Imperial German armies respectively.[105] All such performances as well as "Twelfth Night Revels," theme dinners, and late-night dances were reportedly marked by "sweet simplicity and foolishness" rather than raucous abandon or excess; bohemianism was generally more moderate in Chicago than in places like New York or San Francisco, and this was especially true of the activities of those ladies and gentlemen making up the membership of the Little Room.[106] But however decorous, the activities of the club were seen as extravagances enhancing the sense of distinction among members. Whether the club was simply meeting over tea on a Friday afternoon, or gathering for a "Grand Gastronomic Tour of Europe" with "Monsieur Hobart Chatchamps-Tailleur" as interpreter, Chatfield-Taylor was apparently quite correct when he claimed that it was not only physically separate from the "commercial city," but spoke "a language not of its streets."[107]

During summer months most Chicago studio activity was temporarily suspended as city heat drove artists to seek comfort in the countryside—commonly in camping groups. The first noteworthy summer colony established by Taft and his friends was their Bass Lake camp in northern Indiana. Founded in the mid-nineties on property owned by relatives of sculptor Charles Mulligan, the location became popular very rapidly. By 1897 one source placed the number of participants at the lakeside camp at over three dozen. Tenting was the rule, but Taft and Mulligan had already completed a studio shack by then, and Browne erected another in the form of a rough log cabin.[108] Unfortunately, it was at this point that an alleged outbreak of malaria called the safety of the lake into question and prompted sudden abandonment of the site. Left to find a

25. Horace Spencer Fiske cabin, Eagle's Nest Camp, c. 1900. Courtesy of Lorado Taft Field Campus Archives, Northern Illinois University.

26. Ralph Clarkson cabin (interior), Eagle's Nest Camp, c. 1900. Courtesy of Lorado Taft Field Campus Archives. Northern Illinois University.

new location in more healthful surroundings, some of the original group were lucky enough to encounter a new opportunity almost immediately. In the early summer of 1898, Chicago lawyer Wallace Heckman proposed that Taft and a select group of others establish a new seasonal colony on a portion of the lawyer's summer estate overlooking the Rock River near Oregon, Illinois. A quick visit to inspect the site delighted the group; an agreement was drafted and eleven charter members of the new Eagle's Nest Association signed their promise to pay property taxes plus one dollar and two art lectures annually in return for use of fifteen acres of wooded bluff property. Although tents were again the early form of shelter, more substantial structures were planned almost immediately in this obviously more permanent location, and over the next few years the site was landscaped and several attractive cottages erected. By 1904, the Eagle's Nest colony was so well established that Harriet Monroe wrote a feature for *House Beautiful* describing the picturesque summer community these enterprising artists had created.[109]

In spite of the fact that both Bass Lake and Eagle's Nest camps included several who were not actually practicing artists, there can be no doubt that these colonies were perceived as artists' resorts. Studios were constructed at each location, and some members actually completed a modest amount of work while in residence during the summer months. And at Eagle's Nest, association by-laws even went so far as to codify preference for artists in a hierarchy of membership ranks: beyond charter members, regular membership was available only to "individuals following an artistic profession," while any other interested parties able to claim only "sympathy with the objects and interests of the association" were restricted to either associate or honorary membership status.[110] Once on hand with families and friends, however, the artists expended at least as much energy in recreation as in work. Especially at Eagle's Nest, swimming, boating, hiking, and other outdoor activities were always common; group events included community building projects, camp theatricals and dances, and excursions to local attractions.[111] In an essay on the history of American artists' colonies, Karal Ann Marling suggests there have been two major kinds: those emerging more or less spontaneously at places like Old Lyme and Provincetown, and a second group of "intentional

colonies" like Roycroft Village and the MacDowell Colony, which "arose as a result of advance planning on the part of founders with a mission."[112] Heckman's Eagle's Nest appears to have been intentional, but without specific intent; the lawyer merely provided space for artistic neighbors as a means of cultivating their acquaintance and enjoying their company. The artists, in turn, obliged him, enjoying the vacation opportunity to the fullest.

Just as in the Little Room club, however, the nature of their relaxation at Eagle's Nest was sufficiently out of the ordinary to reinforce the distinctiveness of the group. Initially telling in the accounts of many who recalled the camp was the unique attitude toward dress prevailing among participants. Ada Bartlett Taft, the sculptor's wife, later guessed it was their sense of isolation on the bluff over the river that gave the group courage to adopt such a wide variety of unconventional attire. For special evening entertainment or in welcoming guests, the party often constructed elaborate costumes, appearing on different occasions as ghosts, gypsies, pilgrims, Indians and pioneers, sheiks and odalisques, or Egyptians and "stone Colossi."[113] Especially favored among their many costumes were the Greek robes salvaged after an 1897 Art Institute pageant; ever conscious that the very grounds they enjoyed were earlier inspiration for Margaret Fuller when creating her famous poem, "Ganymede and His Eagle," the campers often donned their flowing robes—whether for special festivities or merely to visit the dining hall or studio.[114] But even daily clothing styles among the Eagle's Nest group were extraordinary by standards of their time. Ignoring conventions demanding "trailing skirts and stiff collars," women of the camp daringly raised hemlines and lowered necklines for summer comfort; men, on the other hand, returned to youthful student fashions with black berets, "Boul Miche" corduroys, and other Parisian oddities.[115] On their private wooded blufftop the group clearly felt able to adopt ways utterly unlike anything they may have considered in a more public setting, indulging fancy and enhancing the distancing established in other ways.

And this impression of the group's distinctiveness was extended beyond the confines of their bluff property by various accounts of members and visitors alike. Before the first season at the new camp was concluded, charter member Horace Spencer Fiske pub-

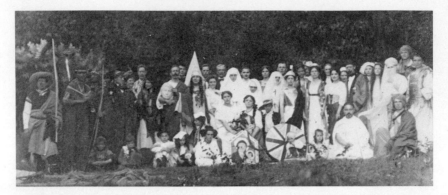

27. Eagle's Nest campers in costume, n.d. Taft wearing his toga and holding a large plaster head study, stands just to the left of the woman in the tall, pointed headdress. Courtesy of Lorado Taft Field Campus Archives, Northern Illinois University.

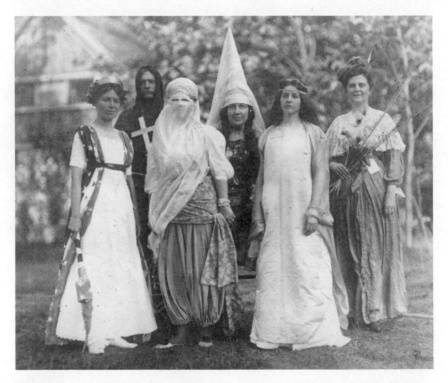

28. Eagle's Nest campers in costume, n.d. Courtesy of Lorado Taft Field Campus Archives, Northern Illinois University.

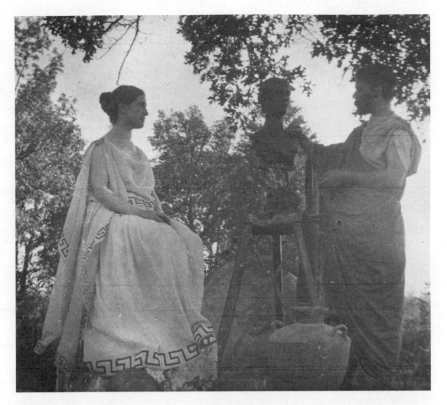

29. Taft and model Eldora Lynde Nixon, both in antique drapery, c. 1898. Courtesy of Lorado Taft Field Campus Archives, Northern Illinois University.

lished an article describing their venture in the Chicago art journal, *Brush and Pencil*. Although at that point it was too early to report on many of the particulars of the camp, Fiske informed readers that the basic goal of the campers was to escape the "restraints of a highly complicated city life" in favor of the simple, physical joys of working in nature.[116] As the camp evolved and more could be told of both place and people creating it, the image of Eagle's Nest took on better definition. Harriet Monroe's article reinforced the image of simple hard work evoked by Fiske, but reported the labors of campers yielding spectacular results in the form of a rustic luxury of flagstone cottages with attractive tiled roofs, verandas, and handmade furniture. Yet she also observed that the same group responsible for hauling stone and hewing

logs took time off to celebrate the anniversary of Margaret Fuller's visit, dressing as "fauns and dryads" to form a special night procession in elaborate rites rechristening the area in her memory.[117] A comparable—if even more fantastic—account of Eagle's Nest called the camp a "shrine to art" made up of cottage "temples" from which "vassal artists wend their way in festal garb to the castle of the overlord" to make annual rent payment at Labor Day.[118] Others, however, chose to focus on the natural setting of the camp and the artists' place within it. There were descriptions of venerable oaks shading "mysterious ravines" around their bluff; forest evenings above the river were said to create an image of times past when the land was inhabited by "blanketed warriors" who seemed still present in the dusk; and campers met along the paths in these same forest shadows were claimed "a company in spirit" with Socrates, Wordsworth, Emerson, and the Barbizon painters.[119] In such accounts of the camp, identities blur—Greeks, Indians, past artists, and present campers become equals in a timeless natural haven. While clearly a heavily romanticized view, it was a view placing Eagle's Nest at a distance from Chicago far greater than its miles.

These activities of summer camps and winter studios complement one another, then, creating an image of Taft's circle as a group striving to maintain a sense of distinction. Their actions appear rather self-consciously contrived at times, but when coupled with explanations offered by Taft and others, their fantasies and poses assume meaning as attempts to gain identity and integrity by separation from the complexities of modern life. Moreover, Taft's participation in studio and camp communities adds a new perspective to any understanding of his sculpture. With this background of beliefs and goals, the *Fountain of the Great Lakes* may be viewed not only as a model of appropriately ideal art offered as an alternative the sculptor considered far superior to ugly Prince Albert-coat statues of the day, but as a symbol of his beliefs regarding the basic nature of art itself. By eliminating representation of recognizable contemporary imagery, generalizing commemoration, and reducing subject to a beautiful essence, Taft sought a timelessness distancing his fountain from modern Chicago just as fully as he and his colleagues distanced themselves from modern society. The fountain presented an odd addition to

the commercial city: the "suave grace of falling water" afforded a considerable contrast to the roar of Michigan Avenue traffic; the "sweet and pleasant dignity" of the composition was utterly unlike any impression given by massive business blocks of the Loop; and the female "lakes" did little to recall that successful lumber dealer whose memory they were to perpetuate.[120] Taft's fountain was in Chicago, but hardly of it—commemorating a Chicagoan, but not representing him. Yet if the sculptor appeared out of step and his work out of place and lacking in proper commemorative value, both were so by design. In cultivating a personal distance and creating an ideal group, Taft's goal was essentially the same: avoidance of modern problems and pitfalls that might weaken his creative ability or limit his artistic statement. In this respect the *Fountain of the Great Lakes* serves as a strong indication of the sculptor's broader concerns—his hopes for his work and his convictions regarding modern art in general.

Sufficiency of Support

If Taft's 1913 dedication address expressed his gratitude for the opportunity represented by the *Fountain of the Great Lakes*, his message also sounded a distinct note of regret and caution. Commending all involved for honorable intentions and exemplary success in the conception and administration of a notable new fund for the beautification of Chicago, he was nonetheless troubled to think that opportunities like his were so few and often came so late. Even as he congratulated his city, Taft felt constrained to warn against complacency. Indeed, at one point the sculptor's comments strayed noticeably to criticism of what he perceived as a serious problem still plaguing all efforts to improve cities like Chicago. However delightful the fruit of the Ferguson Fund, it was in Taft's view only an initial step; the fountain demonstrated what could be construed as laudable interest and a noble direction, but far more was needed. "What Chicago lacks," Taft cautioned, "what all our new American cities so deplorably lack is a background. Our traditions are all before us. Our homes, our streets, our lives are casual. We need something to give us greater solidarity—to put a soul into our community—to make us love this place above all others. This Art alone can do."[1] If the course of development suggested by this first effort were pursued, Taft predicted, the city would most certainly win its deserved "recognition in the world of beauty" and become that place of affection he envisioned.[2] Yet implicit in his wistful prediction was the obvious suggestion that

all possibility for such success and fame lay in the future. Taft clearly hoped his contribution with the *Fountain of the Great Lakes* might prove a good omen, but believed it could at best only signal the ushering in of a proper spirit.

Taft was genuinely concerned about this problem and had articulated much the same caution in several earlier articles. What made this occasion unique was that the warning of his dedication address received a quick answer only moments later in comments by South Park Commissioner John Barton Payne. The commissioner was the third speaker that afternoon, following Taft and Hutchinson on the dais. His acceptance speech signaling official receipt of the fountain by the City of Chicago was somewhat less polished than those that had preceded it, but he was also bolder and more direct in his comments. Following a perfunctory introduction reiterating the appropriateness of the Great Lakes theme, Payne moved immediately to what was for him an obviously more important issue. As if responding specifically to Taft's comments, the commissioner voiced a countering complaint of his own: "It is said that Chicago lacks a background; that its citizenship is affected by materialism; that we have not devoted ourselves to the arts and to the humanities as we might have done. People who make this reflection forget that art and devotion to the humanities for their own sake are the ripe fruits of civilization. They follow that splendid materialism which is expressed in the life, the business, and the commercial success of a city like Chicago."[3] Indeed, as far as Payne was concerned, it was safe to claim the *Fountain of the Great Lakes* as evidence of a full flowering rather than a mere beginning. "What is thus true of Chicago was true of Florence, and of other cities now celebrated for their art," Payne stoutly declared. "Art followed material success."[4] Ferguson's abilities as a lumber merchant resulted in the accumulation of wealth, which in turn allowed for erection of a splendid public fountain capable of standing as symbol of that sequence. For Payne, the process involved early effort leading to material success and climaxed by cultural achievement—and with the *Fountain of the Great Lakes* that final achievement was an accomplished fact, not mere promise of things to come.

Payne's position on this matter was by no means new; many had previously linked material and artistic development in very

similar fashion. When responding to the initial announcement of Ferguson's bequest, for example, one *Tribune* editorial enunciated the equation most bluntly, declaring that just as trade is commonly known to "follow the flag," so "art follows wealth" and "the wealthiest city is likely to have the most art."[5] Others developed similar ideas less baldly with various expansions of the issue raised by Payne in reference to the accomplishments of Florence. The existence of a turn-of-the-century "renaissance" in America—or New York, or Chicago—is a problematic matter today, but however much scholars may use and at times misuse the term, there is little doubt that many American cultural leaders of the time congratulated themselves that theirs was an era pleasingly analogous to that of fifteenth-century Italy.[6] Moreover, there was a conscious cultivation of these perceived parallels, especially in the discussion and encouragement of the arts. The design of everything from cities to sideboards offered clear reflection of this Renaissance influence; scholarship, criticism, collecting patterns, and even patronage of contemporary artists and architects also betrayed obvious biases in this direction. The art that emerged was marked by a sumptuous, aristocratic elegance ranging from Stanford White's ornate Madison Square Garden (1892) crowned by Saint-Gaudens's tiptoe *Diana*, to the staid McKim, Mead, and White design for Boston's Public Library (1895) with Bela Pratt's calm figures of *Art* and *Science* guarding the main entrance.

Such work was certainly an attractive use of a highly regarded period style, but as Richard Guy Wilson aptly observes, it was also an art and architecture of capitalism, impressively expressing wealth and power for observers of the day.[7] If the creation of public palaces like Madison Square Garden, the Boston Public Library, and the Art Institute of Chicago benefited the entire population of their respective cities, those structures also stood as statements of the power enjoyed by the wealthy individuals who had provided financial backing for their creation. And observers of the time lost no opportunity to suggest connections between contemporary patrons of revival styles and the original men and families responsible for financing their Renaissance prototypes. When architect Tom Bingham encouraged wealthy David Marshall to finance a Madison Square Garden for Chicago in Fuller's *With the Procession*, for example, he evoked "the Fuggers, of Augs-

burg, the Loredani and Morosini, of Venice, and the Medici and Tornabuoni, of Florence" as those whose ranks Marshall would join by contributing to his city in this manner.[8] Such contributions, then, not only served as appropriate expressions of public spirit, they demonstrated an age-old pattern of commercial enterprise supporting cultural achievement.

While Payne's adoption of this common opinion regarding connections between art and commerce set him distinctly apart from Taft during the dedication ceremony, the gulf separating commissioner from sculptor became even more apparent as each brought greater specificity to his discussion. Taft, of course, illustrated his claim regarding lack of "background" by describing his own struggle in the decade following the Columbian Exposition. Citing the absence of meaningful work and need for promotion and public education to alert Chicagoans to the importance of art, he painted a gloomy picture of insufficient support for himself and his colleagues in the city. The sculptor was quick to acknowledge the Ferguson Fund as a valuable source of support when it arrived, but he emphasized that by his experience such support was the exception rather than the rule.

Payne, on the other hand, also pointed to Taft's case as the basis for his position, but used the sculptor's career as primary evidence in a curious argument claiming that the commercial leadership of the city did indeed provide local artists with ample support. As the commissioner explained it, Taft's momentous *Fountain of the Great Lakes* was actually the result of a fortunate combination of "genius and a lifetime of study and toil necessary to prepare for such work." Naturally, the genius and toil Payne mentioned were the sculptor's personal contributions—an innate talent and the willingness to work hard in the creation of beautiful sculpture. But by Payne's account, Ferguson provided the opportunity to develop and exercise that special talent by offering the wherewithal, "which might never have been available but for the munificent bequest of this large-minded, far-seeing, successful business man, typical of Chicago."[9] Of course, this was a rather outrageous distortion of the real circumstances of the commission. Ferguson had nothing whatsoever to do with Taft's preparation of the figural group for the fountain: the sculptor received his contract from the Ferguson Fund trustees nearly two years after his work was

first exhibited in the large plaster model. Yet the reality of the cir-
cumstances mattered little to Payne, for the idea of funds flowing
from successful merchant to by then successful Taft formed an
attractive extension of his argument: though the dedication of a
new civic fountain was impressive, the existence of a flourishing
Chicago artist could be cited as evidence of the full value of the
city's commercial base—proving commerce not only necessary
but quite obviously sufficient as "background."

The conflicting views held by Payne and Taft—especially pushed
to the extent they were during the dedication ceremony in 1913—
raise questions of considerable importance for those concerned
about Chicago's cultural development during the late nineteenth
and early twentieth centuries. In retrospect, it matters little which
speaker had his facts fully straight that particular afternoon as the
two offered such divergent opinions regarding support for the arts
in their commercial city. What was important was their difference.
In declaring and arguing for their respective positions, the sculptor
and the commissioner were simply continuing a debate occupying
many before them. Their attention was focused on the specific
case of Taft and his *Fountain of the Great Lakes* in Chicago, but at
issue were the greater and more troublesome problems regarding
the place of art and role of the artist in American culture. If Taft
and his colleagues wanted to maintain a modest distance from the
complexities of modern society, his disagreement with Payne had
more to do with questions of alienation.

Payne's satisfaction regarding the state of American art repre-
sented a relatively new perspective on the subject of cultural
development in this country. Thomas Jefferson may have "panted
after the fine arts," as one of his fellow Virginians claimed, but such
enthusiasm was not the norm in the early republic.[10] Far more
typical was the ambivalence of people like John Adams, sorely
tempted by the beauties of European art but uncertain as to the
place of such art in the United States.[11] In part, the hesitation of
Adams and others who expressed reluctance to embrace the tra-
ditional fine arts in their new nation stemmed from a desire to
achieve full national independence and integrity. The republic,
many believed, could only succeed by rejecting all traces of Old
World influence—aesthetic as well as political and social—and the

natural course was therefore dismissal of older European art as inappropriate for young America. In its place a utilitarian aesthetic emerged, positing the importance of function as a criterion super- seding beauty as a primary measure of value in American art. If a portrait recorded the appearance of a face, or a landscape painting that of a place, these were desirable and sufficient goals requir- ing no special cultivated taste on the part of the viewer. Such was generally the art of the early democracy.[12]

Yet even as this emphasis on utility was tempered by the re- introduction of more traditional aesthetic values very shortly after the turn of the nineteenth century, other early views proposing the relative unimportance of the arts held sway much longer. Con- sidered in the broader context of American goals and experiences, many described art as a matter of little real consequence. Adams articulated this opinion very clearly when explaining to his wife a natural hierarchy of meaningful enterprises he believed would occupy the attention of future generations: "I must study poli- tics and war that my sons may have liberty to study mathematics and philosophy. My sons ought to study mathematics and philoso- phy, geography, natural history and naval architecture, navigation, commerce and agriculture, in order to give their children a right to study painting, poetry, music, architecture, statuary, tapestry, and porcelain."[13] Although certainly intended as a strong, posi- tive statement reflecting his optimism for the future of the young nation he was then helping to form, Adams's words betray his feel- ing that the arts mattered little when posed against useful activities like war, commerce, and the other concerns he cited. In this sce- nario support for art was clearly given low priority as something attended to only after all else is settled. When much the same view prevailed through the following century, implicit at times even in comments of the artists themselves, it quietly retarded the growth of American artists by preventing them from gaining their full measure of support.[14]

One lasting result of this American inclination to undervalue art was a pronounced discomfort for artists attempting to work in this country. Many simply resigned themselves to the hopelessness of their situation and, convinced theirs was a role incompatible with the mainstream of American life, left for friendlier soil. Following the example of early pilgrims like Benjamin West, young Ameri-

cans dedicated to the pursuit of careers as artists were especially
susceptible to this urge, believing it increasingly imperative to find
their respective ways to Europe. Part of this was naturally due to
the better opportunities for study and superior instruction avail-
able abroad, and many young artists went to London, Rome, Flo-
rence, and Paris to avail themselves of the same training enjoyed
by their European counterparts. Equally enticing were other prac-
tical advantages available in foreign studios: materials and trained
craftsmen were closer at hand when needed, working and liv-
ing costs were lower, and contacts with potential patrons among
traveling Americans seemed more likely. Most important, how-
ever, was the perception that the very atmosphere of Europe was
more encouraging. Working abroad, young American artists found
more acceptance for themselves and enthusiasm for their art. Dis-
tance from families and friends was daunting, competition stiff, and
opportunities for disappointment many, but the lure and promise
of Europe proved something most aspiring young Americans could
not ignore. And if some came back from the experience disillu-
sioned or discouraged, most thrived under what they believed far
more appropriate circumstances for the creation of art. Colonies of
expatriate American artists emerged early and flourished through
the nineteenth century, finally becoming institutionalized with the
founding of the American Academy in Rome in 1894.[15]

Unfortunately, while important for American artists, their dis-
sociation from their own culture only drove the wedge deeper
between artist and public in this country. The former, returning
from study abroad, often found conditions at home even more dis-
appointing than before; and the latter, no doubt influenced in some
degree by the opinions of returning artists themselves, lost confi-
dence in the ability of most American arbiters to decide questions
of taste. By the second half of the century, as John Kouwenhoven
points out, there was considerable support for the idea that a long-
standing American record of insensitivity had finally rendered the
nation virtually anesthetic, creating an environment incapable of
providing the encouragement necessary for art.[16] This position was
quite naturally the opposite of that of self-congratulatory cultural
leaders like Payne, but critics of American culture could offer as
evidence for their view an abundantly apparent public indecision
on questions related to art. At times rejecting all native opinion as

naive and therefore inferior to that of cultured Europeans in questions of taste, the public in other cases brashly pushed ahead when some direction or example may have proven helpful indeed. Seldom absolutely certain as to the correct course of action—seeking guidance one moment while rejecting all advice the next—many late nineteenth-century Americans seem in retrospect to have been confused, lacking direction or clear intention in their selection and patronage of art.

Nothing demonstrated this more vividly in postbellum America than the Philadelphia Centennial Exposition of 1876. Positioned on the rolling hills of Fairmount Park, the collection of seven major exhibit buildings of the nation's first truly major exposition stood amidst a welter of smaller structures in stunning evidence of the aesthetic uncertainty characteristic of the period. Architectural styles clashed dramatically in the collection of larger buildings: the Agricultural Building was gothicized, Horticultural Hall was Moorish, and Memorial Hall was based on the grand traditions of the Renaissance. Such a profusion of style may have carried certain symbolism for those guiding development of the exposition, but any intended connections between Gothic spires and American farmers were no doubt lost on the vast majority of visitors.[17] Moreover, the specific applications of revival styles were also of questionable merit. Memorial Hall, the only exhibit building constructed of permanent materials and intended to last beyond the duration of the exposition, was clearly the most important aesthetic statement on the premises. Designed by Bavarian architect Herman Schwarzmann to house the art exhibit, it was an impressive domed pile with arched entrances, clusters of engaged columns, a prominent cornice, and statuary positioned at every available location. Yet in Schwarzmann's design the staid monumentality of the classical Renaissance vocabulary became heavy-handed—especially when his already ponderous structure was outfitted with some of the most graceless, mismatched sculpture imaginable.[18] It was little wonder that more sensitive observers like architect Richard Morris Hunt voiced deep disappointment with both specific structures and overall design at Fairmount Park; the design of a complex created to celebrate a century of national progress displayed only confusion and awkwardness.[19] Although in many respects the Centennial was a tremendous success as it show-

cased American advances in numerous areas, Russell Lynnes was unfortunately accurate in characterizing its artistic side as more ostentatious than effective, lacking the "intellectual substance" that might have produced a more visually coherent statement.[20]

By the time of the next major American international exposition, however, both approach and results were greatly improved. Backing and organization for Chicago's Columbian Exposition came from the same class of local business leaders who had provided direction earlier in Philadelphia, but when Chicagoans reached the stage where physical plans were required, they called in a specialist. Burnham's role as director of works at Jackson Park was essentially similar to that of General Joseph R. Hawley at Fairmount Park: each managed the daily routine of building the physical plant for their respective fairs. The difference was that Burnham exerted far more control over the outcome than had his counterpart at the earlier exposition, carefully selecting architects and artistic advisors with the intention of achieving a more fully integrated visual product.[21] Controlling style, scale, and finally even color, the group of architects and artists Burnham assembled created in their famous White City a complex of breathtakingly monumental grandeur—as fully of a piece as the Centennial was mixed. Critic Montgomery Schuyler noted that the wondrous classical facades overlayered with their wealth of sculptural ornament constituted an example of "holiday" architecture rather than "work-a-day building," but he was nonetheless lavish in his praise of the overall effect as "a success of unity, a triumph of *ensemble.*"[22] If not appropriate as a model for universal application beyond the fairground, the noble structures arranged impressively around their lagoons and canals appeared to mark a new maturity in American taste. Many took the Columbian Exposition as reason for enthusiastic self-congratulation, and a contagious optimism emerged regarding the future progress of aesthetic development in the United States.

Naturally, Chicago's voice was loudest on the subject. Even before it opened, creation of the beautiful new complex in Jackson Park was described as a watershed in the city's development. Previously, as one source explained, Chicago seemed "unable to make her life beautiful as well as prosperous, noble as well as magnificent, cultured as well as affluent"—but the White City emerging

from its swamp on the South Side in 1892 appeared the example needed to change that unfortunate situation.[23] And in the wake of the exposition, this is exactly what most believed had happened. Residents of the city were immensely pleased with what they had created, and even more pleased by the response of visitors reinforcing their good opinion. Although the stockyards were still in place and running as furiously as before, many Chicagoans finally felt free of their "Porkopolis" image with the rest of the world, demonstrating themselves capable of finer things than the manufacture of ham and pork byproducts. As Fuller put it, 1893 seemed a turning point when Chicago ended once and apparently for all its role as the "Cloaca Maxima of modern civilization," turning instead to more meaningful enterprise as "the best people of the town found themselves, for the first time, associated in a worthy effort under the unifying and vivifying impetus of a noble ideal."[24]

Design and physical creation of the exposition was obviously the work of Burnham and his various crews, but real credit for responsibility in this and other cultural achievements of the period was commonly assigned to the American business community. The "best people" to whom Fuller referred were "the men at the head of Chicago's commercial and mercantile interests" who provided the impetus allowing the city's "intellectual and social annexation to the world at large" through their promotion and guidance of the fair.[25] While the novelist had serious reservations regarding the effectiveness and ultimate durability of this "annexation," Fuller was among the majority who recognized the role of these leaders in any attempt to achieve positive change in Chicago. Of course in cases like Ferguson's where it was a matter of cultural philanthropy, commercial leaders naturally assumed a dominant role, for it was the financially successful individual who possessed wealth to contribute for public service. Yet observers like Fuller also saw leaders from the business community as figures capable of organizing and leading even those cultural projects in which their own donations were relatively modest. Serving as presidents, directors, trustees, and active members of various organizations unrelated to their affiliations on Wall or LaSalle Streets, these individuals brought far more than money to the efforts then underway to improve the quality of American cultural life.[26]

For some this sponsorship and direction provided by the busi-

ness community constituted something of an act of redemption—described at times quite directly as the only honorable atonement for Chicago's history of crass materialism. Garland, for example, cited his fellow author Chatfield-Taylor and the painter Frederick Clay Bartlett as individuals who in his estimation "help to redeem Chicago" by applying inherited family fortunes amassed in lumber and hardware to the support of their diligent pursuit of art.[27] Others praised the "impersonal interest" of Chicago's City Beautiful proponents, implying that their "unselfish devotion" to that cause was quite distinct from the self-serving nature of most normal activity in the commercial city.[28] And Taft, speaking directly to business leaders in a 1913 address before the Chicago Association of Commerce, pointed out that nonresidents were reformulating opinions of the city as notice of new cultural improvement began to overshadow earlier images of ruthless, greedy materialism. Editors of several eastern newspapers, Taft explained, finally seemed "quite willing to forget that they had written in the past that we are purely materialistic" as word of the city's new accomplishments and impressive goals spread.[29] While the message was most often stated indirectly, then, it was nonetheless quite clear: Chicago's longstanding reputation for coldhearted acquisitiveness could be changed if the same business leadership responsible for development of that negative image would turn their efforts and resources to more high-minded purposes.

On the other hand, many more saw the turn of business leaders toward promotion of cultural development as part of a very natural, time-honored sequence. In one of a series of articles explaining Chicago to readers of the *New England Magazine* during preparations for the Columbian Exposition in 1892, Franklin Head used the standard argument of the city's raw youth as excuse for the many "massive temples of trade and commerce" and relative dearth of comparable civic buildings and churches.[30] Yet in her turn Lucy Monroe told the same readers that emphasis upon commerce in the city's early history also provided a strong foundation for the arts. By Monroe's account, Chicagoans "wrested wealth from the prairies and lakes, only to learn that it was worthless except as the means to a nobler end"—and at that point the arts began to prosper.[31] In pursuing this line of development, Monroe continued, Chicago followed the path of other important cities

in the past; she cited Venice as the closest parallel ("where the merchants are the kings" and architecture the first art to flourish), but other writers found similarities to many other notable centers.[32] Shaler Mathews, for example, prefaced his 1905 account of "uncommercial Chicago" with frank admission that all he was about to describe was based upon the strong commercial success of the city, and he too posed this as the typical situation for important cities abroad. "In these days it is a little unsafe to refer to ancient history," Mathews pointed out, "but it is worth while recalling that if it had not been for the Greek merchant, Athens would have no Parthenon, that if it had not been for commercialism Rome would have left us few survivals in architecture; and that if the Medici and other Italian despots had not tyrannized trade we should not be going to Italy to study art."[33] For those accepting this view there was no question of redemption or atonement for commercial excesses in the equation; cultural flowering occurred naturally and spontaneously after a period of successful commercial development. "Uncommercial Chicago," as Mathews concluded, was quite simply "the noblest product of commercial Chicago."[34]

This was Payne's position as well. The commissioner spoke of no special need for atonement for past sins of greed; the materialism of commercial Chicago was not something requiring redemption in his view. Quite the contrary, like Mathews, Monroe, Head, and others, he believed it a good, natural, and necessary base for all else. As Payne put it, "Materialism, the desire for personal gain, for material advancement, is part and parcel of human nature. It is the soil, the mature cultivation of which produces the means, while history and time produce the background indispensable for the development of art."[35] It was a very simple matter, then, requiring only that residents of a city or country follow basic instincts leading to the acquisition of wealth; with time that wealth would spontaneously generate all other conditions necessary for the flowering of art. If the process was vague it mattered little in 1913, for there was a great deal of evidence to support Payne's optimism. Those assembled to hear the commissioner's address could consider new libraries, museums, a major university, several new parks, an influential plan for further municipal development, and a beautiful new fountain—collectively indicating that Chicago was well along in a

new course of cultural achievement. And that all was being accomplished through the sponsorship and cooperation of the business community bore out Payne's claims quite nicely. Indeed, citing the case of Ferguson's bequest as a primary example, Payne concluded convincingly that "Chicago should not, therefore, decry materialism any more than she should decry her commercial supremacy, but should cultivate and mould this materialism and use the benefits which it brings until we have the ripe fruit of civilization, love for our fellow man, [and] the humanities which teach us all that we have lived to little purpose unless we can leave the world better for our having lived in it." [36] Materialism was not an obstacle in Payne's opinion—it was the chief means to a better future.

That Taft was reluctant to express an unqualified optimism at the dedication of his new *Fountain of the Great Lakes* no doubt seemed rather ungenerous to people like Payne, but in retrospect the sculptor's position is quite understandable. Despite his increasing personal success and status by 1913—and in spite of all positive signs of cultural improvement around him—Taft was nonetheless part of a community of artists for whom the general situation was far less pleasingly attractive than the park commissioner portrayed it. Individual commissions like Taft's notwithstanding, the group he belonged to felt alienation rather than encouragement in their city. While they sought to achieve a necessary distance from the mainstream of Chicago's rushing commercial life, circumstances often seemed to keep them out of the water altogether. Taft's group probably agreed with Payne that the city had the wherewithal to offer ample support for local art and artists, but in their experience that support was made available only grudgingly. The spontaneous patronage Payne described may have been occurring, but to a degree Taft and his colleagues felt was insufficient to allow the survival, let alone the flowering, of local art.

Of course many artists found a good deal to be pleased about in turn-of-the-century patronage patterns. Several writers have pointed to the growing tendency among cultural leaders of the period to accept certain artists as collaborators rather than mere employees, sharing patrons' values and goals and complementing the efforts of those intent upon bringing about cultural reform.[37]

This new measure of equality allowed architects like Burnham and Stanford White, painters like John LaFarge and Kenyon Cox, and sculptors like Saint-Gaudens and French to enjoy a much enhanced status with an unprecedented degree of participation in elite society. Taft himself benefited along these lines by the early years of the century. As Taft was increasingly recognized as one of the leading artists in Chicago, his stock rose dramatically after receipt of the first Ferguson Fund commission: a spate of articles in national journals, additional commissions for public sculpture in and out of Chicago, and more attention to his ideas for civic beautification were gratifying signs elevating him to national rather than merely regional reputation. And although it was not quite true when one source reported his Ferguson Fund stipend freeing him entirely from "the perfunctory and necessary task" and permitting him finally "to work out his best ideas in serenity," Taft's financial picture brightened considerably as a second Ferguson commission together with orders from outside the city promised economic security over an extended period.[38]

For the vast majority, however, the years surrounding the turn of the century were not marked by any significant improvement in patronage; support continued to come only irregularly, and public sensitivity toward the artists and their products was not appreciably greater than before. However much those like Burnham, LaFarge, and Saint-Gaudens prospered, many American writers of the period still lamented the general situation of less fortunate artists whose efforts went largely unnoticed. This was especially true in Chicago. While Lucy Monroe and Franklin Head cited the value of a commercial base when describing cultural developments in the city for readers of the *New England Magazine* in 1892, William Morton Payne told those same readers that a "dull philistinism" resulting from the city's commercial emphasis actually stunted the growth of Chicago's literary community. Fuller was quite hopeful when chronicling "The Upward Movement in Chicago" in 1897, but two years later he reversed himself entirely, charging that until public imagination was "less devoted to grimy new facts and less dominated by nervous tension and headlong speed," art would remain an "unnecessary incumbrance." A few years later and in spite of her sister's earlier optimism, Harriet Monroe complained in 1905 that too many of her contemporaries

simply took it for granted that "all great art is a thing of the past," not available from modern artists.[39] And it was this lack of support—then as previously—that in Taft's estimation prevented development of the "background" he so sorely missed. As he put it to University of Illinois alumni in an impassioned address in 1907, the success of American art was largely in their hands: public respect would give artists new self-respect, and public encouragement would make them more responsive and responsible in the creation of meaningful work articulating to future generations the special nature of the American experience.[40] Only this could finally lead to a sound cultural background.

Yet making the situation far worse was that Taft and his colleagues not only felt a lack of overall support, they perceived an underlying public hostility to feed their already growing sense of alienation. Indeed, the two problems were very closely related: lack of support could in many cases be directly attributed to the disdain with which the American public regarded the enterprise of the artist. The creative act, after all, was for most a deeply mysterious process utterly unlike the more comprehensible behavior required by most other occupations. The artists' need for contemplation and stimulation from outside sources introduced many periods of apparent inactivity when they seemed uninvolved in any task; specialized language and emphasis on unique individual perception made bases for aesthetic decisions unclear; and critical debate over the products that resulted from such effort caused doubts regarding the legitimacy of studio work. Moreover, the very nature of that "work" raised still more damaging questions as to the seriousness of the artist. Sketching and modeling had long been acceptable as diversions, but hardly the tasks on which meaningful careers were based. The idea of laboring with brushes, paints, pencils, clay, and similar materials was considered with scorn by those engaged in jobs commonly perceived as more demanding or necessary, and individuals who would turn full attention to such light matters were suspect. While leisure was not considered evil in itself, the consensus through the nineteenth and early twentieth centuries was that it was easily abused, excessive free time likely leading to poverty, radicalism, and other social ills.[41] Artists drew precariously close to the edge of excess in their very choice of career—and that they were often less affluent, known at times to

hold objectionable political views, and reported to enjoy the company of nude models in the privacy of their studios made them highly questionable characters.

All such problems were greatly magnified in the atmosphere of Chicago. The hustle and bustle of the dynamic city seemed to preclude quiet contemplation and delicate, slow-paced processes. Chatfield-Taylor claimed the very site of the city seemed to demand enterprise and energy when de La Salle arrived to proclaim the mouth of the Chicago River a future "gate of empire," where residents would arise each day to exclaim, "I act, I move, I push."[42] Whether due to a special "microbe" carried inland on Lake Michigan breezes as Chatfield-Taylor suggested, or simply byproduct of an inexorable flow of trade through the commercial city, the pace of life in turn-of-the-century Chicago was described as both fast and potentially grinding.[43] And it was felt especially inhospitable to those not inclined or accustomed to hard, productive work. A sturdy Viking in "modern business suit," the young hero of Charles Banks's *John Dorn, Promoter* (1906) is a Chicago speculator who organizes lumber combines, floats stock, and still has time for settlement-house work and cultural promotion; while one of his friends reflects in the novel that the young financier would chafe in the calm solitude of the natural domain where his trees grow, Dorn thrives on the dynamic environment of Chicago.[44] In Fuller's *With the Procession*, on the other hand, affluent young Trusdale Marshall is without ambitions beyond leisurely self-entertainment—and for him Chicago proves a constant source of frustration. The tireless activity of the city weighs on him as heavily as its rough appearance, and he finds precious few to form a circle for daily fellowship and entertainment. After experiencing many "deprivations" through the course of the novel, Marshall finally feels forced to take up business, for "what can a man of leisure do, after all, in such a town as this?"[45] "Indeed," Chatfield-Taylor remarked, "our impulsive city is one huge kettle of energy seething the whole day long, no healthy man or woman being able to exist without work of some kind or other to do."[46]

Under these circumstances, artists seemed especially out of place in Chicago. Fuller's parody of his circle of artist friends in the stories of *Under the Skylights* presented a gross exaggeration of the seeming ineptitude of the artist perpetually losing the struggle

for professional existence in the real world of Chicago business-men, but other sources construct surprisingly similar images of the artist as weakling and outsider. In some cases this is a mat-ter of comparison with those more fully a part of the commercial city. Watson Skeet, for example, is Aileen Cowperwood's second consort in *The Titan* (1914); Dreiser describes him as a large, fair, "soft-fleshed" artist whose "archaic naturalness and simplicity" mo-mentarily appeal but do not ultimately satisfy poor betrayed Aileen when considered against the "chilling memory" of her powerful financier husband.[47] Likewise, in Norris's *The Pit* (1903), Laura Dearborn finds the aura of gentle beauty with which artist Shel-don Corthell surrounds himself attractive, and she enjoys his com-panionship and sympathy; yet she too concludes that "the men to whom the woman in her turned were not those of the studio," and she chooses instead Curtis Jadwin, a captain in the "Battle of the Street."[48]

In other cases, the artist is not only an outsider, but positively otherworldly. In Will Payne's *The Story of Eva* (1901) one telling episode has Philip Marvin making a sick call with his friend Mrs. Worthington at the modest Chicago lodgings of an ailing artist named Burroughs. Their friend is dangerously ill, but displays such an impressive courage in the face of his suffering that both visi-tors are tremendously moved. "He seems so far above it!" Mrs. Worthington confides to Philip on their way out. "One can imag-ine him loving—even Death!"[50] Moments later as the pair descend from Burroughs's darkened sickroom to step out into the bright snow-covered city street below, the beautiful courage of the artist is even further highlighted by the startling prospect of Philip's common-law wife, Eva, in a sleighing party led by the well-known local roué, Billy Carlton. For Philip the suffering of poor Burroughs is suddenly even more poignant when posed directly against the gleeful indiscretion of Eva and Carlton—and Mrs. Worthington, failing to recognize Eva in the group, sums up the situation by con-demning the revelers as "ineffably vulgar."[50] Chicago was in this case vulgar—the artist a nearly spiritual being, within yet clearly above it.

Nonetheless, such a flattering view of artists was by no means common; in most instances their position outside the mainstream of Chicago society caused them to be viewed as a potential threat.

Even in Payne's novel it later becomes clear that Philip is in little better company than Eva when the two spy one another outside Burroughs's apartment. The heroine has been misled by circumstances of a sudden social rise and has inadvertently fallen in with the bad company of Carlton and his companions. But Philip has also strayed from the path of right at this point in the story, distracted by the near-mystical persona of artist Burroughs, wary of the sensitive but judgmental Mrs. Worthington, and unable to distinguish the more important concerns from the frivolous. Just as Eva is forced to extricate herself from her new circle of associates after discovering their questionable reputations, Philip is compelled to drop his "little intellectual interests" at the end of the novel when the prospect of parenthood finally shocks him from his former "moral laziness" to a new awareness of what is truly meaningful in life.[51]

Yet while Burroughs simply represents an excessive otherworldliness in Payne's novel, elsewhere the character of the artist is a far more active antagonist. Norris's Corthell, not satisfied that he has lost Laura after her marriage to Jadwin, pursues and nearly wins her away again before his final defeat at the end of the novel; Garland's satanic Jerome Humiston from *Money Magic* shows naive Bertha Haney his lewd paintings in a darkened gallery storeroom in an effort to seduce her and gain access to her husband's money; and Banks's John Dorn faces his most formidable opponent in the scheming artist Felix von Auerbach, who attempts everything from seduction of a friend's wife to incitement of riot in his plot to break the young promoter and gain a fortune.[52] Whether out of touch with reality, sadly flawed in personality, or positively evil, artists often led disjointed lives in Chicago novels of the period. By contrast, when Garland wished to create a more positive artist character like Joe Moss, who "redeemed the artist-world from the shame men like Humiston had put upon it," the novelist was forced to go to great lengths to establish Moss's good character, disassociating him from the more common negative image.[53]

Nor were novelists the only ones describing the artist in negative terms. Critics of the bohemian artists' communities in the later nineteenth century were quick to raise other objections to the personalities of those involved. However interesting and colorful they seemed to more tolerant observers, the carefree lifestyles and

"THE BARON GAVE A GASP OF PAIN AND THE
KNIFE FELL FROM HIS HAND"

30. "The baron gave a gasp of pain and the knife fell from his hand." Illustration by August Abelmann of *John Dorn, Promoter.* by Charles Eugene Banks, 1906. Banks's Baron Felix von Auerbach was the classic fiendish artist, scheming against the protagonist from the outset of the novel.

oddly personal perspectives of artists gave rise to various criticisms in Chicago. Some claimed those involved were given to such behavior because of hidden aberrant traits best kept from light; others found artists essentially childlike in their ways, recommending they be monitored, controlled, and otherwise treated like children; and some watched nervously for signs of degeneration among previously untainted youths who might be contaminated by the presence of local artists.[54] Even Taft joined his voice to these at times, offering surprisingly similar reservations regarding his fellow artists. Naturally, he saw none of the evil projected in fictional characters like von Auerbach and Humiston, but he did describe his circle as an essentially naive lot—if not childlike, at least unprepared for the demands of "real life in Chicago."[55] Moreover, as he explained it artists were indeed handicapped by their personalities, suffering from unseen defects rendering them "gentle unclassified dreamers" incapable of competing for existence in the modern city where they were "lost amid the swarming breadwinners."[56] Raised as arguments in a call for more generous support for his fellow artists and therefore hardly damning in tone or content, Taft's observations nevertheless offer an indication of the broad circulation of such ideas by the early years of the twentieth century. The artist's position as outsider was firmly established.

On the other side of the coin, however, artists and their allies made little effort to bridge the gap. Even beyond the posturing and rhetoric of those who hoped to establish artistic distinction from the common lot, a persistent line of argument from many artists and writers widened the existing gulf perceptibly. In essence, this second side claimed that the mainstream of American society had not only retained its early insensitivity to the arts, but allowed that insensitivity to set more firmly with age—all signs of improvement notwithstanding. Some, especially reflecting on the national scene, found in this situation reason for broad castigation of American life. Henry James, for example, noted sadly that the peculiar focus of interest and energy characteristic of the American businessman resulted in a veritable abdication of responsibility for cultural development. In James's estimation it was a foolish default, ignoring those very things that define the "civilized being" and insuring that the businessman could "never hope to be anything *but* a businessman" in this country.[57] Likewise, the philosopher George

Santayana indicted as "genteel" the tradition of American thought separating the aggressive pursuit of material and political advancement from conservative preference for convention in matters of culture. "The truth is," Santayana observed in 1911, "that one-half of the American mind, that not occupied intensely in practical affairs, has remained, I will not say high-and-dry, but slightly becalmed; it has floated gently in the back-water, while, alongside, in invention and industry and social organization the other half of the mind was leaping down a sort of Niagara Rapids." [58]

Both James and Santayana went on to propose that the gap left by the abdication of American businessmen was quickly filled by American women, causing what both writers deemed a problematic situation further weakening cultural development in this country. The same position was held by many observers in Chicago as well. Hugh Duncan points out that writers ranging from Fuller and Garland to Thorstein Veblen and Edgar Lee Masters referred to a distinct "feminization of Chicago's cultural life" in the years around the turn of the century.[59] While some no doubt agreed with Taft when he praised those patronesses as the single force keeping American art alive, others were more in agreement with James and Santayana, finding the involvement of women a diluting influence.[60] Fuller, for one, was typical in suggesting through characters in *With the Procession* and *Under the Skylights* that the participation of women in Chicago studio life was generally shallow and uninformed; characters like his Susan Bates and Jane Marshall were well intended but had only a limited understanding of the art they discussed—and others like Mrs. Palmer Pence apparently neither knew nor especially cared about work going on in the studios they frequented. Art, Fuller suggested, was for such women more a social than an aesthetic experience.[61]

Yet the strongest criticisms from this side were reserved for the businessman. Having apparently relinquished his role as cultural leader in favor of his commercial endeavors, the businessman seemed to many to be dulled to the point of inability to see or accomplish anything else in life. Fuller again provides a good example of such limitations in his short story "Little O'Grady vs. the Grindstone." Finding themselves in need of decorations for a new bank building, directors of the "Grindstone National" decide to seek guidance from local artists, only to prove the most in-

tractable of clients. When proposals arrive regarding subjects for a major mural cycle depicting "The History of Banking in All Ages," Fuller's bankers remain stodgily immune to any possible charms of the idea, rejecting it in favor of subjects closer to their own limited concerns. As one of the elderly bankers reflects on it, he envisions as an alternative something featuring himself, "a lusty young fellow of twenty-five, the proud new head of a contractor's shop, with his own lumber pile, a dozen lengths of sewer pipe, a mortar bed, a wheelbarrow or two and a horse and cart. No need of going back farther than that. Those early days were glorious and fully worthy to be immortalized."[62] In the end no agreement can be reached, and the artists leave feeling the Grindstone had "ground our noses as long and hard as it could."[63]

Although in a similar vein, criticisms of others were often far more serious in tone. During an address at the Art Institute in 1888, Hutchinson placed much of the blame for the materialism, ugliness, and even political corruption of Chicago squarely on his colleagues in the business community, claiming that the typical businessman had unfortunately evolved by that time into "a mere machine devoted to business."[64] While his position obviously changed significantly by the time of his comments at the 1913 dedication ceremony, Hutchinson's early feeling on the matter reflected the general belief of his artist friends that complacency on the part of commercial leaders was the deciding factor holding the city back on many fronts. Taft was at times even more specific and damning in his criticism. In his 1907 alumni address he stated flatly that the "average business man" was so "engrossed in his great interests, in his 'big deals,' proud of our national prosperity, of the vastness of fields and factories, of the quantity of our products, of the length of our streets and railroads, he has become unspeakably materialistic"—a condition rendering him "practically immune from the appeal of good literature, good music and good art."[65] Such commitment to material prosperity had some immediate justification, Taft continued, but raised many questions regarding the broader quality and meaning of life:

> We must eat, to be sure, for we are hungry with the fierce concentrated appetite of eighty millions of people. We must be clothed and housed, for it is cold. But these things signify nothing beyond their face value; there is no virtue in them. They are necessities of life,

but they are not worth living for. We of Chicago are proud of that great city. Its growth and prosperity are marvels of the age. But what about those two million beings which are its life? Are they really living, those rushing, jostling little insects that one looks down upon from the sky-scrapers; those scurrying, breathless mannikins, always in haste and never getting anywhere? Is this really life? And with all our getting, our monstrous getting, are we building well for the unseen but inevitable generations which are to follow us? Is it enough to leave them vast hoards of wealth, to pile up that great dungeon city of trade for them to scheme and starve their souls in?[66]

His answer to such questions was obvious: far more necessary than all material achievement were "those things which ever have been esteemed the crown and glory of civilization"—the arts.[67] That the businessman was "money-mad, drunken with power and crazed with much achieving" was in Taft's estimation both the problem and the shame of American culture.[68]

Naturally, under the circumstances Taft described, his major fear was that the artist's frustration might simply overwhelm and cause creation of art to cease altogether. Reference to this in Taft's own case appeared when Fuller wrote him late in 1907, congratulating the sculptor on the Ferguson Fund commission while noting at the same time that the support had actually come none too soon. "I am glad Fortune has finally reached your door," Fuller told the forty-seven-year-old Taft, for "the artist who gets beyond forty-five without due measure of recognition and support, both moral and material, is in danger of the Slump. Even *you* couldn't have been expected to draw indefinitely upon your initial endowment of energy and enthusiasm: the reservoir must be pumped and filled."[69]

Yet far more worrisome than the continued struggles of an older figure was the plight of younger artists just beginning their careers in this harsh, unwelcoming environment of Chicago. These younger people were the real hope of the future, and many believed their trials would prove far too much to withstand. Painter Ralph Clarkson explained the problem well when describing the early years of an artist's career as "the most trying epoch" of all, noting that the attempt to adjust from "wonderful years abroad, surrounded by beauty and bohemian freedom, unmindful of earning money" stood in stark contrast to the realities of existence in

"an unattractive environment." [70] If few actually sank to the dishonesty of the evil von Auerbach in Banks's *John Dorn, Promoter*, or the weak Jackson Hart in Robert Herrick's *The Common Lot* (1904), Clarkson suggested far too many turned to compromise in fields like teaching and illustration, "where the demand for their product was greater." [71] And from there it was but a series of short steps to numbing disillusionment. One source charting this course as many saw it in Chicago explained a dramatic fall from an "energized" beginning:

> The blood seems to flow swiftly through the veins. Hope is in the air. We are facile, expressive, delighted at being alive and tremendously confident of the future. We congratulate each other—on almost anything! We are full of brilliant felicitations. But the outside world of sensible Philistine folk know nothing about it. They have never heard of our felicitations, and they do not understand on what we base our expectations. It is probably a mere disease, a kind of microbe of optimism that gets in the blood. As we grow to be forty-ward, we discover our absurdity. And then it is too late. We are committed to a career which it becomes a point of honor to sustain. We cannot desert that haggard and patient mistress of our folly. We cannot tell her that she is not really the glorious creature we thought she was when we were drunk with youth and a contagion of expectancy. [72]

Always sensitive to their importance for the future, Taft was especially concerned about the prospects for young artists, calling for their encouragement on several occasions. The actual basis for the individual genius that emerges from time to time among groups of young artists was difficult to detect, he reasoned, but the need for a receptive, stimulating environment to nurture that genius was clear. "Not one of the great masters came alone in his time nor in his country," Taft explained. "Each represents an army of strivers whose efforts culminate in one." [73] Of course the "army" he mentioned consisted of other artists whose presence helped form the necessary intellectual community sharpening the edge of genius; but just as important to the development of the master painter or sculptor was the overall atmosphere of the country and tenor of the time in which the special individual emerged and found support. This atmosphere—something Taft called "a sentiment, an attitude of mind" on the part of a population—was what

he feared would prove insufficient in American culture. "Ours is not the sentiment," Taft worried, "ours not the attitude of mind, which produces artists. We have not planted and watered; we have not even desired. Whatever develops is in spite of public sentiment and struggles against a frigid atmosphere."[74] Young artists continued to appear full of hope and fired with ambition, but unless the situation improved for them with a more consistent, widespread base of encouragement, their initial enthusiasm was bound to dampen time after time, making any substantial growth of American art impossible.

And while this had long been the complaint of those perceiving the marginal position of art in American culture earlier in the nineteenth century, Taft continued to sound his warning even after most others were citing grounds for new optimism. Speaking specifically of his own city in 1913, the sculptor told an interviewer of many deserving young artists arriving in numbers implying great things for the future "art possibilities" of Chicago; the critical mass was forming at last, and with the proper support from the city these promising newcomers would soon be "enabled to unfold their powers for the common good."[75] Yet even at that point, on the eve of the dedication of his *Fountain of the Great Lakes* and with other commissions in his possession, Taft concluded with a warning raising what was rapidly becoming a virtual obsession with him: "Brightly as burns the flame of inspiration in young minds, it can be put out; I hope Chicago will not be known in history as a city that puts out such fires as these."[77]

The alienation of the artist, then, was promoted and nurtured on both sides. Scorn and distrust prompted those not involved in cultural enterprise to keep the artist at arm's length, harboring images of both the creator and the process as either unsavory or unworthy—and therefore unacceptable. The artist, on the other hand, clung to his own reservations and resentments, developing an increasingly critical attitude toward the society he believed had failed him so consistently. And at the dedication ceremonies, Payne and Taft played out their respective roles to the letter. Even though thankful, the sculptor could not resist adding criticism of Chicago's lack of background; and although clearly in line with the general enthusiasm of the moment, his exceedingly strong praise for Ferguson hints that the lumberman's generosity

was more than a little extraordinary in Chicago. Payne, for his part, returned with comments scolding Taft and any others who would criticize the city and its business leaders; in his argument the city's commercial base was fundamental, cultural development was attractive but hardly necessary, and any who viewed it otherwise were misguided, ungrateful, or both. But the most poignant expression of the gap separating the two sides that afternoon came from Taft. Fully aware of both the significance and the limits of support extended to him with the Ferguson Fund commission resulting in his *Fountain of the Great Lakes*, the sculptor concluded his address with a candid statement putting his gratitude in proper perspective: "Gentlemen, shall I confess it? I have looked upon your splendid citizenship with admiration, sometimes not untouched with envy. I have been jealous of your privilege of doing splendid things for our Chicago. Do you wonder then that it is with deep feeling that I thank you and Mr. Ferguson for permitting me to join you as a stockholder in this community, a contributor in some small way to its heritage?" [77]

CHAPTER

5

Fountains and Modern Chicago

Among Taft's most cherished hopes at the time of the dedication of *Fountain of the Great Lakes* was that the work would mark not only the dawning of a new era of civic beautification in the city, but the beginning of a new Chicago school of sculpture. This was a natural desire in light of his growing interest in young artists, but the dream of Chicago as a center for American sculpture was actually something occupying the sculptor and his friends since the time of preparations for the Columbian Exposition. Taft's old advisor Simeon Williams was one of several in the early nineties convinced that the sudden appearance of so many of the nation's most prestigious sculptors concentrated in Chicago would most assuredly fire interest and create a demand for more work, ultimately making the city a new "headquarters" for American sculpture.[1] Although his predictions proved premature as those who produced the White City's impressive decorations quickly moved on after completing work in Jackson Park, the idea remained strong with Taft. When Ferguson's bequest was announced in 1905, it suddenly appeared the time had come for fulfillment of those long-dormant hopes. "We have young artists here of undoubted talent," Taft rejoiced at the time, whose "dreams of beautiful sculptures" would at last begin to receive necessary support; joining them would be the "ablest" talent from elsewhere in the country, Harriet Monroe pointed out, their ideas and efforts augmenting those of local artists to create an even broader base.[2] The result would

be a thriving professional community finally "making Chicago the home and center of American sculpture."[3] And it was with this in mind that Taft told his audience at the 1913 dedication ceremony of a gratitude both personal and professional: he was without question thankful for the opportunities Ferguson's gift opened in his own career, but he was also thankful on behalf of "Chicago's new school of sculptors, which this bequest makes possible."[4]

By the time of the dedication, Taft noted evidence of this new "school" of sculpture time and again in his accounts of regional art. If some of his observations exaggerated their prospects, he pointed repeatedly to the growing collection of young sculptors in Chicago, existing in what he claimed were circumstances appreciably better than those his own generation knew earlier. In 1912, for example, he told an interviewer that in his estimation young artists could finally obtain a "better fundamental training" in New York, Boston, or Chicago than in Europe, making even temporary expatriation unnecessary; a few months later he told another reporter of expansions at his Midway Studios, detailing work he and his assistants were doing, and explaining that after recent enlistments there were "about seventeen of us all told—a school of sculptors growing up."[5]

And allowing this group even greater coherency and focus was their involvement in a single great project directed by Taft himself. The *Fountain of the Great Lakes* was without doubt a major accomplishment for the sculptor, at last establishing him in Chicago as more than a mere portraitist. Yet by Taft's own admission it was only an initial step, and even before work of casting and assembling that group was completed, he was fully engaged in an even more ambitious project for Chicago. Directing his attention toward the mile-long strip of boulevard called the "Midway" connecting Jackson and Washington Parks along the south edge of the University of Chicago campus, he conceived of a large, complex beautification scheme intended to transform the space into a veritable sculpture garden. By the time the *Fountain of the Great Lakes* was installed, Taft had already received encouragement and funds from a commission allowing initial work on the Midway project. His atelier community was bustling with preparations, and there was apparently a great deal more work to come. It seemed the sculpture program he mapped out for the

Midway would indeed help further define the new Chicago school of sculpture Taft dreamed of.

Taft's plans for the Midway sculpture project were apparently well underway even before he received the initial Ferguson Fund commission for the *Fountain of the Great Lakes* in late 1907. As early as February of 1908 when Browne published his account of the sculptor's career, a description of Taft's "comprehensive scheme" for decoration of the Midway was introduced as additional evidence of his strong interest in civic beautification.[6] Although plans were still somewhat sketchy at that point, Browne's article outlined most of the major components appearing later in Taft's more fully developed proposals. The sculptor's point of departure was what Browne called a "less generally discussed" feature of Burnham's Chicago beautification plans then attracting such eager attention in the city—the introduction of a canal running the length of the Midway to link lagoons in Jackson Park with those in Washington Park to the west.[7] In Taft's program this canal served as a visual core, around which the sculpture was organized: three bridges dedicated to the sciences, the arts, and religion spanned the waterway and carried large statuary groups appropriate to their respective themes; at the east end of the canal was a massive "Fountain of Creation" consisting of numerous figures appearing to emerge from the earth as they acted out the ancient Greek legend of Deucalion and the repopulation of the earth after the flood; and on the opposite end was a group intended to complement the first, in the form of his "Fountain of Time" with figures of all ages and walks of life passing in review.[8] The only significant portion of the plan not mentioned by Browne was an open air "Hall of Fame" Taft added later, involving some one hundred statues of the great leaders of all time in rows paralleling the canal.

In the wake of his victory in gaining the initial Ferguson Fund commission, Taft began lobbying for his Midway ideas almost immediately. In the summer of 1908 he spoke to reporters casually at Eagle's Nest, introducing them to the plan gradually and informally with impromptu diagrams and hastily modeled lumps of wax; a year later he accelerated efforts, offering an initial description of the program to commissioners of the South Park Board, and then to the Chicago public; and by early 1910 newspaper accounts were numerous, detailed, and positive, with columnists like Mon-

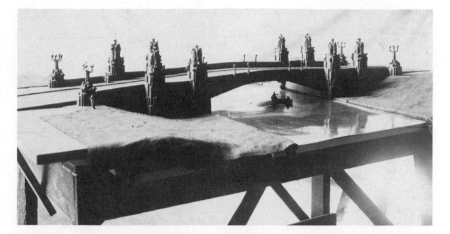

31. Taft's "Midway Bridges," studio model, c. 1910. Taft Papers, University of Illinois.

roe noting the "great activity" and "inspiring enthusiasm" of Taft's studio community as the crew there worked up plaster models to generate more attention.[9] The sculptor was by then referring to the Midway program as his "life work" and directing virtually all his energy to the promotion of the project through public presentations, private interviews, and any other means available.[10] Accounts of the inspiration for the massive fountain groups gradually became more elaborate, photographs of bridge and fountain models were published to allow better insight into the appearance of the proposed work, and lists of notables for the Hall of Fame were compiled and revised in an effort to make it quite clear the sculptor was serious in wishing to make them a broadly representative group.[11] Slowly the project took shape and gained momentum.

And as Taft made his project known, he found increasing support for it. Naturally, Browne pronounced even the earliest version not only beautiful but poetic and meaningful, heralding his friend Taft as one of the true prophets of modern Chicago; other local critics like Oliver and Monroe were also very supportive in the early years, calling the scheme his "Midway Beautiful" project and advising readers that since Chicago had an artist like Taft who was capable of conceiving of such a grand plan, the least the city could do was "fulfill his dreams."[12] Those in official roles were by comparison appropriately cautious, but positive responses came from

their quarter as well. Henry G. Foreman, president of the South Park Board of Commissioners at the time, admitted to reporters in 1909 that he was not sure whether his group would "be able to carry all of Mr. Taft's ideas into effect," yet he was quick to praise the sculptor as a "public-spirited citizen" for his efforts and claimed the project merited "very careful consideration."[13] Over the following few years, as Taft later recalled, his scheme continued to grow and mature, and "new friends" came to the fore to give it exactly that consideration.[14] By the summer of 1912, Art Institute Trustee Frank G. Logan officially introduced the plan to his board colleagues, formally advocating use of money from the Ferguson Fund for development of some portion of Taft's scheme.[15] There were still delays over the next several months, but by the end of the year the trustees were reported "very favorable" to the beautification program and in agreement that money should be allocated for initial work; after a few minor questions were answered and a formal letter of intention forwarded by Taft, all was settled by early 1913.[16]

The first portion of the Midway project commissioned by the trustees of the Ferguson Fund was its western terminus, the *Fountain of Time*. The contract of February 6, 1913, was a brief document, but in retrospect it is interesting for raising two telling issues. In the first place, the agreement stipulated that Taft was commissioned to produce the *Fountain of Time* as a monument "commemorating one hundred years of peace between the United States and Great Britain."[17] The idea of using the fountain to commemorate such an unrelated peace was one emerging late in deliberations. A special meeting of the trustees on December 9 concluded favorably with regard to Taft's plans, but it also rather suddenly occurred to those assembled for the meeting that requirements of Ferguson's will demanded at least superficial attention to the clause calling for commemoration of "worthy men or women of America or important events of American history." Frank Logan wired Taft immediately, informing him of the problem and requesting suggestions; a favorable decision was imminent, Logan explained, but until the sculptor provided a "definite written proposition" solving their problem no action could be taken.[18]

Taft submitted a proposal containing two alternatives for commemoration. His first choice was that his *Fountain of Time* be

used in honoring the memory of "the greatest event in the spiritual life of our city," the 1893 Columbian Exposition; barring that, he suggested as a second option using his fountain to commemorate the centennial of the Treaty of Ghent (1814), "marking a century of perfect understanding between England and America." [19] In fact, neither subject had anything to do with the nature of the fountain composition itself, so it made little real difference that plans for a monument commemorating the exposition were already underway and Taft's second choice was adopted.[20] The important thing—both for the sculptor and the trustees—was the completion of the first step in Taft's beautification scheme; commemoration was in this case a mere formality, providing a pretext for use of the Ferguson Fund.

The second telling clause in Taft's new contract involved instructions calling for creation of nothing more than a "full sized plaster model" of the *Fountain of Time*.[21] A generous sum of $50,000 was allocated for the purpose, scheduled to be paid in annual installments of $10,000 over the following five years as Taft and his assistants worked up the massive figure group; yet the trustees refused to commit beyond the point of the model, reserving the right to reevaluate the project before either going ahead with additional work or having the fountain itself carved in the Georgia marble of Taft's specifications. As one newspaper reported of their decision, the trustees were "understood to be unanimous in their desire to carry the project through in its entirety, but did not consider they had the right to bind the directors of the institution, who may be different men in some cases by 1918, to a definite course of action so far ahead." [22]

The arrangement was perfectly agreeable to Taft. While a student in Paris he was greatly impressed by the French practice of erecting temporary public sculpture in a plaster and fiber mixture called "staff"—at one point writing his family that the inexpensive mixture allowed production of models that would be ideal for pageants and temporary monuments.[23] Once home in the Midwest, he had an opportunity to employ the process extensively in his early career when directing fabrication of sculpture for the Columbian Exposition. And by the later nineties Taft had also come to recognize staff as a material wonderfully suited for use by sculptors wishing to test public reaction to their work. Writ-

ing in 1899, he publicly advocated use of the inexpensive plaster mixture in full-size preliminary models with the double advantage of preventing permanent erection of eyesores while also stirring genuine, widespread popular support for more deserving work.[24] This, of course, was part of his motivation when guiding students in creation of plaster compositions like the "Nymph Fountain" at the Art Institute earlier that same year, and he went on to do the same subsequently for similar projects. In fact, only the day before his *Fountain of Time* commission was officially announced, he told an audience at a meeting of the Chicago Engineers' Club of plans to erect several eight-foot plaster figures along the Midway in order to test scale and determine proper placement of statuary in his proposed Hall of Fame.[25] The contract for a plaster model of the *Fountain of Time* allowed much the same sort of trial and was therefore entirely acceptable to the sculptor as an initial—and in this case very well-paid—stage leading into his Midway beautification project.

By mid-February Taft reported that the plaster model of his new fountain was underway and he looked forward to the rest of the project with great enthusiasm. The main bulk of the work consisted of a mass of some one hundred figures forming a procession rising from waves on the right, peaking with a calm group dominated by an equestrian warrior at center, then descending once again as if pulled down by some unseen force dragging at figures to the far left. Opposite the continuous wave of marching humanity, Taft placed a heavily robed, mysterious figure of Time, towering above and watching the progress of those trooping by. Although the first model required only a quarter-scale version for the trustees' approval, the final group due at the end of five years was scheduled to be 110 feet long with Time reaching a height of twenty feet.[26] The sculptor was elated at the prospect of beginning his massive work. "This is the biggest undertaking I ever have considered," Taft told reporters, "but one which, of all others, I have ached to commence. It undoubtedly is the largest undertaking ever attempted in sculpture." [27] And with commencement of work on his *Fountain of Time*, it seemed certain to many observers that all else in Taft's Midway sculpture program would soon follow. In the announcement of his commission for the new fountain, one newspaper rather frankly stated that they simply "expected"

32. Taft's Midway "Hall of Fame," temporary plaster models erected on site, c. 1910. Taft Papers, University of Illinois.

33. Taft's Midway "Hall of Fame," temporary plaster models erected on site, c. 1910. Taft Papers, University of Illinois.

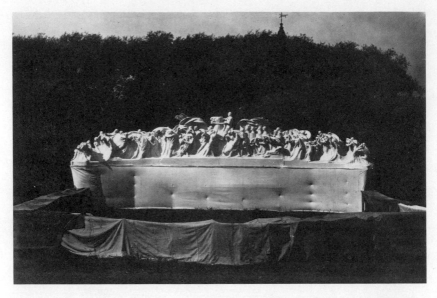

34. Taft's "Fountain of Time," small plaster model assembled on site, 1915. Taft Papers, University of Illinois.

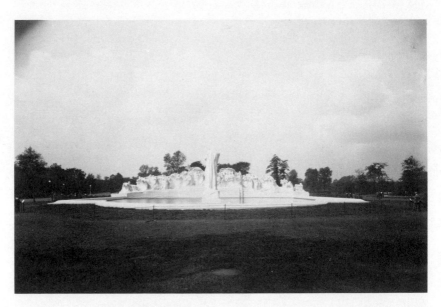

35. Taft's "Fountain of Time," full-scale plaster model assembled on site, 1920. Taft Papers, University of Illinois.

acceptance of Taft's entire plan for the Midway almost immediately.[28] As others pointed out, even if there were some delay, it seemed entirely unlikely the *Fountain of Time* would be left by itself as a fragmentary reminder of what might have been. "What is more likely," observed the *Dial*, "is that it will so impose itself upon the sense of its beholders as to create an imperative for the completion of the whole work." [29]

Taft's fortunes clearly appeared on the rise, then, with some commissions already in hand and others apparently in the offing. And as went Taft's career at the time, so went prospects of his school of young sculptors at the Midway Studios. They benefited immediately from his *Fountain of Time* commission, earning their portions of the annual stipend as they contributed labor necessary for constructing plaster models. But in Taft's view the group's potential for success was even greater in the future when commissions for remaining portions of his Midway beautification project would come directly to individual members of the sculpture community he was forming. The older sculptor explained he had never intended to assume responsibility for all work in his vast plan: "It did not occur to me that I should furnish half a hundred figures for the adornment of the Midway. At most it will take fifty years to realize the plan, and I shall be neither modeling nor carving at the end of that time." [30] Instead, he felt the work should go to the ambitious younger sculptors coming up through the ranks. His role, he explained, was only to suggest a broad scheme for improvements, which would then be implemented by those to follow. It was certainly a generous, attractive idea, providing not only guidance and short-term support for the younger members of his Chicago school of sculpture, but laying the groundwork insuring their continued direction and support in the future. The problem was that even in 1913, at the height of Taft's career with success apparently guaranteed, vague rumblings of discontent and indications of change were surfacing—gradually but perceptibly slowing his momentum and signaling the ultimate failure of his school before it was even fully underway.

Some of the change in Taft's status became apparent with the erection and dedication of his *Fountain of the Great Lakes* in the early fall. The majority, of course, heralded the work as a won-

derful cultural achievement, claiming it marked the new course for Chicago's future development from commercial crossroads to City Beautiful. Some, however, were somewhat less enthusiastic when they finally saw the work, giving voice to a variety of complaints about the appearance and meaning of this new fountain. While it was clearly an ideal figural composition considered appropriate and even commendable within the value structure of those wishing to transform Chicago into a graceful city of Old World charm, others not as susceptible to that charm were puzzled or even offended by the sculpture. Where admirers found a noble theme and beautiful forms, critics saw only confusing imagery and a disturbing lack of decorum. Although certainly by no means an overwhelming tide of criticism, their comments linked with others on related matters began a gradual erosion of the foundation of support Taft had only recently managed to build.

Among the most basic problems shared by several observers involved the identities of the fountain figures and their connection to the Great Lakes. The lakes certainly provided a noteworthy American theme, and the figures were well executed and attractive, but the concept of using these bronze women as effigies personifying bodies of water posed significant difficulties for some viewers. In fact the relationship between the figures of Taft's composition and the lakes they were purported to symbolize had actually been a subject of discussion from the time of the commission in late 1907. Some claimed the bronzes suggested only the relative elevation of the lakes, the close interrelation of the five waterways, or simply a poetic sense of the rhythm and motion of water.[31] Others, however, refused to be satisfied with such vague explanations, seeking more definite contours, directional orientation, and similar physical features capable of associating the women more directly with the lakes. Although admitting to feelings of impatience over the public's inability to appreciate the "deeper sentiment" of the work, one writer pointed out it had been "interesting to watch, at times when this group has been on exhibition, the number of people who would busy themselves in determining the geographical names of the different damsels."[32] If the ladies were lakes, it seemed, most wished to know which was which. Even Harriet Monroe, generally favorable in her estimate of Taft and his work at the time of the dedication, conceded that the sculptor's

women were vaguely disappointing for her, reflecting neither the geographic configuration of the lakes nor the true spirit of the nation's inland seas.[33]

And on this issue of the spirit projected by his group, there was certainly very little precedent for the manner in which Taft had developed the figures of his fountain composition. Carl Smith is correct in noting that the lake played a surprisingly small part in the consciousness of Chicago novelists of the period, but when it did emerge as a factor in either fictional or other accounts of the city, massive Lake Michigan appeared as a presence quite different from the placid ladies of Taft's work.[34] Observers in Chicago had long described the tremendous body of water beside them as an invigorating stimulus providing residents not only the opportunity but the positive encouragement to develop and succeed as a population of dynamic builders and leaders. When Chatfield-Taylor referred to a "microbe of the 'Chicago Spirit'" carried inland by lake breezes, he was merely giving fanciful form to a current of energy many felt in the bracing air of Michigan.[35] In fiction of the period, a similar quality appeared at times as characters like Norris's Laura Jadwin found "the cold, pure glitter of Lake Michigan, green with an intense mineral hue, dotted with whitecaps, and flashing under the morning sky" a natural influence lifting the burden of vague anxieties from her preoccupied mind.[36] For these and other writers, the lake possessed a sharp, quickening power bringing energy to Chicagoans, and in the words of poet Horace Spencer Fiske, "Guiding with sleepless eye her eager sons."[37] Such an image was rather at odds with the more relaxed, languid figures gracefully spilling trickles of water in Taft's fountain.

Taft's ladies were still less appropriate in light of another prominent lake image appearing even more frequently in Chicago novels of the period. Beyond its beauty or its invigorating power, Garland wrote, the lake had "other moods" liable to appear unexpectedly and have awesome impact on the city: "It could be angry, dangerous. Sometimes it rolled sullenly, and convoluted in oily surges beneath its coverlid of snow, like a bed of monstrous serpents. Sometimes the leaden sky shut down over it, and from the desolate northeast a snowstorm rushed, hissing and howling. Sometimes it slumbered for days, quiet as a sleeping boa, then awoke and was a presence and a voice in the night, fit to make the hardiest trem-

ble."[38] It was this mood of the lake that Garland's Rose Dutcher and Warren Mason observe and find so moving; as witnesses to a tremendous spring storm in *Rose of Dutcher's Coolly*, they are exhilarated by the fury of nature and inspired by the heroism of those struggling against its power.[39]

In other cases, however, more violent moods of the lake were posed as a direct challenge to fictional heroes and heroines. Banks's John Dorn faces a storm very like that described by Garland, sees friends in peril as their ship attempts to escape high lake seas, and rises to the occasion as the sole witness possessing strength and courage enough to row to the rescue; likewise, Thea Kronberg in Willa Cather's *Song of the Lark* (1915) struggles through Chicago as a lake gale makes the city a roaring, brutal hell, feeling the presence of an evil "power abroad in the world" seeking to conquer her, yet determining to meet the challenge and make her way in spite of all such obstacles.[40] And even when Michigan was not rising to beat against the city's breakwaters, it could prove a frightening natural force threatening those who encountered it. Heroine Dora Glenn issues an ill-advised swimming challenge to the aptly named Constance Dare in Robert Morss Lovett's *A Wingéd Victory* (1907) only to find that once well into the lake a strong, cold current sweeps them far off course, dangerously sapping her opponent's strength; Constance pitifully gives in to the lake, observing the futility of struggling against nature's power, but Dora shows her mettle by swimming on and ultimately saving them both.[41] Whether inspiration or challenge, this image of a violent lake was clearly compelling.

That Taft elected a more quiet form for his personification of the lakes was not due to any lack of familiarity with more vigorous precedents. The sculptor was very well aware of a wide variety of both European and American fountain compositions offering inspiration for greater exuberance and power. In a special sculpture number of *Art and Progress* published in early 1913, Taft's contribution was an article entitled "Fountains" where he displayed a wide-ranging knowledge of the topic. His descriptions included many examples, extending from staid Italian pools and "dribbling dolphin-fountains" to the "tumult of Bernini," the "spectacular" MacMonnies fountain at the Columbian Exposition, and "grandiose" works by the likes of Charles Grafly and Philip Martiny

"UP AND DOWN IN THE MOUNTAIN OF TOSSING
WATERS THE BOAT RODE BRAVELY"

36. "Up and down in the mountain of tossing waters the boat rode bravely."
Illustration by August Abelmann of *John Dorn, Promoter,* by Charles Eugene
Banks, (1906). Abelmann's image of the lake in this illustration—together with
that of Banks's novel—better characterizes popular views of Lake Michigan than
the impression offered by Taft's *Fountain of the Great Lakes.*

at the later Buffalo and St. Louis fairs.[42] Moreover, his personal files
contained a cover from an 1892 issue of the illustrated Chicago
weekly, the *Graphic,* featuring a photograph of Bitter's *Water Un-
controlled,* an allegorical group created to serve as one in an
alternating series of "controlled" and "uncontrolled" compositions
flanking entrances to the Administration Building at the Columbian
Exposition.[43] Bitter's group presented the wild, untamed power of
water with a dynamic, interlocking series of figures punctuated by
violently thrusting waves and arranged in a steep-sided triangular
configuration culminating in the straining gesture of a skyward-
reaching Neptune. Had Taft been looking for clues to a more active

Great Lakes group, he surely possessed an ample supply in works he wrote about and knew well.

Yet while he was fully aware of a wide range of possibilities, Taft's decision in this case reflected his long-standing preference for public sculpture possessing a quiet dignity. Indeed, here and elsewhere this preference appears to have outweighed considerations of subject in the sculptor's mind. Later in his career in response to another commission involving very similar issues, Taft defined his outlook quite clearly. Called in as one of several artists to produce sculpture for the new Louisiana State Capitol in the early 1930s, he eventually completed two large groups entitled *The Patriots* and *The Pioneers* to flank the main entrance to the towering structure designed by Weiss, Dreyfous & Seiferth.[44] Also under discussion in 1931, however, was a major fountain tentatively called "The Father of Waters," which became a subject of considerable disagreement between Taft and architect Leon C. Weiss. In February of that year Weiss initiated the debate with a letter responding to the sculptor's proposals for all three major sculpture groups then underway in the Midway Studios. Although he had an assortment of constructive criticisms for Taft's two entrance groups, Weiss came down firmly against the sculptor's plans for "The Father of Waters," claiming that the quietly playful character of Taft's proposed group missed the major "thoughts" behind the fountain concept; the architect called instead for a work presenting the Mississippi as "a mighty master, leading its train of subsidiaries—dashing madly down toward the sea," yet mastered by the "brave and conquering people" populating its banks.[45] Taft responded frankly that he could muster little sympathy for Weiss's ideas. The traditional image of the "quiet river god" was far more appropriate, Taft explained, adding he would always feel "sculpture is the static, the 'hint of eternity'; violence does not appeal to me."[46] When Weiss returned with a second lengthy explanation of his ideas, suggesting that having "lived behind the banks of the Mississippi River through almost half a century" gave him a rather well-informed perspective, Taft responded by expressing hope an upcoming visit would allow them to reach an agreement, but regretfully concluding, "I am afraid that my ideals of a static monumental art may make it impossible to satisfy you."[47]

If the debate regarding imagery to represent the Great Lakes

never reached such an articulate level, it was apparent that Taft's characterization was viewed skeptically by many. Monroe was not the only one to make reference to an unsettling disparity between the beautiful figures and the spirit of the lakes they personified. The morning of the dedication, Chicago's *Daily News* offered a perfect indication of the problem with a photograph running the full width of the page over a short announcement of the afternoon's ceremonies. The picture was actually a photomontage, juxtaposing Taft's *Fountain of the Great Lakes* with Lake Michigan: centered was a photo of the sculpture, cropped to an inverted *T* displaying the figures above the broad base of the pool; to either side of this view of the new fountain were photos of the lake itself, crashing violently against a battered breakwater and throwing spray to heights seemingly greater than the sculpture at center. Scale, cropping, and composition were clearly intended to offer a humorous relocation, bringing the ladies and the lake together for comparison—and captioning completed the message. The headline over the photograph pronounced the fountain ready, adding that the lake was "In a Spirited Mood Coincidentally"; a longer caption below reinforced this message, explaining that while Taft's work was set for the event, "old Lake Michigan, which one of the five figures symbolizes, artistically embellishes its shore line by flashing its waves high and pompously over the breakwater, with its well known vigor, as if to celebrate the importance of the occasion."[48] Although obviously lighthearted in tone, the description of the "old" lake, "flashing" with "well known vigor" against the breakwater provided a far more easily acceptable image of the Great Lakes than that projected by Taft's elegant, graceful young women serenely going about their business of trickling water from shell to shell.

In addition to problems with the general character of the group, many viewers had difficulty with the appearance of the individual figures of Taft's fountain. Geographic associations and questions of appropriate spirit, for example, were not the only identity issues surfacing with the young ladies Taft created. Also troubling to some who observed them at the time was the matter of the human "type" Taft represented. The sculptor himself acknowledged one level of this problem during his dedication address when reporting that certain viewers believed his figures were, "or should be,"

American Indians; the idea had occurred to him, he went on rather chauvinistically, but was "never seriously entertained, since the Indian type of womanhood is hardly our ideal, while a classic Diana in moccasins and feathers, a prettified, characterless Indian is no longer acceptable in art."[49]

Less easily answered, however, were other objections to the kind of figures Taft had modeled. At a time when the Gibson girl represented a natural "new woman" in the American imagination, and the former attraction of voluptuous beauties like Lillian Russell had given way to an appreciation for the more athletic image of Lillie Langtry, Taft's figures could seem quite misproportioned to some viewers.[50] While writers like Browne found them "beautiful female figures of ample form and dignity," others disrespectfully proclaimed them "packing house ladies."[51] And when coeds from Grinnell College or members of Chicago's Kendall College of Physical Education assumed the poses of Taft's fountain figures in "living sculpture" exercises, the difference between modern young women and the bronze statues Taft had created was even clearer. The former seemed but faint echoes of the more substantial bronze prototypes as they took their poses, demonstrating beyond doubt the extent to which the more active, energetic lifestyle of modern American women made Taft's figural types seem dated.[52]

Moreover, an even more obvious difference between Taft's fountain figures and the young women participating in "living sculpture" exercises involved their respective clothing. While coeds and physical education students performed their exercises fully clothed, the abundant draperies of Taft's composition were deployed more as a means of reinforcing the visual flow of form than out of any special concern for modesty. In fact, three of the figures in the fountain composition were modeled nude from the waist up—grounds for further objection in Chicago. Taft had actually encountered problems along these lines earlier when his students' "Nymph Fountain" had appeared on virtually the same spot in 1899. People like Mrs. Susanna M. D. Fry of the Women's Christian Temperance Union and Mrs. Catherine Waugh McCulloch of the Civic Federation's Social Purity Committee voiced both general objections to the public exhibition of nudity and specific criticisms of the nymphs, which Fry charged were modeled in a state of

37. "Living sculpture" exercise: "Fountain of the Great Lakes." Students from the Kendall College of Physical Education at their summer camp at Powers Lake, Wisc., n.d. Taft Papers, University of Illinois.

undress more for the "sake of nudity than for the sake of art." [53] In March of 1913, however, a reproduction of Paul Chabas's *September Morn* (1912) generated even more attention when confiscated by police as "lewd and indecent" after they discovered it on display in the show window of a Wabash Avenue gallery. A colorful court case with testimony by police, a local school superintendent, a Roman Catholic priest, and several critics, art dealers, and collectors finally settled the matter with a verdict denying that the nudity of the young woman in the picture made it indecent.[54] Yet such a stir was created by the case that Mayor Carter H. Harrison went to the Chicago City Council ten days later with a proposed amendment to the municipal obscenity law, expanding the existing ban on sale of indecent materials in order to preclude future exhibition "in any place where the same can be seen from the public highway or in a public place frequented by children which is not connected with any art or educational exhibition, any picture representing a person in a nude state." [55] That such an extreme—and dubious—ordinance could pass with the council's unanimous approval indicates the seriousness with which Chicagoans viewed the matter.

When the *Fountain of the Great Lakes* was set in place just over three months after passage of Harrison's amendment, the partial nudity of Taft's bronze figures was far less revealing and therefore less objectionable than that of the fully nude young woman of Chabas's painting. Nonetheless, the new figures facing Grant Park at the side of the Art Institute still raised questions regarding the propriety of such public art and the city's responsibility for controlling it. Shortly after the official dedication, the *Tribune* finally broached the subject in a special article treating the matter with a general good humor yet suggesting the gravity of the problem it posed. The feature covered a full page, dominated by a large color drawing of a Chicago police officer about to throw a blanket over one of the lower figures of the fountain: above, a banner headline asked "Will Police Suppress Chicago's September Morn?" The text was clearly not in sympathy with those behind the new obscenity law, and after reviewing the *September Morn* incident, suggested some of the difficulties of enforcement and judgment, concluding that a "streak of over-accentuated puritanism" in some public

censor could have serious consequences for important works like Taft's.[56]

Recognizing immediately that the article was by no means unfriendly, Taft joked openly about the matter a few weeks later in a public address. The sculptor told his audience of Chicago businessmen that the *Tribune*'s use of a "colored cartoon" and light tone only demonstrated that the subject of nudity in public art was so thoroughly exhausted it required eye-catching presentation to attract any attention at all.[57] Yet the very fact that the problem had emerged again is evidence of just how tenacious a hold was maintained by those who would serve as watchdogs protecting Chicago from such immoral imagery at the time. Even in 1913, attitudes in the American Midwest were worlds apart from those of sophisticated Parisians, and while tame paintings like *September Morn* could provoke scandal, monumental bronzes like the *Fountain of the Great Lakes* were by no means immune to criticism on moral grounds. It was simply one more way in which Taft's figural group proved disquieting and dissatisfying—one more area of weakness in his overall support.

Far more problematic than these scattered criticisms of his *Fountain of the Great Lakes*, however, was the public response to that vast program of bridges, fountains, and statuary Taft proposed to beautify the Midway. While questions regarding the identity and propriety of the *Great Lakes* were largely a nuisance diminishing only slightly the gratifying overall approval he felt for his work, Taft's Midway proposal faced far more widespread and serious opposition. In the early stages there were merely questions and some reservations regarding the subjects he proposed for his program; but soon queries and doubts turned to more solid and at times even scornful criticism. And as he worked on his special project through the years, Taft's role changed accordingly. Initially an enthusiastic City Beautiful advocate who sincerely believed he had a wonderful gift for Chicago and offered his Midway plan with confident pride, he gradually became more and more defensive, feeling compelled to respond to specific criticisms with specific answers and explanations. In the end there was a note of bewilderment in Taft's discussions of his unfulfilled plans; having com-

mitted himself to his project and done so much to develop it, he was unable to understand events that caused early public interest to give way to skepticism, opposition, and finally indifference.

Among the first to warn Taft of possible problems with his scheme for the Midway was none other than the real dean of Chicago beautification, Burnham himself. In the spring of 1910, as the sculptor was publicizing his project with greater intensity and enjoying considerable attention in the Chicago press, Burnham wrote him privately expressing reservations. The architect no doubt appreciated the fact that Taft's ideas stemmed from his own suggestions for beautification of the broad parkway connecting Jackson and Washington Parks, and he explained at the outset that the general Midway scheme was appealing. The problem had to do with what Burnham termed the "architectural possibility" of Taft's plan: the number and variety of proposed elements seemed to Burnham to lack the "solid, consistent mass" required in such a broad space, preventing the work from achieving a necessary unity and causing only visual confusion. Burnham's criticisms were made softly, objections qualified as "purely architectural" and cushioned by compliments and good wishes for the sculptor's ultimate success with a plan for the space. Nonetheless, it was clear he felt Taft's proposal failed to demonstrate a proper sensitivity to the full range of problems requiring attention in such a scheme. In closing he warned the sculptor of the need for more than "continuity of poetic ideas" in devising a fully comprehensive program of beautification.[58]

Others, however, were critical of those "poetic ideas" as well. One source noted, for example, that "many people" felt Taft's selection of great men to be honored in his Midway Hall of Fame ill-advised; his claim that he wished to achieve "sequence in decoration" with his list was not a sufficiently strong argument for those who found the likes of Aristophanes, Buddha, Copernicus, Demosthenes, Giotto, Pindar, Spinoza, and Zoroaster altogether too obscure and distant from twentieth-century Chicago.[59] Surprisingly enough, one of the most outspoken critics of Taft's alleged insensitivity at this stage was the sculptor's friend and fellow member of the Little Room, Roswell Field. In a humorous but biting *Chicago Examiner* piece, the novelist took Taft to task for failing to recognize how foreign his ideas were to Chicagoans. Like others, Field

challenged the sculptor's judgment in choosing heroes for his pan-theon, claiming that "local talent" like Theodore Thomas and Jane Addams were just two of many far more appropriate than the vast majority selected by Taft; the sculptor's list, Field predicted after considering the preponderance of names from antiquity, would make the Midway attractive only to "Greek fruit peddlers and stand keepers" flocking there to glory in the "fame and achieve-ments of their ancestors."[60] But Field also criticized Taft's ideas for the fountains at either end of the parkway. Basing the "Fountain of Creation" on an ancient Greek myth "when we have a goodly number of first class myths of our own" was to the novelist inex-plicable; likewise, plans to use an "everlasting human procession" for the proposed *Fountain of Time* was equally mystifying when "every schoolboy knows that creation and time, as they apply to Chicago, began back in the nineteenth century, and that real his-tory has been humming ever since." "Mr. Taft has his residence on the South Side," Field informed his readers, "and there is a popu-lar apprehension that he has fallen under the malignly pedantic influences of the University of Chicago."

Field was actually enjoying himself as much at the expense of narrow-minded local critics as that of Taft when he wrote his *Examiner* assessment of the Midway plans. Although he claimed to be drawing his ideas largely from an "observant art critic" who had "walked, trotted and galloped through all the art sections of Europe," his obviously slangy colloquialism gave the impres-sion of man-on-the-street candor and common sense, as in his response to Taft's Hall of Fame list: "Great people these, doubtless, in their day and generation, but—to borrow from a darling West-ern statesman—'What have they done for Butte?' Why should we squander our thousands and hundreds of thousands to assist in the perpetuation of the fame of men who have never heard of Chicago and who have no established genealogical or historical connection therewith? This is a poser."[61] Yet however clear the parody of local prejudices and opinions carried by Field's fatuous observations and folksy tone, there was nonetheless a message for Taft in these comments as well. The idea that much of the sculp-tural program proposed for the Midway would be well beyond the understanding or appreciation of most Chicagoans came through even more clearly when Field dismissed Thucydides, Euripides,

Bach, and Molière as "a lot of dead, hence unappreciative, foreign-
ers"; and when he went on to call for "useful and commemorative
education" involving "historical lessons" telling of the Fort Dear-
born massacre, the Chicago Fire, and the Columbian Exposition
as answers to "the carping stranger who says that we have no
history," Taft could stand warned.[62]

After the initial flurry of objections when Taft began his seri-
ous publicity program in 1910, the interest of his critics waned
for some time; as long as the proposal was only that, it seems,
opponents saw little reason to continue their campaign against
Taft's ideas. However, in early 1913 when the sculptor suddenly
received his official commission for the *Fountain of Time* and
simultaneously announced plans to erect eight-foot plaster models
of some of the proposed figures for the Midway Hall of Fame,
critics again emerged.[63] The *Tribune*, for example, pointed out that
Taft "could hardly propose more masterfully," but lamented that
the sculptor's "courage excels his discretion," for although indus-
trious and talented, Taft was simply "not a Renascence." In their
estimation, the Midway proposal involved an unfortunately exces-
sive scheme presenting the "judicious Chicagoan" with cause for
alarm: "The setting up of 100 statues of 'musicians, authors, drama-
tists, poets, sculptors, and painters'—really, Chicago, with all her
naive errors, deserves nothing like that!"[64] New York's *Evening
Telegram* apparently agreed fully that the scheme was magnilo-
quent in tone and incomprehensible in detail—and they delighted
in the prospect of Chicago's embarrassment. As an editorial in that
paper explained, they felt Taft should "go to it," and as he collected
discarded World's Fair statuary or whatever other odd works he
needed for the project, "if there's any lackage there's a bunch of
Shakespeares, Bobby Burnses, Mendelssohns and others lining the
Mall in Central Park we might send on to help out."[65]

But the real storm broke in the fall after the dedication of the
Fountain of the Great Lakes when longtime supporter Harriet
Monroe had a sudden change of heart and emerged as Taft's most
public and potentially damaging opponent. The reason for her new
position at that point is not entirely clear, but that it represented
a dramatic turnabout is undeniable. As late as mid-June, Monroe
reported having seen a partial model of the *Fountain of Time* and
was enthusiastic about the work; although only a fragment and

but one-third scale, she pronounced it "nothing less than stupendous, a sculptural interpretation of human life big enough to meet the challenger [*sic*] of this age of vast things—of locomotives, turbines, battle ships, gigantic skyscrapers—all the huge and powerfully modern engines of war and peace."[66] Yet by mid-November she reversed her opinion, explaining that on the matter of Taft's latest project she could "only confess herself in doubt."[67]

The reevaluation may have stemmed from disappointment over the final appearance of the *Fountain of the Great Lakes*. Although she noted just after the dedication that her criticisms of that work were only "slight and personal exceptions," she did cite a puzzling "hint of plaintiveness, of solicitude" in the figures' expressions together with a slight rigidity in modeling as features that kept them from conveying the "free wild spirits" of the lakes.[68] A more immediate reason for her November reservations regarding the second fountain, however, was the exhibition of Taft's partial model at the Art Institute that fall. Given the opportunity to study it there more carefully than earlier in Taft's studio, Monroe perceived problems. As she reflected that the proposed work would require a vast sum of money for completion, necessarily tying up the income from the Ferguson Fund for several years, those problems were magnified. "No committee should be left to decide so momentous a question alone," Monroe finally concluded. "Its counsels should be reinforced by those of connoisseurs, amateurs, and the plain people; for it is only when the artist and his patron are so supported that a noble result may be hoped for in any art."[69] To accomplish this, she called for a special "symposium," asking readers to send their opinions in order that she might use her column to air "the pros and cons in the matter" and thereby help shape policy with regard to use of the Ferguson Fund in this instance.[70]

Taft wrote Monroe immediately, thanking her for her concern and expressing his most sincere interest in her findings, but the result of her survey was predictable before any amateur critics put the first word to paper—and it was certainly not to be a result favorable to Taft.[71] In the very terms of her initial call for opinions, Monroe defined nicely many areas for possible objections to the *Fountain of Time*. She asked viewers to think seriously of the financial commitment, indicating it to be in the neighborhood

of three to four hundred thousand dollars, draining income from the Ferguson Fund for at least a decade; she reminded them that poetry of concept was not sufficient in a public monument without a proper consideration of "sculpturesque values," and then went on to offer several ideas of ways in which a work might fall short of the mark on that score; she suggested comparisons with great works from Egypt, ancient Greece, and Renaissance Italy; and she mentioned as well other noteworthy contemporary sculptors like Rodin and Saint-Gaudens who might be regarded as yardsticks against which to measure Taft. Although posed as a means of obtaining an objective reading of public opinion, her agenda was quite clear from the outset; she was providing opportunity and suggesting criteria for criticism.

If there was any doubt as to her intentions, they became even more clear with her first report of opinions one week later. Response that first week was apparently not overwhelming; beyond Taft's brief letter of thanks, Monroe had only two others she felt worth sharing with the public. One followed her lead in condemning the expenditure of so much money on "one narrow, egregious scheme" and suggested instead funding for several smaller works to allow a more natural "art evolution" in the city; the other used her comments on "sculpturesque values" as a point of departure, suggesting that even such visual qualities could not save a work that was incomprehensible, and expressing the fear that Taft's *Fountain of Time* was just that. Yet Monroe did not restrict her report to those few written assessments actually reaching her desk. Following the letters, she related a conversation she enjoyed that week while viewing the fountain fragment on display at the Art Institute. Her companions remained anonymous, identified only as "an architect, a painter, and a scholar"—and all three found fault with the proposed work. The architect felt Taft's fountain lacked sufficient presence to stand as an adequate visual terminus for the long Midway space; the painter claimed it devoid of "sculpturesque form" and predicted it would not be at all effective when enlarged; and the scholar believed it unfortunately "metaphysical" in subject and better suited to a cemetery than a public pleasure ground.[72] Mixing reports of private conversations so closely with the public letters she received was of course a questionable practice, directing the findings of her "survey" some-

what more than some may have found legitimate, but it is clear that opposition to Taft's work was coming to the surface following Monroe's prompting.

Other responses reinforced and expanded the first criticisms. In less than a month the picture of public opinion regarding Taft's *Fountain of Time* was well established. There were a handful of favorable comments—and one uncomfortably earnest letter of praise from a young man who described himself as "just awakening to the beautiful in the sculptural expression of art"—but on the whole Taft had good reason to be shaken by what he read in Monroe's weekly column that fall. The fountain was criticized for both visual and conceptual deficiencies, described as something unable to "carry" in silhouette and termed "trifling" in meaning; artists and public alike objected to the heavy commitment of funds required to see such a vast project through to completion; and one observer noted that the choice of Taft over possibilities like Rodin reflected a distressing application of merely "local standards" to a decision more aptly made on the basis of "world standards."[73]

Through it all, Taft maintained a magnanimous public image, receiving all criticisms well and refusing to be angered in any way by the developments of Monroe's column. When a friend wrote at one point to inquire whether there was anything he could do to "smother some of the unjust criticisms," Taft returned with the observation that "Harriet is not bothering me much. She means all right but was laboring under a misapprehension. The fact is that my contract calls for precisely the thing that she was crusading about, i.e. the making and exhibition of the full size plaster model in place. So it is up to me to make good. The work is going well and I am more enthusiastic and more confident than ever. A little judicious opposition now and then helps some natures you know."[74] Exactly how much of this was true and how much mere bravado is difficult to tell, but Taft could hardly have believed Monroe unaware of requirements for a preliminary plaster model. Even if he had by some chance missed her column in June explaining just that fact to readers, terms of the contract were so well reported earlier that no interested party could have overlooked that point.[75] Whatever the case, it seems the sculptor had just decided to continue along his normal course, promoting his work wherever possible and creating the *Fountain of Time* according to

original plans without regard for any criticisms of its appearance or placement.

Yet as his work progressed, it was clear Monroe was by no means the only one losing enthusiasm for Taft's sculpture. Trustees from the Art Institute came to inspect the scale model in progress in Taft's studio late the following year and found fault with both the silhouette of the group and the modeling of individual features; Howard Van Doren Shaw, the architect responsible for designing a base and pool for Taft's fountain, agreed with their criticisms and added to them his own reservations regarding the general curve of the composition and even the number and identity of some of the components.[76] The sculptor's response went unrecorded at the time, but his preparation of the work seems to have been unaffected. In May of 1915 his twenty-foot model was accepted by Ferguson administrators, and with their approval Taft went ahead with enlargement to a full-size plaster obviously based closely on the small preliminary models.[77] By early 1918 South Park Commissioners granted official permission to erect the temporary plaster fountain on the west end of the Midway, just inside Washington Park, and after a slight delay caused by Taft's wartime service with the YMCA abroad, it was finally assembled in the late summer of 1920.[78]

When the plaster model of the *Fountain of Time* finally appeared, then, over seven years were elapsed since issuance of the original contract, and as many had predicted, official opinion regarding Taft's ideas had changed in that time. Although the sculptor investigated costs of marble, granite, and even bronze, the trustees' enthusiasm for his project was greatly cooled and little more serious consideration was given the notion of allocating the hundreds of thousands of dollars required to complete the composition in such materials.[79] Rather than the fine Georgia marble of Taft's original specifications, the trustees could finally only be persuaded to fund casting of the enormous group in concrete—a compromise at best. John J. Earley, a Washington, D.C., contractor with a reputation for cast concrete architectural work, was brought in to undertake the project, completing his work by the fall of 1922.[80]

The official dedication of the concrete *Fountain of Time* finally

38. Taft's *Fountain of Time*, concrete, 1922. Taft Papers, University of Illinois.

occurred on November 15 of that year, but it was not the grand affair staged nine years earlier for Taft's *Fountain of the Great Lakes*: Hutchinson was too ill to attend and had to be replaced by Frank Logan, whose praises of Ferguson seemed merely conventional; Taft's expression of gratitude seemed likewise pro forma after airing so many times in the past; and although one newspaper claimed "Throngs Attend Dedication of Big Outdoor Statue," photographs accompanying the article showed a sparse crowd made to seem even smaller by the vast space of the Midway.[81] Perhaps the most telling note, however, was a brief comment Taft made during his dedication address. After offering his thanks for the honor of a second Ferguson Fund commission, he ventured the opinion that such opportunity was all anyone could ask: "I have been tendered every possible assistance, and if I have failed it is my own fault."[82] In Taft's 1913 dedication address there had

been ample expression of the sculptor's modesty and humility, but never even a remote hint of possible failure; by 1922 failure seemed somehow more possible—and in the case of his Midway dreams even probable. His original plans had been criticized heavily, his *Fountain of Time* was completed but not as envisioned, and there appeared no opportunity for the remainder of his vast scheme to find necessary support. A turning point had been reached and passed.

As is so often the case in such instances, the change in Taft's fortunes was due to a regrettable but unavoidable combination of external circumstances and personal goals. In the first place, the sculptor was in his early fifties when he received his commission for the *Fountain of Time*, and in his early sixties when that portion of the Midway project was finally completed, leaving him free to turn to the next stage of his scheme. His age would perhaps not have been a factor at all at some other point in history, but with changes occuring so rapidly in early twentieth-century art, the sculptor and others of his generation and training found themselves quickly overtaken and passed by younger artists adopting newer directions. Taft was very much a product of the nineteenth century; however he might have attempted to address future generations with his messages, his ideas and work recalled to observers the glories of the Columbian Exposition and the values represented there.[83] Exacerbating that problem, however, was the sculptor's attempt to impose what he believed a proper distance between his work and any contemporary distractions or influences that might jeopardize the integrity of his creations. Although conceived as a means of allowing him to achieve a true timelessness, this effort only further removed Taft from his context in twentieth-century Chicago.

Some evidence of their datedness may be perceived in reactions of Taft and his entire circle when faced with the emergence of more insistent forms of modern expression. Naturally, they believed themselves sufficiently modern in outlook and felt their work an appropriate reflection of modern life. When James Spencer Dickerson reviewed the 1908 Chicago Society of Artists exhibition, for example, he deemed the work of his friend Taft and the others "essentially modern," claiming it "exemplified the

art of our own time" and "was made by men and women alive to the poetry, the romance, the intimate life of the present hour."[84] Yet as more contemporary observers have pointed out, many of those constituting the established creative community of Chicago experienced a serious and growing sense of shock in the face of accelerated changes in American culture and art after the turn of the century.[85] Garland, for example, was always an active, vocal advocate of art capable of serving as an effective response to American life, but he refused to believe that the more strident forms of modernism emerging in sources like Harriet Monroe's *Poetry* magazine might be achieving just that.[86] Fuller, for his part, served as proofreader and member of the advisory board of *Poetry*, but remained steadfastly critical of the spare, harsh appearance of modern architecture in his city.[87] And as early as 1910 Taft told a joint meeting of the American Academy of Arts and Letters and the National Institute of Arts and Letters that recent sculpture suffered from the bad influence of those who failed to place sufficient importance on traditional values: "In place of a self-respecting art worthy of its ancient lineage, we find in Paris to-day the puerile effronteries of Matisse and of Maillot [*sic*], delighting in their very ineptitude a public avid of new sensations. Realism and unbridled cleverness have run their course, and the jaded critics find refreshment in willful bungling and pretence of naiveté."[88]

At base, the inability of Taft and his colleagues to accept many of the new developments occurring around them reflects what Warren I. Susman has identified as the widespread early twentieth-century conflict between ideals of "character" and those of an emerging cult of "personality."[89] Character, according to Susman, was largely a nineteenth-century concept of identity involving general notions of allegiance to established moral codes and traditions, coupled with a strong sense of duty to others. Taft and his circle were devout believers in time-honored aesthetic, ethical, and moral values; they viewed the opportunity to serve through their work as a matter of utmost importance and saw no reason to seek new freedoms from those traditional values informing the development of western culture for so many centuries. The new twentieth-century cult of personality, on the other hand, is in Susman's account an attitude placing the highest premium on unique qualities capable of establishing the individual's identity as some-

thing quite distinct from all others. This naturally led to the rejection of many traditional values by younger artists more eager to express their selfhood than they were to fall into step behind leaders of earlier generations. Of course, as an explanation for the many new styles and directions of early twentieth-century art, this is a rather simplistic theory; yet insofar as it offers insight into the basis for the growing hostility between conservators of tradition like Taft and younger generations pulling increasingly away from those same traditions, Susman's assessment is helpful. The conflict was not only one of style, it was a matter of worldview.

And the conflict came through most clearly in Chicago in early 1913 when the International Exhibition of Modern Art arrived at the Art Institute fresh from its scandalous run at New York's Sixty-Ninth Infantry Regimental Armory. The Armory Show, as it has since been known, opened in Chicago on March 24 and ran through mid-April.[90] Influential members of the Art Institute had arranged to have it shown at that institution over objections of Director French, and when the Chicago public finally saw the Fauvism, Cubism, and other aggressively modern styles assembled for the show, their response was by all accounts even more overwhelmingly negative than that of the New York audience before them.[91] Among the most vocal in their condemnation of what they saw in the galleries were Chicago artists, many of whom devoted considerable energy to lectures warning both public and students of the evils of the new work. After touring the shocking exhibition during the first day of public admission, for example, Browne told a capacity audience in Fullerton Hall that such work should by no means be taken seriously, for it was only a case of art "trying to prove ITSELF by ITS own ITNESS"; he then went on to tell tales of the artists, focusing on van Gogh's insanity and suicide, the depravity of Gauguin's South Seas life, and Matisse's alleged claim that the daubs of his young child were masterpieces.[92] Clarkson, too, spoke to general audiences of the madness of the new styles, while at the same time pleading with his students to avoid the temptations of seductive color and easy techniques as means to quick fame.[93]

The most extravagant of the many events showcasing the scorn of Chicago artists, however, was a special "futurist party" sponsored by the Chicago Society of Artists and held at the Art Institute

just two days after the Armory Show opened. The room where the event was held was decorated with an assortment of "futurist pictures" sporting titles like "Chicago Artists Going to Hell," "Stewed Descending a Staircase," and "Ace and Ten Spot Surrounded by Nudes"; "futurist costumes" featured women with excelsior and wood shavings fixed in their hair, men wearing suits of shingles, and many with lavishly applied greasepaint makeup.[94] The highlight of the evening was what one report called a "Cubist spasm":

> Twelve stalwart Indians, all with their feathers and paint, and dressed in what were made to look like cube gowns—squares of cardboard fastened together, and held up by hand—entered the hall and marched around the place with their war whoops. Miss Magda Heuermann and her Cubist dog Fido, which ran on wheels, brought up the procession. The orchestra played:
>
> > "I live in a madhouse over on the hills,
> > And I play in the meadows with the daffydills,
> > I'm going crazy—don't you want to come along?"[95]

Descriptions of such a fanciful occasion make it seem in retrospect like something of a precursor to the Dada events occurring only a few years later, but of course intentions in Chicago were vastly different. Faculty, students, local artists, and others who participated in the high jinks of this "futurist party" at the Art Institute were merely adopting the most bizarre behavior they could imagine as a means of staging a hilarious parody of works by artists who seemed so entirely beyond the pale as to be utterly ridiculous.

Despite their ridicule, however, the appearance of the Armory Show in Chicago did at least identify the existence of new directions with which many had been unfamiliar. It is doubtful that Alson Smith was later accurate in claiming that the show "launched the Post-Impressionist school in Chicago," but it did help establish the word "Postimpressionism" in the local vocabulary.[96] Moreover, the mere fact that artists like Browne and Clarkson felt compelled to protest the work so vigorously suggests the threat they felt by its presence in their midst. Some of their obvious consternation may have been caused by the fact that, like Taft, they had discovered on return visits to their beloved Paris that old idols had been "replaced by strange gods" of modernism.[97] That such an unsettling transformation could be occurring even in so revered

an art center was no doubt difficult for them to understand and made their own positions at home seem strangely vulnerable. And on the home front, there is evidence that many of the group had grown increasingly aware of their age and sensed they were no longer the city's rising artistic community. Garland later recalled a by then rare evening party of the Little Room that happened to occur in the Fine Arts Building at the very time the Armory Show was on view across the street in galleries of the Art Institute. Those assembled, Garland later reflected, were "mainly elderly folk" who "danced old-fashioned dances" and took turns entertaining each other with old songs like "The Rolling Stone." Even at the time, he was distinctly conscious of the homely "borderland simplicity" of the group, pronouncing their lifestyle "amazingly rural," their amusements "monotonous."[98]

These decorous—and for Garland always sober—activities made the "elderly folk" of the Little Room appear positively antiquated to many of their younger colleagues in the city. Youths like Dreiser's Eugene Witla were at the time arriving in Chicago with great dreams of the artist's life as something entirely out of the commonplace; to assume the role of the artist was "to live in a studio, to have a certain freedom in morals and temperament not accorded to the ordinary person."[99] With such freedoms, young artists could pursue new directions, finding the personal distinction they sought. Yet the older artists of the Little Room seized few of these freedoms. They did seek a modest distancing from contemporary society, but less to enable the assertion of self than as a means of ensuring that traditional values would remain untainted by influence of modern tastes and fashions. And in keeping with this attitude, the behavior of the group was unusual but quite moderate. Although Garland may have been extreme in his complete abhorrence of alcohol, most of the group distrusted anything smacking of "Latin Quarter mannerism"; a touch of rum was occasionally reported to have found its way into the Little Room samovar, but that was generally as close as the group ever came to bohemian debauchery.[100] Gradually, the conservative standards, prosaic entertainments, and slower pace of the group made them appear increasingly unappealing to younger artists, and the Little Room circle weakened as its numbers declined.[101] Taft, of course, had his colony of sculptors working in the Midway Stu-

dios, but compared with the likes of Manierre Dawson, Stanislaw Szukalski, Rudolph Wisenborn, and other modernists gaining attention in the city, his Chicago "school" of sculptors was of little Chicago "school" of sculptors was of little real consequence.[102]

The clearest evidence of Taft's datedness, however, may be seen in the very nature of the sculpture he planned and produced for modern Chicago. At a time when the raw strength of the city was fast becoming a compelling inspiration to many of the younger artists outside his immediate circle, Taft and his school continued to work as if twentieth-century Chicago were something to be resisted, its appearance and character transformed. Taft attempted this by designing sculpture he believed capable of carrying timeless themes and traditional imagery into the open spaces of the young metropolis, hoping the example of such work might stimulate development of proper values and appropriate traditions among local citizens. To his immense disappointment, responses never met expectations. When the Midway scheme failed, it was quite apparent he had been wrong in his basic assumptions about what was wanted by his fellow Chicagoans, and in the mid-twenties when the *Tribune* identified his *Fountain of Time* as one of its "pet atrocities" in the city, it seemed possible Taft had even been incorrect in estimating what his city needed. The article indicated that the fountain was selected for "atrocity" status in part simply because of its ugliness; one critic, the paper pointed out, claimed the curving row of white figures looked unfortunately like false teeth smiling across the end of the Midway. But beyond that, the article proposed that Chicago possessed a distinctive character making such work seem hopelessly pretentious and inappropriate. "Like a stripped fighter," the *Tribune* concluded, "Chicago is beautiful when it doesn't mean to be. No city can surpass it. But when Chicago tries, 'dolls up' and decorates, the result too often is sad, if not atrocious."[103]

As important as it was, however, such clear datedness was not the only problem facing Taft. Beyond the differences in generational perspective and the new alienation it promoted was the matter of the self-imposed distancing the sculptor and his circle had always felt so crucial. As they sought to minimize potential distractions of contemporary American culture, they also reduced the possibility for any more positive influence from the normal

course of American life. Their intentions were of course laudable in the abstract, but as applied the result was often an enhancement of traditional ideals at the expense of meaningful contemporary values. Roswell Field grossly overstated his objections to Taft's Midway plans when inquiring why "good Illinois money" should be spent on "classic myths" and images of "dead, hence unappreciative, foreigners," but the impulse behind the question had a certain legitimacy.[104] Taft's ideas were frequently beyond the ability of most Chicagoans to grasp from the appearance of the sculpture he proposed; but even if understood, the values underlying the work were in many cases unrelated to anything those viewers might have felt important. Although hoping to achieve a "hint of eternity" by eliminating anything relating too closely to his own time, Taft often succeeded only in forging strong links to the past.[105]

A good example of the extent to which the sculptor's total adherence to tradition was at times not only out of keeping with contemporary values but actually in conflict with some of his own beliefs may be seen in Taft's use of female figures as central images in his *Fountain of the Great Lakes*. The figures are obviously employed as the visual and conceptual core of this fountain; they form the mounting pyramidal mass and symbolize the five Great Lakes. Beyond that, they provide the rationale allowing the fountain to function as fountain. The group was adapted from Taft's childhood memories of the Greek myth of the Danaides—sisters ordered by their father Danaus to kill their husbands and then condemned to the unending task of carrying water to a bottomless vessel in Hades. Taft was quick to admit his version involved significant transformations from the original myth: to arrive at his composition the number of sisters was reduced from forty-nine to five, and his new "American Danaides" were made to seem as if "their cruel atonement has become a glad duty, cheerfully performed."[106] The transformation was necessary, however, for the story of the Danaides was merely a point of early departure suggesting a group of female water bearers roughly appropriate to his eventual theme. The resulting five lakes were then arranged to pour water from their shells as a means of symbolizing the ceaseless flow through the Great Lakes and Saint Lawrence into the Atlantic. Yet taking

a classical source as his point of departure—however remote—
allowed Taft his cherished distancing from contemporary issues
and imagery while simultaneously providing a firm base of tradi-
tion lending the work some measure of universality.

Given Taft's Beaux-Arts training, this was a highly natural, even
expected course for him to take; his *Fountain of the Great Lakes*
followed the pattern of allegorical sculpture he knew and appreci-
ated most fully, and was in this respect not at all extraordinary. In
retrospect, however, what makes this remarkable is the fact that
the women Taft presented in this manner become such innocu-
ous images. Serving only as objects whose importance lies entirely
in their physical attractiveness and ability to compose in graceful
combination, the figures curiously seem to refute the very posi-
tion Taft had long advocated in other ways. While the sculptor
developed a reputation for offering strong, consistent, and highly
public support for women's rights, he remained unable to trans-
late his opinions into meaningful statements—or even refrain from
undermining those opinions—in his work.

Taft undoubtedly came by his feminist perspective early, for
his mother was a strong advocate of woman suffrage.[107] Later, in
Chicago, his career placed him in closer contact with the main
figures of the movement when the Equal Suffrage Association and
the Cook County Woman's Suffrage party opened offices below his
studio in the Fine Arts Building.[108] At the same time, Taft's acquain-
tance with many important individuals like Frances Willard, Jane
Addams, Harriet Monroe, and Anna Morgan demonstrated to him
the ability of women as active, contributing members of society,
successful in many different fields. Those who were probably most
impressive in this regard, however, were the young women Taft
instructed in his classes at the Art Institute. Although originally
rather condescending in his attitude toward young ladies he be-
lieved would view his sculpture classes merely as a way to "amuse
themselves," Taft gained a rapid respect for the women students he
encountered, offering more and more enthusiastic encouragement
over the years.[109] By 1892, when put in the position of foreman
directing enlargement of sculpture for the Columbian Exposition,
Taft hired a special crew of young women, giving them the same
opportunity to reap the benefits of unique professional experience

and high salary enjoyed by young men working in the temporary studios at Jackson Park; in at least one case he even helped one of the young women of this crew to obtain separate commissions of her own to design figures for both the Illinois and the Indiana State Buildings.[110]

Taft's sister, Zulime Taft Garland, later recalled that the sculptor had an abiding faith in the abilities of the young women he worked with over the years, always convinced one or another was "going to do something" and always thoroughly discouraged when any would give up her career for the conventional role of wife and mother.[111] And many of those who went through his classes and studio did go on to make their marks in the profession. In 1908 three of the seven women who had by that time gained membership in the National Sculpture Society were former Taft students; a decade later when the sculptor made inquiries in preparation for an article on women sculptors of America, many of the colleagues Taft approached for recommendations responded with lists composed largely of his own former students as the major figures to be included in such a survey.[112] In many respects, then, Taft was in his way just as strong a supporter of feminist ideals as other outspoken male proponents at the turn of the century.

Yet in his work, the sculptor retained a far more traditional view of women as beautiful objects to be arranged in harmonious compositions—a view consciously rejected at the time by other feminists. Taft's fellow Chicagoan Floyd Dell, in the introduction to his 1913 collection of biographical essays, *Women as World Builders: Studies in Modern Feminism*, disparagingly termed this more traditional view mere "woman-worship" based entirely on an unfortunate "spirit of Romance." Characterizing it as an "attitude toward woman which accepts her sex as a miraculous justification for her existence," the young critic explained that such worship ran throughout western thought over the centuries, obscuring women's "wonderful possibilities" as contributing members of society.[113] Dell's biographical studies that followed were then intended to set the record straight, detailing recent accomplishments of several important women as evidence of the real range of those possibilities.

That Taft would have agreed in principle and found the lessons of Dell's studies important is unquestionable—but such ideas did

not extend to his own work. Not that the split involved any conscious slighting of modern women; Taft was in fact doing neither more nor less than the vast majority of his contemporaries by producing work that presented the American woman "pictorially, rather than as a person."[114] In this case, however, the significant gap between the sculptor's personal advocacy of feminist ideals and the total absence of those ideals in his work is striking. What it reflects is the extent of the distancing he sought and achieved. Having determined that the integrity of his work demanded its separation from complexities of modern society, Taft pursued this separation to the point where his sculpture was at times not only safely free from those complexities, but unfortunately adrift from his own beliefs.

This was of course something virtually impossible for a sculptor with Taft's training and experience to detect or avoid at the time; from his perspective, works like the *Fountain of the Great Lakes* were nicely rooted in traditions appropriately dominating western art for centuries. From our later vantage point, however, Taft's inability to bridge the distance he created between his work and its cultural context—even in matters of clear importance in his own life—provides further evidence explaining the decline he eventually suffered. At a time when new directions in art were making significant inroads into his influence, the fact that his work was also incapable of appealing to contemporaries in its message further diminished Taft's importance and success in Chicago. It was not necessarily that his ideas suddenly turned bad or that his work declined in quality; rather, his style merely came to seem dated and his ideals ceased to be compelling.

In 1923, a decade after the dedication of the *Fountain of the Great Lakes*, the editor of the *Christian Century* asked Taft to write an article for their magazine under the title "Why I Have Found Life Worth Living." The theme immediately sparked numerous recollections for Taft, and the piece the sculptor eventually composed ranged widely over a considerable variety of his pet ideas and beliefs, conveying throughout an essentially positive impression of overall satisfaction with life as an artist. Near the end of the article, however, Taft outlined what he called the "working program" he felt had shaped his life: "I hold that as intelligent people we have a

right to: (1) all of the beauty around us, the beauty of nature which most of us never perceive; (2) all of the inheritance of the past, of which we Americans are particularly unconscious; and (3) the talent which springs up perennially but which America's rushing life is wont to extinguish before it takes root." [115]

Although easily passed over in the text of this article because so often expressed earlier in one form or another, Taft's creed has a sad irony to it when forwarded in 1923. The notion that Americans are intelligent and therefore deserving of the beauty, traditions, and new talent possessed by the nation is naturally flattering and something few would have disagreed with. Yet each of the compliments is ultimately undermined by the sculptor's phrasing. Beauty goes unperceived, the past is ignored, talent is thwarted—and any people so insensitive to what life offers can hardly be credited with the intelligence Taft mentions. It is doubtful that he recognized the irony of his list at the time; the sculptor was merely combining in carrot-and-stick fashion what he perceived as attractions and warnings. [116] Yet in light of frustrations and disappointments grown increasingly pronounced in his life by that time, the statement has a poignancy about it when considered today. Taft's vision of beauty had lost most of its adherents in Chicago by the mid-twenties; traditions were in more than one way things of the past in the jazz age; and perhaps most unsettling of all to Taft, the Chicago school of sculptors he hoped to form was not progressing to the attention and support originally imagined. His talent had not been entirely thwarted, but it had never been allowed to take strong root and thrive as he had once dreamed.

Notes

Introduction

1. Lorado Taft, "The Monuments of Chicago," *Art and Archaeology*, 12 (September–October, 1921), 120–27.

2. Ibid., 120, 123. It may be argued that Taft's harsh criticism of Rebisso's *Grant* had something to do with the fact that the latter had received the commission for this monument after a competition Taft himself had hoped to win in 1886.

3. Ibid., 124.

4. Ibid., 120.

5. L[ena] M. McC[auley], "Art and Artists," *Chicago Evening Post*, 11 September 1913, 6.

6. Harriet Monroe, "Chicago Artist Wins Gold Medal at 'Old Salon' in Paris," *Chicago Tribune*, 15 June 1913, II, 7.

7. For the official program, see "Exercises of Dedication of the Ferguson Fountain of the Great Lakes," *Dedication of the Ferguson Fountain of the Great Lakes* (n.p. [1913]), 19–20. A copy of this booklet is in Box 10, Lorado Taft Papers, Archives, University of Illinois Library, Urbana, Illinois (hereafter cited as Taft Papers, University of Illinois).

8. "More Pet Atrocities," *Chicago Tribune*, news clipping dated 6 January 1926, in Box 11, Taft Papers, University of Illinois.

9. Secondary literature on Taft and his career is limited to a mere handful of studies and reminiscences. Nonetheless, one notable indication of a renewal of interest in the sculptor is Allen S. Weller's recent work, including *Lorado Taft: A Retrospective Exhibition*, exh. cat. published as *Bulletin of the Krannert Art Museum*, 8 (1983); and *Lorado in Paris: The Letters of Lorado Taft, 1880–1885* (Urbana: University of Illinois Press, 1985). For other listings, see the Bibliographic Essay.

1. Patronage, Beautification, and Service

1. "Address of Charles L. Hutchinson," *Dedication of the Ferguson Fountain of the Great Lakes*, 35.

2. Ibid.

3. "Gives $1,000,000 for Chicago Art," *Chicago Tribune*, 15 April 1905, 2; "Million for City Art," *Chicago Record-Herald*, 15 April 1905, 3.

4. "Introductory," *Dedication of the Ferguson Fountain of the Great Lakes*, 8.

5. See "Million for City Art," 3; and "Biography," *Dedication of the Ferguson Fountain of the Great Lakes*, 14–15.

6. For more on the Bates bequest, see Ira J. Bach and Mary Lackritz Gray, *A Guide to Chicago's Public Sculpture* (Chicago: University of Chicago Press, 1983), 140.

7. See James L. Riedy, *Chicago Sculpture* (Urbana: University of Illinois Press, 1981), 45–46.

8. "Statues for Chicago," *Chicago Tribune*, 16 April 1905, III, 4.

9. Luis Kutner, "The Case of the B. F. Ferguson Monument Fund," in *Legal Aspects of Charitable Trusts and Foundations* (Chicago: Commerce Clearing House, 1970), 162.

10. Daniel H. Burnham and Edward H. Bennett, *Plan of Chicago* (1909; reprint ed., New York: Da Capo Press, 1970), 121.

11. Kutner, "The Case of the B. F. Ferguson Monument Fund," 162; and John Drury, *Old Chicago Houses* (Chicago: University of Chicago Press, 1941), 191.

12. Chesterwood, in Glendale, Mass., was purchased by French in 1897, the same year he began work on his equestrian *George Washington*. The work was commissioned by the Women of America, an organization who sought it as a gift to the citizens of France. The original was unveiled on 4 July 1900. See Michael T. Richman, *Daniel Chester French: An American Sculptor*, exh. cat. (New York: Metropolitan Museum of Art, 1976), 34; and Wayne Craven, *Sculpture in America* (New York: Thomas Y. Crowell Co., 1968), 399.

Hutchinson's visit to French's studio was a visit not only to the new studio of a famous American sculptor, but to the brother of his Art Institute colleague, William M. R. French. Upon his return to Chicago, Hutchinson was successful in obtaining donations from Clarence Buckingham, E. B. Butler, R. T. Crane, William A. Fuller, Mr. and Mrs. F. T. Haskell, Harlan N. Higinbotham, Thomas Murdock, Byron L. Smith, Otto Young, and Ferguson. See *Annual Report of the South Park Commissioners for the Fiscal Year, 1904* (Chicago: Henry O. Shepard Co., n.d.), 13.

13. For suggestions regarding possible Taft influence in Ferguson's decision, see "Lorado Taft and the Western School of Sculptors," *Craftsman*, 14 (April, 1908), 24; and John Justin Smith, "Sculptors Fight Move to Use Ferguson Million for Building," *Chicago Daily News*, 31 May 1955, 11.

14. "Address of Lorado Taft," *Dedication of the Ferguson Fountain of the Great Lakes*, 29.

15. "Million for City Art," 3.

16. "Gives $1,000,000 for Chicago Art," 2.

17. Lorado Taft, "A Million Dollars for Sculpture," *World To-Day*, 8 (June, 1905), 628–30.

18. Shaler Mathews, "Uncommercial Chicago," *World To-Day*, 9 (September, 1905), 990.

19. Lorado Taft, "Exhibition of Statuary at Art Institute, Chicago," *Sketch Book*, 5 (August, 1906), 450.

20. Students responsible for modeling individual figures in this first version included Nellie V. Walker (Superior), Angelica McNulty (Huron), Clara Leonard (Michigan), Lily Schoenbrun (Erie), and Edith Parker (Ontario). A second student team worked on ten figures for a composition entitled "Funeral Group," no doubt an early version of the cement piece currently on the grounds of the Lorado Taft Field Campus of Northern Illinois University near Oregon, Ill. See "Sculpture at the Chicago Art Institute," *Monumental News*, 14 (August, 1902), 468–70.

21. Hutchinson to Taft, 17 January 1906, Box 10, Taft Papers, University of Illinois.

22. L[ena] M. McC[auley], "Art and Artists," *Chicago Evening Post*, 20 January 1906, 5.

23. *The Art Institute of Chicago: Twenty-Seventh Annual Report* (Chicago: Art Institute of Chicago [1906]), 28. While the catalog for this 1906 exhibition lists only one bust by Taft ("Portrait bust, a painter"—no doubt the portrait of his friend, Ralph Clarkson), a newspaper article describing Taft's success at the show explains that the sculptor's bust of Charles B. Farwell was also on display. See *Works by Chicago Artists*, exh. cat. (Chicago: Art Institute of Chicago, 1906), 29; and L[ena] M. McC[auley], "Prizes at the Artists' Exhibition," *Chicago Evening Post*. 16 February 1906, 4.

24. McC[auley], "Prizes at the Artists' Exhibition," 4.

25. "To Dedicate Gift Fountain of Great Lakes Tomorrow," *Chicago Evening Post*, 8 September 1913, 5.

26. "Art Institute Governors Will Beautify the City," *Chicago Tribune*, 5 June 1906, 11.

27. *The Art Institute of Chicago: Twenty-Eighth Annual Report* (Chicago: Art Institute of Chicago [1907]), 17.

28. In 1897 Lake Front Park was a mere twenty-five acres; by 1906 it was reported that the new Grant Park land reclamation project had nearly reached its goal of filling an area of 202 acres. In the meantime, the firm of Olmstead Brothers had been retained in 1903 to devise plans for several new Chicago parks, including the new Grant Park. The plan they published the following year involved extensive developments for the new park, including construction of the Field Museum and Crerar Library as well as erection of numerous statues and fountains and paving of several formal promenades. Over the following months their plans were continued, leading to the creation of elaborate three-dimensional model of the park and detailed elevations and bird's-eye views of the proposed museum and library. *Report of the South Park Commissioners to the Board of Country Commissioners of Cook County* (Chicago: Cameron, Amberg and Co., 1898), 13; *Report of the South Park Commissioners to the Board of County Commissioners of Cook County* (Chicago: Ryan and Hart Co., 1904), 9; *Annual Report*

of the South Park Commissioners for the Fiscal Year, 1904 (Chicago: Henry O. Shepard Co., n.d.), 8–11, plan opposite 38; *Annual Report of the South Park Commissioners for the Fiscal Year, 1905* (Chicago: M. A. Donohue and Co., n.d.), 7: *Report of the South Park Commissioners: For a Period of Fifteen Months from December 1, 1906, to February 29, 1908, Inclusive* (Chicago: n.p., n.d.), 7–10, 86–90.

29. Ward eventually won his case when the Illinois State Supreme Court agreed that an 1836 Chicago Canal Commissioners' action in establishing open lakefront space prohibited development of more new building in Grant Park. See Lois Wille, *Forever Open, Clear and Free: The Historic Struggle for Chicago's Lakefront* (Chicago: Henry Regnery Co., 1972), 71–81; and Douglas Schroeder, *The Issue of the Lakefront: An Historical Critical Survey* (Chicago: Chicago Heritage Committee, 1964).

For a good account placing this turn-of-the-century movement to expand Chicago's park system in a broader national context, see Michael P. McCarthy, "Politics and the Parks: Chicago Businessmen and the Recreation Movement," *Journal of the Illinois State Historical Society*, 65 (Summer, 1972), 158–72.

30. *The Art Institute of Chicago: Twenty-Ninth Annual Report* (Chicago: Art Institute of Chicago [1908]), 29.

31. Simeon Williams to Taft, 10 August 1886, Box 6, Taft Papers, University of Illinois. The photo of Taft's "Spirit of the Great Lakes" model appeared in *Century Magazine*, 72 (July, 1906), 397.

32. Almy to Taft, 27 June 1906, Box 10, Taft Papers, University of Illinois.

33. Almy to Taft, 4 October 1906, Box 10, Taft Papers, University of Illinois. Taft's letters to Almy have not been located, but the latter's comments offer a good indication of the sculptor's position at this time.

34. Cover, *Illustrated Sunday Magazine of the Buffalo Illustrated Times*, 10 February 1907, copy in Box 10, Taft Papers, University of Illinois.

35. French to Taft, 15 October 1907, Box 10, Taft Papers, University of Illinois.

36. *The Art Institute of Chicago: Twenty-Ninth Annual Report*, 29.

37. See Contract, 16 December 1907, Box 10, Taft Papers, University of Illinois. The $38,000 awarded Taft at the time probably seemed overly generous to some, exceeding the $33,750 in interest income reported available at that point. However, by the following May, Carpenter reported to the South Park Board that the Ferguson fund income had grown to $63,000, and additional commissions were considered. See *The Art Institute of Chicago: Twenty-Ninth Annual Report*, 29; and *Report of the South Park Commissioners: For a Period of Fifteen Months from December 1, 1906, to February 29, 1908, Inclusive*. 92.

The amount granted to Taft by the first contract of 1907 was significantly increased by a second extended to him some five years later. This second agreement called for the addition of two small ancillary figures representing "Fish-Boys" to flank the main group of the fountain. Payment for these figures, again including casting and installation, amounted to $7,000. See Contract, 16 January 1913, Box 10, Taft Papers, University of Illinois.

38. E. P. Bell, "The Message of Art: Lorado Taft and the City Beautiful," *Chicago Daily News*, 17 April 1913, 8.

39. Charles Francis Browne, "Lorado Taft: Sculptor," *World To-Day*. 14 (February, 1908), 191–92.

40. *The Art Institute of Chicago: Twenty-Ninth Annual Report*, 29.

41. "South Parks to Have Gateway," *Chicago Daily News*, 20 February 1908, 2.

42. *The Art Institute of Chicago: Thirtieth Annual Report* (Chicago: Art Institute of Chicago [1909]), 18, 24.

43. *Annual Report of the South Park Commissioners for the Fiscal Year Ended February 28, 1910* (Chicago: n.p., n.d.), 16.

44. "The Great Lakes' Nearly Ready," *Chicago Daily News*, 16 April 1910, 12.

45. Unidentified news clipping from "Solitude of the Soul" File, n.d., Box 10, Taft Papers, University of Illinois.

46. "Fountain Soon to Run," *Chicago Daily News*, 10 May 1913, 6.

47. "Lorado Taft's Great Fountain Going Up in Grant Park," *Chicago Tribune*, 12 August 1913, 3.

48. "Unveil New Taft Fountain on Lake Front Tomorrow," *Chicago Inter Ocean*, 8 September 1913, 3.

49. For more on the early response to the Burnham plan, see Mel Scott, *American City Planning Since 1890* (Berkeley: University of California Press, 1969), 138–39; and Michael McCarthy, "Chicago Businessmen and the Burnham Plan," *Journal of the Illinois State Historical Society*, 63 (Autumn, 1970), 228–56.

50. See especially Guerin's watercolors in Burnham and Bennett, *Plan of Chicago*, plates 112, 116, and 118.

51. "Address of Charles L. Hutchinson," 35.

52. Ibid., 37.

53. Ibid., 38.

54. In 1890, while abroad with his friend Martin Ryerson to investigate the possibility of acquiring some portion of the famous Demidoff collection for the Art Institute, Hutchinson also recorded his observations of the "fine monuments" of European cities, expressing the wish that Chicago could obtain similar impressive works. See Kathleen D. McCarthy, *Noblesse Oblige: Charity and Cultural Philanthropy in Chicago, 1849–1929* (Chicago: University of Chicago Press, 1982), 86.

55. "Would Beautify City," *Chicago Daily News*, 5 June 1899, 2.

56. Thomas Goodspeed, "Charles Lawrence Hutchinson," *University [of Chicago] Record*, n.s. 11 (January, 1925), 63.

57. Ibid., 62.

58. Scott, *American City Planning Since 1890*, 44. For more on these organizations, see Jon A. Peterson, "The City Beautiful Movement: Forgotten Origins and Lost Meanings," *Journal of Urban History*, 2 (August, 1976), 415–34; and Harvey A. Kantor, "The City Beautiful in New York," *New York Historical Society Quarterly*, 67 (April, 1973), 148–71.

59. Charles Mulford Robinson, "Improvement in City Life. III. Aesthetic Progress," *Atlantic Monthly*, 83 (June, 1899), 771–85. For intriguing (and differing) accounts of Robinson and others involved in beautification efforts as part of far broader American cultural patterns in the late nineteenth and early twentieth centuries, see Richard Guy Wilson, "Architecture, Landscape, and City Plan-

ning," in *The American Renaissance, 1876–1917*, exh. cat. (New York: Brooklyn Museum, 1979), 75–109; and Mario Maniera-Elia, "Toward an 'Imperial City': Daniel H. Burnham and the City Beautiful Movement," in *The American City from the Civil War to the New Deal*, trans. Barbara Luigi La Penta (Cambridge, Mass.: MIT Press, 1979), 1–142.

60. Lucy B. Monroe, "Art Chicago," *New England Magazine*, n.s. 6 (June, 1892), 411–32; William Morton Payne, "Literary Chicago," *New England Magazine*, n.s. 7 (February, 1893), 683–700

61. Franklin H. Head, "The Heart of Chicago," *New England Magazine*, n.s. 6 (July, 1892), 553–54, 561.

62. William Dean Howells, "Letters of an Altrurian Traveller," *Cosmopolitan Magazine*, 16 (December, 1893), 218.

63. "Chicago's Higher Evolution," *Dial*, 13 (1 October 1892), 205–6.

64. Ibid., 206.

65. Henry Blake Fuller, "The Upward Movement in Chicago," *Atlantic Monthly*, 80 (October, 1897), 547.

66. "Making the City Beautiful," *Chicago Tribune*, 17 June 1899, II, 12.

67. Lorado Taft, "Municipal Art," *Chicago Record*, 29 April 1899, 4.

68. Frederick S. Lamb, "Municipal Art," *Municipal Affairs*, 1 (1897), 674–88.

69. Brooks Adams, "Public Art—The Test of Greatness," *Municipal Affairs*, 5 (1901), 810–16.

70. Burnham quoted in Thomas S. Hines, *Burnham of Chicago* (Chicago: University of Chicago Press, 1974), 315.

71. Municipal Improvement Association of New Orleans quoted in Robinson, "Aesthetic Progress," 784.

72. Ibid.

73. Wallace Heckman, "What Is the Use of Art?" *Brush and Pencil*, 4 (July, 1899), 194. Heckman, lawyer for the University of Chicago at the time, was by the later 1890s a good friend of Taft and his circle, forming a longstanding relationship with them after his donation of land for their summer camp in 1898. See, pp. 108–9.

74. Thomas J. Schlereth, "Big Money and High Culture: The Commercial Club of Chicago and Charles L. Hutchinson," *Great Lakes Review: A Journal of Midwest Culture*, 3 (Summer, 1976), 16.

75. "Praise and Blame; Mayor Hears," *Chicago Tribune*, 8 October 1905, 1.

76. For an account of events leading to this merger, see Hines, *Burnham of Chicago*, 314–21.

77. Lorado Taft, "That Fountain," *Brush and Pencil*, 4 (August, 1899), 248–54.

78. Some measure of the uneven quality of figures in the "Nymph Fountain" may be gathered from the fact that only one of the ten students involved in the project went on to do serious professional work. Evelyn B. Longman spent two years as a student at the Art Institute, then went to New York where she served additional time as an assistant to Hermon A. MacNeil and Daniel Chester French. After establishing herself as an independent sculptor she won commissions all over the country. See James Spencer Dickerson, "Evelyn B. Longman," *World To-*

Day 14 (May, 1908), 526–30; and Lorado Taft, "Women Sculptors of America," *Mentor*, 6 (1 February 1919), 2–4.

79. "View Art Institute Fountain," *Chicago Daily News*, 16 June 1899, 1.

80. "Nymphs the Town Talk," *Chicago Tribune*, 18 June 1899, I, 8.

81. Ibid. See also "Nymph Group in Favor," *Chicago Tribune*, 17 June 1899, 1.

82. "The Nymph Fountain," *Chicago Times-Herald*, 18 June 1899, II, 4; and "The Nymphs on the Lake Front," *Chicago Tribune*, 18 June 1899, IV, 32.

83. "Nymphs the Town Talk," 8.

84. Taft, "That Fountain," 252.

85. Ibid., 254.

86. Heckman, "What Is the Use of Art?" 194.

87. Francis W. Parker, "An Appreciation of Chicago," *World To-Day*, 9 (September, 1905), 999.

88. "Address of Charles L. Hutchinson," 39.

89. Ibid.

90. Cotton Mather, *A Christian at His Calling* (1701), excerpt in *The American Gospel of Success: Individualism and Beyond*, ed. Moses Rischin (1965; reprint ed., New York: New Viewpoints, 1974), 23–30.

91. Sigmund Diamond, *The Reputation of the American Businessman* (1955; reprint ed., Gloucester, Mass.: Peter Smith, 1970), 83. Diamond notes that this assessment of the American businessman was especially apparent in estimates of J.P. Morgan at the time of his death in 1913.

92. Theodore Roosevelt quoted in James Oliver Robertson, *American Myth, American Reality* (New York: Hill and Wang, 1980), 184.

93. Andrew Carnegie, *The Empire of Business* (New York: Doubleday, Page and Co., 1902), 138–40.

94. Reverend William Lawrence quoted in Larzer Ziff, "Afterword," in Theodore Dreiser, *The Financier* (1912; reprint ed., New York: New American Library, 1967), 451.

95. See Diamond, *The Reputation of the American Businessman*, 104–5.

96. Theodore Dreiser, "The American Financier," in *Hey Rub-a-Dub-Dub: A Book of Mystery and Wonder and Terror of Life* (New York: Boni and Liveright, 1920), 74. Dreiser's trilogy on the career of Frank Cowperwood included *The Financier* (1912), *The Titan* (1914), and *The Stoic* (1947).

97. Helen Lefkowitz Horowitz, *Culture and the City: Cultural Philanthropy in Chicago from the 1880s to 1917* (Lexington: University Press of Kentucky, 1976) 68. Horowitz's study is certainly most valuable for any wishing to come to an understanding of cultural philanthropy in Chicago, while Kathleen D. McCarthy's *Noblesse Oblige* expands both period and coverage of other charitable activities in the city. Beyond these, however, for a useful comparative study of philanthropic practices in several major American cities at the time, see Frederic Cople Jaher, *The Urban Establishment: Upper Strata in Boston, New York, Charleston, Chicago, and Los Angeles* (Urbana: University of Illinois Press, 1982). Also helpful for putting practices of the period in perspective are studies of American philanthropic patterns preceding and following the time, including Robert H. Bremner,

The Public Good: Philanthropy and Welfare in the Civil War Era (New York: Alfred A. Knopf, 1980); and Robert F. Arnove, ed., *Philanthropy and Cultural Imperialism: The Foundations at Home and Abroad* (Bloomington: Indiana University Press, 1980).

98. Robinson, "Aesthetic Progress," 785.

99. McCarthy, *Noblesse Oblige*, 152–53.

100. "Crane Belabors Fads of the Rich," *Chicago Tribune*, 29 December 1907, 1.

101. Ibid. It is interesting that Crane was listed among those contributing money for the purchase of the equestrian *George Washington* for Chicago's Washington Park only a few years earlier. See p. 180, n. 12.

102. Henry Blake Fuller, *The Cliff-Dwellers* (1893; reprint ed., New York: Holt, Rinehart and Winston, 1973), 40.

103. Ralph Clarkson, "The Art Situation in Chicago," *Arts for America*, 7 (January, 1898), 270–71. For an account of Clarkson's introduction and arrival to the city in the 1890s, see Kenneth R. Hey, "Ralph Clarkson: An Academic Painter in an Era of Change," *Journal of the Illinois State Historical Society*, 76 (Autumn, 1983), 177-94.

104. Goodspeed, "Charles Lawrence Hutchinson," 61.

105. Ibid., 75. At the time of his death, Hutchinson bequeathed the remains of his estate to a wide assortment of worthy civic causes.

106. Lorado Taft, "Charles L. Hutchinson and American Art," in *Charles Lawrence Hutchinson, 1854–1924* (Chicago: Art Institute of Chicago, 1925), 11–12.

107. Aline Gorren, "American Society and the Artist," *Scribner's Magazine*, 26 (November, 1899), 629.

108. "Notable Portrait of Ferguson Fund Donor Prepared by Lorado Taft," *Chicago Record-Herald*, 3 August 1913, II, 8.

109. Quite accessible when the fountain faced south along the elevated promenade on the south side of the Art Institute, this plaque is now virtually out of sight following the 1963 relocation of the work to its present position facing west from the Michigan Avenue side of the Morton wing. By then commemoration had apparently ceased to be the major concern it was at the time of the dedication.

2. Realized Ambition

1. "Address of Lorado Taft," *Dedication of the Ferguson Fountain of the Great Lakes*, 25.

2. Ibid., 26.

3. For an account of Taft's early contact with Williams in Paris, see Weller, *Lorado in Paris*, 255–56.

4. Williams to Taft, 9 March 1891, Box 4; Williams to Taft, 24 February 1886, Box 4; and Williams to Taft, 19 March 1886, Box 6, Taft Papers, University of Illinois.

5. For the sculptor's own account of his naiveté upon reaching Chicago, see Lorado Taft, "Dreams and Death Masks," *Chicago Record*, 6 June 1899, 4.

6. Taft to Family, 7 April 1886; and Taft to Family, January 1886, Box 6, Taft Papers, University of Illinois.

7. In addition to an occasional call to create butter sculpture for local promotional efforts, Taft was at one point hired to travel to Michigan to create a substantial butter portrait of the director of a Michigan fair. See Taft to Family, 6 November 1890; and Taft to Family, 9 November 1890, Box 6, Taft Papers, University of Illinois.

8. See Taft to Family, 7 March 1886; Taft to Family, 9 March 1886; and Taft to Family, 17 October 1887, Box 6, Taft Papers, University of Illinois.

9. Taft to Family, January 1886, Box 6, Taft Papers, University of Illinois.

10. Taft's work for McKain was so extensive that the sculptor was actually compelled to take up residence in Indianapolis for a good part of the fall of 1887. See Taft to Family, 15 September 1887, Box 6, Taft Papers, University of Illinois.

11. Taft to Mary Lucy Taft, 9 February 1890, Box 6, Taft Papers, University of Illinois.

12. For a good description of Taft's early work to master the art of portraiture, see Weller, *Lorado in Paris*, 102.

13. Taft to Family, January 1886, Box 6, Taft Papers, University of Illinois. See also "Passed into History," *Chicago Inter Ocean*, 17 July 1888, 1.

14. See Taft to Family, 1 April 1890, Box 6, Taft Papers, University of Illinois.

15. Browne, "Lorado Taft: Sculptor," 197. For more on Taft's portraiture, see Allen S. Weller, *Lorado Taft: A Retrospective Exhibition*; and my own "Conferring Status: Lorado Taft's Portraits of an Artistic Community," *Illinois Historical Journal*, 78 (Autumn, 1985), 162–78.

16. See Taft's list of studio visitors in Taft to Family, 20 January 1889, Box 6, Taft Papers, University of Illinois.

17. Taft to Family [April, 1891], Box 6, Taft Papers, University of Illinois.

18. Ibid.

19. In 1889 Taft had indicated his general interest in the World's Fair, noting in a letter home that he hoped "we may whip New York!" Taft to Mary Lucy Taft, 8 August 1889, Box 6, Taft Papers, University of Illinois. For a good account of Chicago's efforts to be named host city for the Columbian Exposition, see R. Reid Badger, *The Great American Fair: The World's Columbian Exposition and American Culture* (Chicago: Nelson Hall, 1979), 43–52.

20. See J.S. Merrill, ed., *Art Clippings from the Pen of Walter Cranston Larned and Other Critics at the Fair*, Box 29; and "Horticultural Building at World's Fair," typescript, Box 10, Taft Papers, University of Illinois.

21. Janet Scudder, *Modeling My Life* (New York: Harcourt, Brace and Co., 1925), 60. Taft's sister, Zulime Taft Garland, was also a member of the crew he directed; she later recalled the work in "Mrs. Garland's Recollections of Lorado Taft," typescript, 29 December 1936, 6, Box 1, Taft Papers, University of Illinois.

22. Lorado Taft, "Sculpture at the World's Fair as Vividly Recreated by Chicago's Distinguished Master, Lorado Taft," *Chicago Commerce*, 19, pt. 2 (6 October 1923), 26. His complete absorption with preparations at Jackson Park may have been a most welcome diversion for Taft following the sudden death of his

young wife, Carrie Scales Taft, in childbirth in 1891. Whatever the case, that he allowed work at the fair to eclipse all else in his career for a time is clear from the letter he wrote Art Institute Director French accounting for his long absence from the Loop by explaining that he was required to be at the Horticultural Building "all the time during working hours." See Taft to French, 22 September 1892, William Merchant Richardson French Collection, Ryerson Library, Art Institute of Chicago. Use of this collection permitted by courtesy of the Art Institute of Chicago.

23. Taft, "Sculpture at World's Fair," 26. Woodlawn, the suburban neighborhood immediately south of the Midway Plaisance, boomed to a population of approximately twenty thousand with preparations for the exposition, including both permanent residents and more transient numbers working at the fair. With the close of the exposition, the neighborhood was among several that suffered from overdevelopment with high vacancy rates and low property values. See Harold M. Mayer and Richard C. Wade, *Chicago: Growth of a Metropolis* (Chicago: University of Chicago Press, 1969), 172–75, 200.

24. Taft, "Sculpture at the World's Fair," 26.

25. Unfortunately, the best eye-witness account of the activity of sculptors working in buildings like the Horticultural Building to enlarge work for the fair is unpublished. Lee Lawrie, a young assistant in Alexander Phimister Proctor's crew at the time, later wrote a very helpful account of the crews, camaraderie, and competition among sculptors working on preparations in Jackson Park. Lawrie's account is in a fragmented typescript entitled "Boy Wanted," Boxes 46–47, Lee O. Lawrie Papers, Manuscripts Division, Library of Congress, Washington, D. C.

26. Hamlin Garland, *A Son of the Middle Border* (1917; reprint ed., Lincoln: University of Nebraska Press, 1979), 457.

27. Garland attended the Literary Congress in Chicago on William Dean Howells's recommendation. On July 14 at a session on modern fiction, Garland's paper entitled "Local Color in Fiction" so irritated the romantic Catherwood that she interrupted the next speaker to offer comment. Her comments, in turn, drew a passionate response from Garland. Although the event concluded peacefully, the local press took up the issue and extended it for several weeks as the most colorful event of the meeting. For more on Garland's introduction to Chicago during the summer of 1893, see Jesse Sidney Goldstein, "Two Literary Radicals: Garland and Markham in Chicago, 1893," *American Literature*, 17 (May, 1945), 152–60; and Donald Pizer, "A Summer Campaign in Chicago: Hamlin Garland Defends a Native Art, " *Western Humanities Review*, 13 (Autumn, 1959), 375–82.

28. The Attic Club was a temporary group, disbanded when certain members proved uncongenial; the Wise Diners was a luncheon club including Taft, Fuller, Irving K. Pond, Allen B. Pond, and a number of others who met regularly at the Albion Cafe in Chicago in the early 1890s. For more on these groups, see Irving Kane Pond, "The Sons of Mary and Elihu," manuscript, Irving Kane Pond Papers, American Academy and Institute of Arts and Letters, New York (microfilm at the University of Michigan Historical Collections, Bentley Historical Library, Ann Arbor), J11, K3. For further explanation of summer camps at Bass Lake and Rock River, see, pp. 106–112.

29. For an expression of such surprise, see Emily Wheaton, *The Russells in Chicago* (1901; reprint ed., Boston: L.C. Page and Co., 1902), 231.

30. Hamlin Garland, *Crumbling Idols* (1894; reprint ed., Cambridge, Mass.: Belknap Press of Harvard University Press, 1960), 141.

Accounts of Fuller and Garland are plentiful, but some providing clear indications of the complexities of their relationship are Larzer Ziff, *The American 1890s: Life and Times of a Lost Generation* (New York: Viking Press, 1966); Robert C. Bray, *Rediscoveries: Literature and Place in Illinois* (Urbana: University of Illinois Press, 1982); and Robert M. Weiss, "The Shock of Experience: A Group of Chicago's Writers Face the Twentieth Century," (Ph.D. diss., University of Wisconsin, 1966).

31. See Hamlin Garland, "Successful Efforts to Teach Art to the Masses: Work of an Art-Association in Western Towns," *Forum*, 19 (July, 1895), 607–8.

32. Taft to Don Carlos Taft, 9 March 1886, Box 6, Taft Papers, University of Illinois; French to Taft, 10 July 1886, French Papers, Art Institute of Chicago. For more on the early years of the School of the Art Institute of Chicago, see Peter C. Marzio, "A Museum and a School: An Uneasy but Creative Union," *Chicago History*, 8 (Spring, 1979), 20–52.

33. Taft's sister, Zulime Taft Garland, later recalled that she was sometimes pressed into service as a second speaker when the sculptor was double-booked. See "Mrs. Garland's Recollections of Lorado Taft," 6–7.

34. "A Prairie Sculptor," *Chicago Inter Ocean*, 18 December 1892, Illustrated Supplement, 1–2.

35. Edward Osgood Brown, "The Chicago Literary Club," *Papers of the Bibliographic Society of America*, 11 (April, 1917), 98.

36. Taft to Family, 2 April 1889, Box 6, Taft Papers, University of Illinois.

37. Taft to Mary Lucy Taft, 1 March 1890; Taft to Mary Lucy Taft, 9–10 March 1890, Box 6, Taft Papers, University of Illinois.

38. Neil Harris, *The Artist in American Society: The Formative Years, 1790–1860* (New York: Simon and Schuster, 1966), 263. For an excellent account of one of the more famous of these tasteful studios, see Nicolai Cikovsky, Jr., "William Merritt Chase's Tenth Street Studio," *Archives of American Art Journal*, 16 (1976), 2–14.

39. Taft to Don Carlos Taft, 9 March 1886, Box 6, Taft Papers, University of Illinois.

40. Taft quoted in Neil M. Clark, "A Wonderful Thing Happened to This Boy!" *American Magazine*, 93 (April, 1922), 144. For an account of Taft's moves from studio to studio during these years, see Lewis W. Williams "Lorado Taft: American Sculptor and Art Missionary," (Ph.D. diss., University of Chicago, 1958), 52, 64, 70, 72.

41. See "Walks among the Artists," *Graphic*, 2 (January, 1890), 59.

42. Henry Blake Fuller, "The Downfall of Abner Joyce," *Under the Skylights* (1901; reprint ed., New York: Garrett Press, 1968), 16–17. Just as Fuller's Abner Joyce is Garland, his Stephen Giles is a thinly disguised Taft.

43. Taft to Family, 10–11 February 1886, Box 6, Taft Papers, University of Illinois.

44. For an account of the changes Taft was forced to make in his studio, see Taft to Family, 17 October 1887, 10 August 1889, 1 April 1890, all Box 6; and Taft to Family, 13 April [1892?], Box 5, Taft Papers, University of Illinois.

45. Williams to Taft, 25 April 1890, Box 4, Taft Papers, University of Illinois.

46. "Address of Lorado Taft," 26–27.

47. Henry Blake Fuller, *With the Procession* (New York: Harper and Brothers Publishers, 1895), 91.

48. Fuller, "Little O'Grady vs. the Grindstone," *Under the Skylights*, 152–58.

49. Hamlin Garland, *Money Magic* (New York: Harper and Brothers, 1907), 194.

50. Anna Morgan, *My Chicago* (Chicago: Ralph Fletcher Seymour, 1918), 61.

51. Hamlin Garland, *Rose of Dutcher's Coolly* (1895; reprint ed., Lincoln: University of Nebraska Press, 1969), 295–97.

52. Wheaton, *The Russells in Chicago*, 132.

53. Ibid., 131.

54. Ibid., 135.

55. Taft to Family, 17 October 1887, Box 6, Taft Papers, University of Illinois.

56. Taft to Mary Lucy Taft, 9 March 1890, Box 6, Taft Papers, University of Illinois.

57. Gorren, "American Society and the Artist," 633.

58. Wheaton, *The Russells in Chicago*, 131.

59. Henry Blake Fuller, "Art in America," *Bookman*, 10 (November, 1899), 220.

60. See Horowitz, *Culture and the City*, 38; and Horowitz, "The Art Institute of Chicago: The First Forty Years," *Chicago History*, 8 (Spring, 1979), 2–15.

61. Lucy Monroe, "Art in Chicago," 411.

62. Taft, "Dreams and Death Masks," 4.

63. James Spencer Dickerson, "The Art Movement in Chicago," *World To-Day*, 14 (April, 1908), 374.

64. The two ends of the Court of Honor were dominated by French's *Republic* and MacMonnies's *Triumph of Columbia*; others who came west to produce work for locations around this important central basin included Karl Bitter (Administration Building), Philip Martiny (Agricultural Hall), Edward C. Potter (Peristyle), Alexander Phimister Proctor (bridges and walks), and Saint-Gaudens's pupil Mary Lawrence (heroic *Columbus* before the Administration Building). Taft's work for the Horticultural Building, on the other hand, was on the west side of the northern lagoon, somewhat removed from the prestigious Court of Honor. For a building-by-building account of the architecture and art of the fair, see David F. Burg, *Chicago's White City of 1893* (Lexington: University Press of Kentucky, 1976), 114–78.

65. See Patricia Erens, *Masterpieces: Famous Chicagoans and Their Paintings* (Chicago: Chicago Review Press, 1979); and "The Great Grey City," *Apollo: The Magazine of the Arts*, 84 (September, 1966), 172–77.

66. For the best picture of ill-fated scrambling after commissions, see Fuller's "Little O'Grady *vs.* the Grindstone," 143–323. Garland wrote that Taft read one of Fuller's satirical pieces to a group of their artist friends late in 1900—perhaps

this very story. Although all gathered could quite easily see themselves in the fictional community Fuller created, Garland still indicated his appreciation of it, calling the work "capital satire." See John Pilkington, "Fuller, Garland, Taft, and the Art of the West," *Papers On Language and Literature*, 8 Supplement (Fall, 1972), 48–49.

67. See Taft to French, 30 October 1895, and 25 September 1896, French Papers, Art Institute of Chicago.

68. "Address of Lorado Taft," 26.

69. Lorado Taft, "The Exhibition of the National Sculpture Society," *Brush and Pencil*, 2 (July, 1898), 155; and Lorado Taft, "American Sculpture and Sculptors," *Chautauquan*, 22 (January, 1896), 387, 395.

70. Lorado Taft, "Are Americans Inartistic?" *Chicago Record*, 27 February 1899, 5.

71. Lorado Taft, "The Artist and the City," *Chicago Record*, 16 May 1899, 4.

72. Taft, "Dreams and Death Masks," 4.

73. Ibid.

74. See Henry Blake Fuller, "Notes on Lorado Taft," *Century Magazine*, 76 (October, 1908), 618. Fuller claimed that after the "naif demands and appreciations" of Chicago society in the early years of Taft's career, a "wider field and a fairer future opened out with the coming of the World's Columbian Exposition."

75. Taft, "Dreams and Death Masks," 4.

76. "Address of Lorado Taft," 26.

77. Lucy Monroe, "Art in Chicago," 424.

78. For an early description of Taft's initial idea behind these "clay talks," see Taft to Family, 30 December 1889, Box 6, Taft Papers, University of Illinois.

79. "The Author," in Lorado Taft, *The Appreciation of Sculpture*, Reading with a Purpose, No. 17 (Chicago: American Library Association, 1927), 7. See also Elizabeth Haseltine, "Lorado Taft—Master Sculptor," *School Arts Magazine*, 25 (January, 1926), 267.

80. Lorado Taft, "Why I Have Found Life Worth Living," *Christian Century*, 45 (7 June 1923), 725–26.

81. Taft to Family, 2 April 1889, Box 6, Taft Papers, University of Illinois.

82. Taft to Don Carlos Taft [1890], Box 6, Taft Papers, University of Illinois. For more on these first efforts as well as reprints of four early samples of Taft's newspaper writing, see Weller, *Lorado in Paris*, 261–82.

83. Hamlin Garland, *Roadside Meetings* (New York: Macmillan Co., 1930), 265.

84. Garland, "Successful Efforts to Teach Art to the Masses," 608.

85. Ibid., 607.

86. A good example of efforts along these lines may be found in a pair of booklets published anonymously by Taft and his colleagues in the mid-nineties. Ostensibly comments generated by visits to local exhibitions, the booklets reported on discussions of works by the "Critical Triumvirate"—a sculptor, a novelist, and a "conservative" painter (Taft, Garland, and Browne, respectively). See The Critical Triumvirate. *Five Hoosier Painters: Being a Discussion of the Holiday Exhibit of the Indianapolis Group, in Chicago* (Chicago: Central Art Association, 1894);

and The Critical Triumvirate, *Impressions on Impressionism: Being a Discussion of the American Art Exhibition at the Art Institute, Chicago* (Chicago: Central Art Association, 1894).

87. Garland, "Successful Efforts to Teach Art to the Masses," 608. Donald Pizer offers a humorous anecdote originating with Harriet Monroe, who reported on one occasion finding the organization's president, Garland, and first vice president, Taft, "at work nailing up boxes" in Taft's studio in preparation for shipping an exhibition. See Pizer, *Hamlin Garland's Early Work and Career*, University of California English Studies, No. 22 (Berkeley: University of California Press, 1960), 138.

88. Fuller, "The Upward Movement in Chicago," 546; and Lorado Taft, "Exhibition of Statuary at Art Institute, Chicago," 453.

89. Garland, "Successful Efforts to Teach Art to the Masses," 609. Garland's personal preferences surfaced most clearly in the work promoted by this organization. The two-person show involved "the painting of William Reaugh, the cowboy painter; and the pictures of shipping in Chicago River by James Needham." Such painting was not only produced by regional artists, but took regional themes.

90. See C[harles] F[rancis] B[rowne], "Chicago, 1897," *Arts for America*, 7 (January, 1898), 301–2.

91. For a description and list of participants and their assignments on the "Dewey Arch" project, see "Notes and Reviews. Public Art in New York," *Municipal Affairs*, 3 (1899), 755–58. For a more recent assessment, see Marjorie P. Balge, "The Dewey Arch: Sculpture or Architecture?" *Archives of American Art Journal*, 23 (1983), 2–6.

92. "Art," *Chicago Tribune*, 3 September 1899, 30; "Art," *Chicago Tribune*, 24 September 1899, 41.

93. See several views of New York's "Dewey Arch" and Chicago's "Court of Honor" published in the *Chicago Tribune*: 17 September 1899, 8; 26 September 1899, 3, 5; 27 September 1899, 2, 3; 30 September 1899, 3; and 1 October 1899, 8. The temporary sculpture produced in Chicago in conjunction with this Autumn Festival has been incorrectly linked to a Chicago "Dewey celebration" comparable to that in New York. In fact, while Dewey arrived in New York at about the time Taft and Mulligan completed work on their State Street Court of Honor, the admiral could not be prevailed upon to schedule a visit to Chicago for several months. Only after a surprisingly sudden November marriage, lengthy honeymoon, and a series of political indelicacies did he finally make his way west to Chicago in late April, 1900. When he arrived, his welcome in the city was marked by a spectacular light show, several replicas of *Olympia*, and a colossal statue of the admiral himself, but no Taft sculpture remained. See John Garry Clifford, "Admiral Dewey Visits Chicago," *Journal of the Illinois State Historical Society*, 60 (Autumn, 1967), 245–66.

94. "The Editor," *Brush and Pencil*, 5 (November, 1899), 96.

95. "Art by Contract," *Milwaukee Free Press*, 23 February 1908, copy in Box 11, Taft Papers, University of Illinois.

96. Fuller to Taft, 3 November [1907], Folder 1889–1920, Lorado Taft Papers, Manuscripts Division, Chicago Historical Society.

97. See "Taft Begins Statue," *Chicago Daily News*, 15 February 1913, 5.

98. See "Plaster Casts Will Test Midway Scheme," *Chicago Daily News*, 30 January 1913, 16.

99. "Address of Lorado Taft," 31.

3. Commemoration without Representation

1. "Introductory," *Dedication of the Ferguson Fountain of the Great Lakes*, 8.

2. "Gives $1,000,000 for Chicago Art," 2; "Art Ideas Are Numerous," *Chicago Tribune*, 16 April 1905, I, 8.

3. "Art Ideas Are Numerous," 8.

4. *The Art Institute of Chicago: Twenty-Eighth Annual Report*, 17.

5. "Statues for Chicago," 4.

6. "Address of Lorado Taft," 25–26. Taft mentioned Burnham's advice on this matter several different times, always rather vague as to the time of this train ride. It is tempting to think that it may have occurred a few years after the World's Columbian Exposition, in 1897. That fall Taft had temporarily moved back to Evanston (where he had lived during his short first marriage prior to his wife's death in 1891), and Burnham, long a resident of Evanston himself, was deeply involved in serious consideration of his Chicago beautification plans, having taken the matter up officially with the Chicago Commercial Club and Chicago Merchants' Club the previous spring. See Taft to French, 4 September 1897, French Papers, Art Institute of Chicago; and Hines, *Burnham of Chicago*, 314–15.

7. For an interesting contemporary account of the decline of Great Lakes shipping in favor of rail transport during this time, see George C. Sikes, "Chicago—North America's Transportation Center," *American Review of Reviews*, 57 (March, 1918), 273–80.

8. Henry Blake Fuller, "Chicago's Book of Days," *Outlook*, 69 (5 October 1908), 292.

9. Carl S. Smith, *Chicago and the American Literary Imagination, 1880–1920* (Chicago: University of Chicago Press, 1984), 178.

10. Fuller, "Notes on Lorado Taft," 618.

11. Browne, "Lorado Taft: Sculptor," 192.

12. Garland, *Crumbling Idols*, 50, 108.

13. Hamlin Garland, *A Daughter of the Middle Border* (New York: Macmillan Co., 1921), 7.

14. Garland, *Roadside Meetings*, 265.

15. See "Biographical," *Dedication of the Ferguson Fountain of the Great Lakes*, 13–15.

16. "Address of Charles L. Hutchinson," 36.

17. "Art Ideas Are Numerous," 8. The *Sir Walter Scott Monument* in Edinburgh consisted of a large Gothic spire designed by the architect George Kemp

shortly after Scott's death in 1832; however, it was not officially inaugurated until sculptor Sir John Steell completed his seated figure of Scott for the heart of the monument in 1846. As one source has pointed out, discussions of this monument concluded that "while an architectural monument was the obvious answer, a statue must form part of it." See Benedict Read, *Victorian Sculpture* (New Haven: Yale University Press, 1982), 113–17.

18. "Art Ideas Are Numerous," 8.

19. Taft, "A Million Dollars for Sculpture," 629.

20. Ibid.

21. "Art in Memorial Form," *New York Times*, 3 November 1895, 28.

22. Ibid. This memorial honoring Irish patriots was never completed.

23. June Hargrove, "A Social History of the Public Monument in Ohio," in *The Public Monument and Its Audience*, exh. cat. (Cleveland: Cleveland Museum of Art, 1977), 33–34.

24. Craven, *Sculpture in America*, 235–36.

25. Hargrove, "A Social History of the Public Monument in Ohio," 34–39; also see *Brief Historical Sketch of the Cuyahoga County Soldiers' and Sailors' Monument* (1896; reprint ed., Cleveland: Monument Commissioners, 1977), passim.

26. Bach and Gray, *A Guide to Chicago's Public Sculpture*, 359.

27. Ibid. For additional information on Volk's other portraits of Douglas, see Craven, *Sculpture in America*, 240–42.

28. Underwood's solemn soldier figure was reportedly adapted from a painting entitled *Appomattox* by John A. Elder, another Confederate veteran. See Bach and Gray, *A Guide to Chicago's Public Sculpture*, 349.

29. For a more complete listing of public portraits in Chicago, see the valuable chronological chart in Bach and Gray, *A Guide to Chicago's Public Sculpture*, xix–xx.

30. Lee Lawrie, "Boy Wanted," typescript, 14, Folder 12, Box 46, Lee O. Lawrie Papers. Lawrie, an assistant in Park's studio when the Hull portrait was underway, recalled Addams's visit quite clearly in his unpublished autobiography.

31. Philip Poindexter, "Public Monuments and Statues—II," *Leslie's Weekly*, 76 (22 June 1893), 404.

32. "Deformities in Art," *Leslie's Weekly*, 76 (25 May 1893), 330.

33. "Deformities in Sculpture," *Leslie's Weekly*, 76 (1 June 1893), 356.

34. Charles Lopez, "Municipal Sculpture," *Municipal Affairs*, 5 (1901), 704.

35. For comparable analyses, see Karl Bitter, "Municipal Sculpture," *Municipal Affairs*, 2 (1898), 73–97; H. K. Bush-Brown, "New York City Monuments," *Municipal Affairs*, 3 (1899), 602–15; and William Ordway Partridge, "The True Relation of Sculpture to Architecture," *Forum*, 29 (March, 1900), 44–53.

36. "From the Battery to Harlem: Suggestions of the National Sculpture Society," *Municipal Affairs*, 3 (1899), 616–50.

37. Ibid., 617–19.

38. Mrs. Herman J. Hall, "Park Inconsistencies," *American Park and Outdoor Art Association*, 7 (July, 1903), 19, quoted in Galen Cranz, *The Politics of Park Design: A History of Urban Parks in America* (Cambridge, Mass.: MIT Press,

1982), 55–56. Cranz notes that such attitudes were apparent from the early 1870s.

39. "Art Societies and City Parks," *Garden and Forest*, 6 (12 July 1893), 292.

40. Lorado Taft, "Public Monuments," *Chicago Record*, 1 June 1899, 4.

41. Fuller, "The Upward Movement in Chicago," 541.

42. Taft to John S. Flowers, 13 April 1905, Box 14, Taft Papers, University of Illinois.

43. Taft, "The Monuments of Chicago," 120.

44. Ibid., 124.

45. Ibid.

46. Taft, "Public Monuments," 4.

47. Taft, "The Monuments of Chicago," 122–23.

48. Philip Poindexter, "Inartistic Public Monuments," *Leslie's Weekly*, 76 (1 June 1893), 350–51.

49. Bitter, "Municipal Sculpture," 75.

50. Ibid., 76.

51. "The Soldiers and Sailors Monument—A Protest from Gen. Rush C. Hawkins," *New York Times: Saturday Review of Books and Art*, 16 April 1898, 254.

52. Bitter, "Municipal Sculpture," 75.

53. "Some Art Topics of the Week," *New York Times*, 29 May 1893, 4.

54. "Says Our Statues Are Bad," *New York Times*, 7 June 1894, 4.

55. Taft, "American Sculpture and Sculptors," 387.

56. The pedestal in this case is also typical of the sort frequently criticized by Bitter and others. Squat and blocky, it sports the single word "COLFAX," a bronze relief representing Rebekah and Isaac, and four rather short, bulbous columns. The relief and various divisions of the pedestal were to have symbolic meaning relating to the Oddfellows organization responsible for commissioning the work. In the case of this awkward pedestal, however, Taft cannot be blamed, for the work was the product of McKain's company. See "Ready for the Dedication," *Indianapolis Journal*, 17 May 1887, 5.

57. Taft quoted in Garland, *Roadside Meetings*, 264.

58. Taft quoted in Clark, "A Wonderful Thing Happened to This Boy!" 144.

59. Taft, "Public Monuments," 4.

60. Ibid.

61. Taft, "The Artist and the City," 4.

62. Lorado Taft, "Man vs. Clothes in Art," *Chicago Record*, 20 May 1899, 4.

63. Ibid.

64. Ibid.

65. Ibid.

66. Taft paraphrased in L[ena] M. McC[auley], "Prizes at the Artists' Exhibition," 4. Weller notes the importance of an emphasis on the ideal in Taft's training at the Ecole des Beaux-Arts in the early 1880s, pointing out that the sculptor began preaching the gospel of pure beauty as early as his first return visit from Paris in 1883. See Weller, *Lorado in Paris*, 55–56, 213–15. For more on the general importance of the ideal in American art of this period, see Richard Guy

Wilson, et al., *The American Renaissance: 1876–1917*. For the ideal in Chicago, see Ethel Joyce Hammer, "Attitudes toward Art in the Nineteen Twenties in Chicago" (Ph.D. diss., University of Chicago, 1975), 8–54; and Horowitz, *Culture and the City*, 88–92.

67. "Address of Lorado Taft," 30; Lorado Taft, "Old-Time Ideals," *[University of Illinois] Alumni Quarterly*, 1 (July, 1907), 156.

68. William James Stedman quoted in Wilson, "The Great Civilization," in *The American Renaissance: 1876–1917*, 30.

69. Taft, "Old-Time Ideals," 156.

70. Browne, "Lorado Taft: Sculptor," 191.

71. "Address of Lorado Taft," 30–31.

72. Taft, "A Million Dollars for Sculpture," 630.

73. Taft, "The Artist and the City," 4.

74. Ibid.

75. Wilson, "The Great Civilization," 19.

76. T. J. Jackson Lears, *No Place of Grace: Antimodernism and the Transformation of American Culture, 1880–1920* (New York: Pantheon Books, 1981), 85.

77. Gorren, "American Society and the Artist," 632.

78. William Ordway Partridge, "The American School of Sculpture," *Forum*, 29 (June, 1900), 499. Of course Partridge was but one of a host of writers advocating a turn (or return) to the simple life for late nineteenth- and early twentieth-century Americans. Some indication of just how broadly compelling the notion was at this time may be found in such diverse sources as Lears, *No Place of Grace*, 60–96; Gwendolyn Wright, *Moralism and the Model Home: Domestic Architecture and Cultural Conflict in Chicago, 1873–1913* (Chicago: University of Chicago Press, 1980); and, especially, David E. Shi, *The Simple Life: Plain Living and High Thinking in American Culture* (New York: .Oxford University Press, 1985), 175–214.

79. Fuller, "The Downfall of Abner Joyce," 139.

80. Taft to Family, 7 April 1886, Box 6, Taft Papers, University of Illinois.

81. For more on the transformation of the Studebaker Building to the Fine Arts Building, see Jean Pomaranc, *Fine Arts Building* (Chicago: Commission on Chicago Historical and Architectural Landmarks, 1977); and Perry R. Duis, " 'Where Is Athens Now?' The Fine Arts Building 1898 to 1918," *Chicago History*, 6 (Summer, 1977), 66–78. For an account of subsequent uses of the Fine Arts Building, see Duis, " 'All Else Passes—Art Alone Endures': The Fine Arts Building 1918–1930," *Chicago History*, 7 (Spring, 1978), 40–51.

82. Morgan, *My Chicago*, 61.

83. Murals were painted by Frank X. Leyendecker, Ralph Clarkson, Oliver Dennett Grover, Charles Francis Browne, Frederick Clay Bartlett, Martha Baker, and Bertha Menzler-Peyton. See Duis, " 'Where Is Athens Now?' " 72.

84. "The Artistic 'Tenth Floor' in Chicago," *New York Evening Post*, 14 May 1904, Saturday Supplement, 6.

85. John T. McCutcheon, *Drawn from Memory* (New York: Bobbs-Merrill Co., 1950), 221.

86. Garland, *Money Magic*, 192.

87. Ibid.

88. Hobart Chatfield Chatfield-Taylor, *Two Women and a Fool* (Chicago: Stone and Kimball, 1895), 138–39.

89. Ibid., 20.

90. Ibid., 20–21.

91. Ibid., 19.

92. Garland, *Money Magic*, 204. Of course the most celebrated example of this equation between the streets of Chicago and the canyons of the West is from the wonderful introduction to Fuller's *The Cliff-Dwellers* (1893), where everything from the boilers to the telegraph poles of modern Chicago is described as an urban counterpart to some natural feature of the West's canyonlands.

93. On the balls, see "The Artistic 'Tenth Floor' in Chicago," 6. For a humorous but telling account of the impact and importance of costumes, see Fuller, "The Downfall of Abner Joyce," 92–96, 105–7.

94. On visitors, see the following: Hamlin Garland, *Companions on the Trail: A Literary Chronicle* (New York: Macmillan Co., 1931), 260–61 (James); Garland, *Roadside Meetings*, 389–90 (Zangwill); and Pond, "The Sons of Mary and Elihu," J13–J18 (Duncan).

95. For an example of the conflicting information on the founding of this studio club, compare Morgan, *My Chicago*, 188–89; and Duis, " 'Where Is Athens Now?' " 70.

96. Pond, "Sons of Mary and Elihu," J11. Pond noted that it was a "newspaper woman" the initial group found so obnoxious, but this did not prevent them from including others later who had no actual artistic background. Franklin Head, for example, was admitted to the club largely because other members enjoyed him and appreciated his gracious hospitality. Pond recalled that they decided Head's "published Club essays and 'historical' papers placed him among the literati," but also contributing was that "his home was the favorite rendezvous in Chicago" for local and visiting artists (J10). Permission to quote from this manuscript has been granted by the American Academy and Institute of Arts and Letters, New York.

97. Ibid., J11.

98. Elia W. Peattie, "The Artistic Side of Chicago," *Atlantic Monthly*, 84 (December, 1899), 830.

99. Bert Leston Taylor, *The Charlatans* (New York: Grosset and Dunlap, 1906), 237.

100. Pond, "The Sons of Mary and Elihu," J8.

101. Madelene Yale Wynne, *The Little Room and Other Stories* (Chicago: Way and Williams, 1895), 10, 14–17.

102. Ibid., 30–31.

103. "It Is Said," *Chicago Evening Herald*, 30 March 1901, 2–3.

104. Morgan, *My Chicago*, 190–91.

105. Pond, "The Sons of Mary and Elihu," J18–J19.

106. Wheaton, *The Russells in Chicago*, 235. Albert Parry later pointed out that unlike their counterparts elsewhere, these Chicago bohemians "even in their most convivial moments, are *ladies* and *gentlemen*" who "do not figure in police reports." Parry, *Garrets and Pretenders: A History of Bohemianism in America*

(1933; reprint ed., New York: Dover Publications, 1960), 176. For more on the development of an image of the artist-bohemian by this time, see Marilyn R. Brown, *Gypsies and Other Bohemians: The Myth of the Artist in Nineteenth Century France*, Studies in the Fine Arts: The Avant-Garde, no. 51 (Ann Arbor: UMI Research Press, 1985).

107. *The Little Room: A Vernal Diversion in Favor of George Barr Mc-Cutcheon*, undated pamphlet in "The Little Room, 1898–1906," Little Room Papers, Special Collections, Newberry Library, Chicago; Hobart Chatfield Chatfield-Taylor, *Cities of Many Men: A Wanderer's Memories of London, Paris, New York, and Chicago During Half a Century* (New York: Houghton Mifflin Co., 1925), 281.

108. See "Lorado Taft and His Camp," typescript copy from *Kansas City Star*, 19 September 1897, Box 19, Taft Papers, University of Illinois.

109. Harriet Moroe, "Eagle's Nest Camp: A Colony of Artists and Writers," *House Beautiful*, 16 (August, 1904), 5–10. For a list of participants and a more thorough chronology of the camp, see Athalae Elliott McGuire, "Eagle's Nest Association, 1898–1942" (M.S. thesis, Northern Illinois University, 1964).

110. "Eagle's Nest Association: By-Laws and Constitution," reprinted in McGuire, "Eagle's Nest Association," 19.

111. See McGuire, "Eagle's Nest Association," 67–76; and Ada Bartlett Taft, *Lorado Taft: Sculptor and Citizen* (Greensboro, N.C.: Mary Taft Smith, 1946), 42–52.

112. Karal Ann Marling, *Woodstock: An American Art Colony, 1902–1977*, exh. cat. (Poughkeepsie, N.Y.: Vassar College Art Gallery, 1977), [p. 2]. Marling's study focuses on an art colony that was itself something of an exception to the rule she describes. Woodstock actually combined aspects of both the unplanned and intentional colonies from the outset. Other recent studies of colonization efforts by American artists include Michael Jacobs, *The Good and Simple Life: Artist Colonies in Europe and America* (Oxford: Phaidon Press, 1985); Susan Faxon Olney, et al., *A Circle of Friends: Art Colonies of Cornish and Dublin*, exh. cat. (Durham: University of New Hampshire, 1985); and Charles Eldredge, et al., *Art in New Mexico, 1900–1945: Paths to Taos and Santa Fe*, exh. cat. (New York: Abbeville Press [for National Museum of American Art, Smithsonian Institution], 1986).

113. Ada Bartlett Taft, *Lorado Taft, Sculptor and Citizen*, 45–47; and Josephine Craven Chandler, "Eagle's Nest Camp, Barbizon of Chicago Artists," *Art and Archaeology*, 12 (November, 1921), 204.

114. For her own account of her 1843 visit to the site, see S[arah] M[argaret] Fuller, *Summer on the Lakes in 1843* (Boston: Charles D. Little and James Brown, 1844), 51–57. The robes were initially salvaged from the Art Institute for use at the earlier Bass Lake Camp. See "Lorado Taft and His Camp," typescript copy from *Kansas City Star*. The special appeal of the simple, togalike garments is clear from extant photos of the campers; in virtually every instance when groups gathered in costume, some wore Greek robes. Part of the attraction may have been a simple matter of accessibility and simplicity, but one recent account proposes as well that ancient Greece stood as an especially compelling metaphor

for youth, simplicity, and beauty in the Victorian imagination. Although certainly not an extraordinary concept in itself, considering the Greek robes as they were used in the context of almost childishly carefree entertainments at Eagle's Nest, the view is appropriate. See Richard Jenkins, *The Victorians and Ancient Greece* (Cambridge: Harvard University Press, 1980), 163–74.

115. Ada Bartlett Taft, *Lorado Taft, Sculptor and Citizen*, 45.

116. Horace Spencer Fiske, "The Eagle's Nest," *Brush and Pencil*, 2 (September, 1898), 273. Fiske's comments clearly suggest that their camp was an extension of what has already been noted as a broader drive to achieve a measure of simplicity (see above, p. 198, n. 114). Rugged rural cottages and camps were a common retreat for many more than the Eagle's Nest artists, and as the popularity of the automobile grew shortly after the turn of the century, many more began taking advantage of an even greater mobility. See John A. Jakle, *The Tourist: Travel in Twentieth-Century North America* (Lincoln: University of Nebraska Press, 1985), 63–79, 101–13; and Warren James Belasco, *Americans on the Road: From Autocamp to Motel, 1910–1945* (Cambridge, Mass.: MIT Press, 1979). In Illinois, the Illinois and Rock Rivers were especially popular with hunters and other tourists seeking escape from the congestion of the city, and Oregon was early cited as an attractive destination. See *An Inimitable Summer Resort* (Chicago: Chicago, Burlington, and Quincy Railroad, [c. 1880s]); Charles P. Root, "Rock River Country Splendid Goal for the Motor Party," *Chicago Herald-Examiner*, Automobile Section, 19 May 1918, 1; Norman T. Moline, *Mobility and the Small Town, 1900–1930: Transportation Change in Oregon, Illinois*, University of Chicago Department of Geography Research Paper No. 132 (Chicago: Department of Geography, University of Chicago, 1971); and Paul W. Parmalee and Forrest D. Loomis, *Decoys and Decoy Carvers of Illinois* (DeKalb: Northern Illinois University Press, 1979), 2–30. What sets Taft and his fellow campers at Eagle's Nest apart from all others was a self-consciousness in their cultivation of exotic dress and fanciful behavior. For more on this self-consciousness both at Eagle's Nest and in the Little Room, see the author's "The Artist Is Out: Recreations of the Little Room and Eagle's Nest," *Selected Papers in Illinois History, 1984–1985* (Springfield: Illinois State Historical Society, 1987).

117. Monroe, "Eagle's Nest Camp: A Colony of Artists and Writers," 5.

118. Stanley R. Osborn, "Chicagoans at Play: No. 8—Wallace Heckman, Feudal Overlord," *Chicago Record-Herald*, 24 October 1913, 5.

119. L[ena] M. McC[auley], "At Eagle's Nest," *Chicago Evening Post*, 7 July 1911, 6.

120. "The Great Lakes," *Chicago Evening Post*, 10 September 1913, 8.

4. Sufficiency of Support

1. "Address of Lorado Taft," 30.

2. Ibid.

3. "Address of Honorable John Barton Payne," *Dedication of the Ferguson Fountain of the Great Lakes*, 43–44.

4. Ibid., 47.

5. "Statues for Chicago," 4.

6. Indicative of the range of these "renaissance" studies are F.O. Mathiessen, *American Renaissance* (New York: Oxford University Press, 1941); Bernard Duffey, *The Chicago Renaissance in American Letters* (East Lansing: Michigan State College Press, 1954); Dale Kramer, *Chicago Renaissance: The Literary Life in the Midwest, 1900–1930* (New York: Appleton-Century, 1966); Nathan Irwin Huggins, *The Harlem Renaissance* (New York: Oxford University Press, 1917); Arthur Frank Wertheim, *The New York Little Renaissance: Iconoclasm, Modernism, and Nationalism in American Culture, 1908–1917* (New York: New York University Press, 1976); and Sam Hunter, ed., *An American Renaissance: Painting and Sculpture Since 1940*, exh. cat. (New York: Abbeville Press [for Museum of Art, Fort Lauderdale], 1986).

7. Wilson, "The Great Civilization," 16.

8. Fuller, *With the Procession*, 196.

9. "Address of Honorable John Barton Payne," 46.

10. Edmund Randolph quoted in Marie Kimball, "Jefferson, Patron of the Arts," *Antiques*, 43 (April, 1943), 164.

11. For a good account of Adams's views, see Wendell D. Garrett, "John Adams and the Limited Role of the Fine Arts," *Winterthur Portfolio*, 1 (1964), 243–55.

12. For further discussion of this impact of nationalism and utilitarianism on American art in the early republic, see J. Meredith Neil, *Toward a National Taste: America's Quest for Aesthetic Independence* (Honolulu: University Press of Hawaii, 1975), 1–22; and John A. Kouwenhoven, *The Arts in Modern American Civilization* (1948; reprint ed., New York: W. W. Norton and Co., 1967), 75–91.

13. John Adams to Abigail Adams, April, 1780, quoted in Garrett, "John Adams and the Limited Role of the Fine Arts," 255.

14. The postbellum Walt Whitman articulated this view in his foreward-looking *Democratic Vistas* (1871), where he defined three stages of national growth involving, respectively, political development, material development, and finally development of the "interior life." See Emily Stipes Watts, *The Businessman in American Literature* (Athens: University of Georgia Press, 1982), 49–51.

15. The American sculptor John Rogers was certainly in a minority when he left first Paris, then Rome, and finally Europe, disillusioned after a brief seven-month sojourn in 1858–59. Far more typical was the case of the architect Charles Follen McKim, who arrived in Europe in 1867 and returned only when the Franco-Prussian War forced him home in 1870. McKim had such strong, positive memories of his time studying abroad—especially in the Eternal City—that he was later instrumental in helping to found the American Academy in Rome. See David H. Wallace, *John Rogers: The People's Sculptor* (Middletown, Conn.: Wesleyan University Press, 1967), 65–74; and Lucia and Alan Valentine, *The American Academy in Rome, 1894–1969* (Charlottesville: University Press of Virginia, 1973), 3–5.

16. Kouwenhoven, *The Arts in Modern American Civilization*, 86–87.

17. See John G. Cawelti, "America on Display: The World's Fairs of 1876, 1893, 1933," in *The Age of Industrialism in America*, ed. Frederic Cople Jaher (New

York: Free Press, 1968), 326–27. For the most complete account of the Centennial Exposition, see John Maass, *The Glorious Enterprise: The Centennial Exhibition of 1876 and H. J. Schwarzmann, Architect-in-Chief* (Watkins Glen, N.Y.: American Life Foundation, 1973); for consideration of the Centennial Exposition as it compared with other international expositions, see John Allwood, *The Great Exhibitions* (London: Studio Vista, 1977).

18. Positioned at various points across the roofline of Memorial Hall were assorted allegorical figures made of zinc and stone, looming without regard for scale or visibility from below. The finial figure of *Columbia* designed by German sculptor A. J. M. Müller took the highest position on its cupola over the dome, but criticisms coming after it was hoisted to its perch necessitated changes only "making a bad case worse" as one observer noted at the time. Perhaps most surprising, however, was the addition of a pair of *Pegasus* groups flanking the main entrance; saved from an Austrian foundry scrap heap by a well-meaning Philadelphian traveling abroad, they were shipped back to Fairmount Park for use at Memorial Hall after authorities had condemned them as too poorly scaled for the same position before Vienna's Opera House. See David Sellin, "The Centennial, " in *Sculpture of a City: Philadelphia's Treasures in Bronze and Stone*, ed. Nicholas B. Wainwright (Philadelphia: Fairmount Park Art Association, 1974), 78–83.

20. Russell Lynnes, *The Tastemakers: The Shaping of American Popular Taste* (1949; reprint ed., New York: Dover Publications, 1980), 115. Taft was among the visitors to Philadelphia's Centennial Exposition. Although only in his mid-teens and possessing precious little experience of art at the time, his personal journal record of the family trip east that summer contained a mixed review of the art he encountered at the fairgrounds. For a complete account of his visit, see Weller, *Lorado in Paris*, 25–31.

21. For a comparison of the roles of Hawley and Burnham, see Cawelti, "America on Display," 320. On Burnham's role in planning the Columbian Exposition, see Hines, *Burnham of Chicago*, 73–91.

22. Montgomery Schuyler, "Last Words about the World's Fair," *Architectural Record*, 3 (December, 1893), 292, 299.

23. "Chicago's Higher Evolution," 205.

24. Fuller, "The Upward Movement in Chicago," 534.

25. Ibid.

26. Horowitz identifies thirty-four such leaders in Chicago, listing their cultural affiliations in an appendix—and these are only the individuals active in more than one area of the arts and sciences. See Horowitz, *Culture and the City*, 229–34.

27. Hamlin Garland, *My Friendly Contemporaries: A Literary Log* (New York: Macmillan Co., 1932), 30. What Garland neglected to mention was the fact that individuals like Bartlett were second-generation cultural figures in the city. Horowitz points out that Frederick Bartlett's father, Adolphus C. Bartlett, was himself one of the leading figures in the early efforts to develop certain key cultural institutions in Chicago. See Horowitz, *Culture and the City*, 168, 230.

28. Giselle d'Unger, "A Sculptor's Dream of the Chicago Beautiful," *Fine Arts*

Journal, 27 (March, 1912), 158. Although this article is generally on Taft and his plans for the beautification of Chicago, d'Unger is referring to Ferguson in this passage.

29. Taft quoted in "There's Nothing the Matter with the Art Institute Which a Million Dollars Cannot Cure," *Chicago Commerce*, 9 (21 November 1913), 32.

30. Head, "The Heart of Chicago," 551.

31. Lucy Monroe, "Art in Chicago," 411.

32. Ibid.

33. Mathews, "Uncommercial Chicago," 984.

34. Ibid., 990.

35. "Address of Honorable John Barton Payne," 45.

36. Ibid., 48.

37. See, for example, Cawelti, "America on Display," 336; Horowitz, *Culture and the City*, 168–70; and Wilson, "The Great Civilization," 19.

38. Elia W. Peattie, "Books and Art in Chicago," *New York Evening Post*, 14 December 1907, III, 1.

39. Payne, "Literary Chicago," 683–84; Fuller, "Art in America," 224; and Harriet Monroe, "Ferguson Bequest New Impetus for Art," *Chicago Examiner*, 22 April 1905, news clipping in Box 11, Taft Papers, University of Illinois.

40. Taft, "Old-Time Ideals," 163.

41. For a good account of the turn-of-the-century notion that moderate amounts of leisure could serve as an antidote to the monotony of industrial America, see Daniel T. Rodgers, *The Work Ethic in Industrial America, 1850 to 1920* (Chicago: University of Chicago Press, 1974), 90–93.

42. Sieur de La Salle quoted in Hobart Chatfield Chatfield-Taylor, *Chicago* (New York: Houghton Mifflin Co., 1917), 119.

43. Ibid., 117.

44. Charles Eugene Banks, *John Dorn, Promoter* (Chicago: Monarch Book Co., 1906), 43, 151.

45. Fuller, *With the Procession*, 87–88, 294.

46. Chatfield-Taylor, *Chicago*, 118.

47. Theodore Dreiser, *The Titan* (1914; reprint ed., New York: New American Library, 1965), 355.

48. Frank Norris, *The Pit: A Story of Chicago* (1903; reprint ed., New York: Grove Press, 1956), 65. It is interesting that Norris placed Corthell's studio in the Fine Arts Building (p. 112).

49. Will Payne, *The Story of Eva* (New York: Houghton Mifflin and Co., 1901), 229.

50. Ibid., 230.

51. Ibid., 317.

52. Corthell's attempt to win back Laura happens only gradually, and at first unconsciously. The climax occurs when she agrees in a weak moment to leave Jadwin and go with Corthell—only to decide against him again as her husband returns to her. See Norris, *The Pit*, 407–12. Humiston, too, gradually insinuates himself into Bertha's confidence, but in a more deceitfully conscious fashion, with the mind of a libertine. See Garland, *Money Magic*, 255–63. And Banks's von

Auerbach—the worst of the lot—shows his hand at the outset of the novel as his plot begins to unfold, continuing as the chief villain to the melodramatic climax when Dorn uses a simple ruler to fend off the artist's sudden stiletto attack and force him to a confession. See Banks, *John Dorn, Promoter*, 36–44, 346–50.

53. Garland, *Money Magic*, 288. The character of Moss was quite different from other artists in appearance ("neat and trig" in salt and pepper suit, bowler, and ready-made four-in-hand), homey behavior (quick with a "How de do" establishing him immediately as "a good fellow"), and goals (based on a general "art for service" ideal). For a good description of this unique fictional artist, see Garland, *Money Magic*, 190–94.

54. Parry, *Garrets and Pretenders*, 175–84.

55. Taft, "Dreams and Death Masks," 4.

56. Taft, "Old-Time Ideals," 162.

57. Henry James, *The American Scene* (1907; reprint ed., New York: Charles Scribner's Sons, 1946), 345.

58. George Santayana, "The Genteel Tradition in American Philosophy," in *The Genteel Tradition: Nine Essays by George Santayana*, ed. Douglas L. Wilson (Cambridge Mass.: Harvard University Press, 1967), 39–40.

59. Hugh Dalziel Duncan, *The Rise of Chicago as a Literary Center from 1885–1920* (Totowa, N.J.: Bedminster Press, 1964), 105–6.

60. Taft, "Old-Time Ideals," 161.

61. Without doubt the most comprehensive account of this matter is found in Ann Douglas, *The Feminization of American Culture* (New York: Alfred A. Knopf, 1977). Although she speaks more of their influence on popular literature than the visual arts, Douglas makes it clear that nineteenth-century women assumed a new role as "prime consumers of American culture" (p. 8) largely as a means of gaining some measure of power through the only avenues socially acceptable at the time.

62. Fuller, "Little O'Grady vs. the Grindstone," 208–9.

63. Ibid., 323.

64. Hutchinson quoted in Horowitz, "The Art Institute of Chicago," 2.

65. Taft, "Old-Time Ideals," 158.

66. Ibid.

67. Ibid.

68. Ibid., 161.

69. Fuller to Taft, 3 November [1907], Taft Papers, Chicago Historical Society.

70. Ralph Clarkson, "Chicago Painters, Past and Present," *Art and Archaeology*, 12 (September–October, 1921), 134–35.

71. Ibid., 135. In Herrick's novel, Jackson Hart is a young architect trained abroad and thrust into the realities of commercial Chicago to make his way. After a sequence of unethical and illegal practices establish his material success, a disastrous fire in one of his inadequately constructed buildings finally shocks him to a reevaluation of his career and a reordering of his priorities.

72. "The Artistic 'Tenth Floor' in Chicago," 6.

73. Taft, "The Artist and the City," 4.

74. Ibid.

75. Taft quoted in Bell, "The Message of Art: Lorado Taft and the City," 8.

76. Ibid.

77. "The Address of Lorado Taft," 31.

5. Fountains and Modern Chicago

1. Williams to Taft, 9 March 1891, Box 4, Taft Papers, University of Illinois.

2. Taft, "A Million Dollars for Sculpture," 628; Monroe, "Ferguson Bequest New Impetus for Art."

3. Mathews, "Uncommercial Chicago," 990.

4. "Address of Lorado Taft," 29.

5. " 'Chicago Plan' Liked by Artists," *Chicago Tribune*, 15 September 1912, II, 3; "Taft Begins Statue," *Chicago Daily News*, 15 February 1913, 5.

6. Browne, "Lorado Taft: Sculptor," 198. The earliest development of Taft's interest and ideas for the Midway is not clear, but it does appear that he had been working on the project for some time by 1908. Reporting in 1910, another source noted that it was by then "several years ago" that the project had been initiated. See Maude I. G. Oliver, "Among the Artists," *Chicago Record Herald*, 1 May 1910, 4.

7. Browne, "Lorado Taft: Sculptor," 198. Burnham's plan for the city was not yet available in published form at this point, but had been much promoted and discussed. When the official planning document finally appeared, the lavish publication included maps and drawings showing the bridged Midway canal Taft had targeted for embellishment. See Burnham and Bennett, *Plan of Chicago*, ill. 50, 53.

8. Taft explained the genesis for the "Fountain of Time' composition in his 1907 address to the University of Illinois alumni, noting it had been inspired by a "vagrant line or two" from a poem by Austin Dobson entitled "The Paradox of Time":

> Time goes, you say? Ah, no.
> Alas, Time stays; we go!

Taft, "Old-Time Ideals," 156.

9. See Oliver, "Among the Artists," 4; "Plan to Adorn Midway Given by Lorado Taft," *Chicago Record-Herald*, 19 June 1909, 14; "Great Hall of Fame Is Plan of Midway," *Chicago Evening Post*, 28 August 1909, 3; Harriet Monroe, "Concerning Lorado Taft's Plan to Fringe the Midway with Art," *Chicago Tribune*, 1 May 1910, II, 5.

10. "Midway to Be Dream in Marble," *Chicago Inter Ocean*, 22 May 1910, 5.

11. See Peter B. Wright, "Apotheosis of the Midway Plaisance: Lorado Taft's Symposium of Adornment with Sculpture," *Architectural Record*, 28 (November, 1910), 335–49; and d'Unger, "A Sculptor's Dream of the Chicago Beautiful," 158–66.

12. Browne, "Lorado Taft: Sculptor," 198; Oliver, "Among the Artists," 4; Monroe, "Concerning Lorado Taft's Plan to Fringe the Midway with Art," 5.

13. "Plan to Adorn Midway Given by Lorado Taft," 14.

14. "Plaster Casts Will Test Midway Scheme," 16.

15. William M. R. French to Taft, 11 June 1912, Box 12, Taft Papers, University of Illinois.

16. William M. R. French to Taft (telegram), 9 December 1912, Box 12, Taft Papers, University of Illinois.

17. "Contract between the Trustees of the Art Institute of Chicago and Lorado Taft for a Monument Entitled 'Fountain of Time' Commemorating One Hundred Years of Peace between the United States and Great Britain," typescript, 6 February 1913, Box 12, Taft Papers, University of Illinois.

18. Frank G. Logan to Taft (telegram), 9 December 1912, Box 12, Taft Papers, University of Illinois.

19. Taft to Trustees of the Art Institute, n.d., laid on "Minutes of the Trustees of the Art Institute," typescript, 30 January 1913 [p. 1], copy in Box 12, Taft Papers, University of Illinois. Taft's alternative here seems an unlikely choice, but may well have been prompted by the suggestion of others. Immediately below Taft's communication in the "Minutes" cited above was listed another from the "United States Daughters of 1812, State of Illinois," calling for erection of two monuments: "one monument to commemorate the Massacre of Fort Dearborn and the other as a memorial of one hundred years of peace between the United States and England." Moreover, Hutchinson was at the time serving as treasurer for an organization calling itself the Chicago Group to Celebrate 100 Years of Peace between England and the United States. See Goodspeed, "Charles Lawrence Hutchinson," 62.

20. In 1918 a smaller model of French's famous *Republic* was erected to mark the twenty-fifth anniversary of the Columbian Exposition. The work was a twenty-four-foot model of the original sixty-five-foot figure that had stood at the east end of the Court of Honor. This was the commemoration already under consideration by the trustees when Taft's proposal was made. See Bach and Gray, *A Guide to Chicago's Public Sculpture*, 242–43.

21. "Contract between the Trustees of the Art Institute of Chicago and Lorado Taft for a Monument Entitled 'Fountain of Time.'"

22. "Name Lorado Taft as First Sculptor in Midway Scheme," *Chicago Evening Post*, 31 January 1913, 1.

23. See Weller, *Lorado in Paris*, 182–84.

24. Taft, "Public Monuments," 4.

25. "Plaster Casts Will Test Midway Scheme," 16.

26. Dimensions listed in "Contract between the Trustees of the Art Institute of Chicago and Lorado Taft for a Monument Entitled 'Fountain of Time.'"

27. "Fountain of Time Modeling Given to Lorado Taft," *Chicago Inter Ocean*, 1 February 1913, 3.

28. "Lorado Taft Gets Job of Beautifying Midway," *Chicago Record-Herald*, 1 February 1913, 18.

29. "A Dream to Be Realized," *Dial*, 54 (16 February 1913), 122.

30. "Taft Begins Statue," 5.

31. See Robert H. Moulton, "Chicago's Dream of Civic Beauty Realized in the Symbolic Marble of Lorado Taft," *Craftsman*, 25 (November, 1913), 123; "Unveil New Taft Fountain on Lake Front Tomorrow," 3; and Maude I. G. Oliver, "Lorado Taft—An Appreciation," *Midland*, 19 December 1907, 16.

32. Oliver, "Lorado Taft—An Appreciation," 16.

33. Harriet Monroe, "Lake Monument Triumph in Art," *Chicago Tribune*, 14 September 1913, II, 5.

34. See, p. 72.

35. Chatfield-Taylor, *Chicago*, 117.

36. Norris, *The Pit*, 237.

37. Horace Spencer Fiske, "An Ode to Chicago," in *Chicago in Picture and Poetry* (Chicago: Ralph Fletcher Seymour for the Industrial Art League, 1903), 175.

38. Garland, *Rose of Dutcher's Coolly*, 338.

39. Ibid., 338–49.

40. Banks, *John Dorn, Promoter*, 159–68; Willa Cather, *The Song of the Lark* (1915; reprint ed., Boston: Houghton Mifflin Co., 1983), 252–55.

41. Robert Morss Lovett, *A Wingéd Victory* (New York: Duffield and Co., 1907), 154–58.

42. Lorado Taft, "Fountains," *Art and Progress*, 4 (March, 1913), 892–99.

43. See cover, *Graphic*, 3 December 1892, in Box 1, Taft Papers, University of Illinois.

44. For a discussion of the entrance groups Taft completed for this project, see Vincent F. Kubly, *The Louisiana Capitol: Its Art and Architecture* (Gretna, La.: Pelican Publishing Company, 1977), 35–37.

45. Weiss to Taft, 19 February 1931, Box 13, Taft Papers, University of Illinois.

46. Taft to Weiss, n.d. [handwritten draft of reply on final page of Weiss to Taft, 19 February 1931], Box 13, Taft Papers, University of Illinois.

47. Weiss to Taft, 26 February 1931; Taft to Weiss, n.d. [handwritten draft of reply on second page of Weiss to Taft, 26 February 1931], Box 13, Taft Papers, University of Illinois.

48. "Fountain 'The Spirit of the Great Lakes' Ready," *Chicago Daily News*, 9 September 1913, 3.

49. "Address of Lorado Taft," 28. In speaking of the "classic Diana in moccasins and feathers," Taft was no doubt referring to works like Hiram Powers's *The Last of the Tribe* (1873), which shows a rather anglicized Indian maiden. That such an image no longer seemed appropriate to Taft was due at least in part to the influence of Garland's "veritism," a call for truth in artistic representation first articulated in *Crumbling Idols* in the 1890s. But beyond that, at the dedication of his *Blackhawk* at Eagle's Nest just two years earlier, Taft had heard addresses by others reflecting the growing acceptance of the American Indian as a distinct cultural group rather than an underdeveloped species of savages. See addresses of Edgar A. Bancroft, Dr. Charles E. Eastman, and Laura M. Cornelius in *Lorado Taft's Indian Statue "Black Hawk": An Account of the Unveiling Ceremonies at Eagle's Nest Bluff, Oregon, Illinois, July the First, Nineteen Hundred and Eleven, Frank O. Lowden Presiding* (Chicago: University of Chicago Press for

Wallace Heckman, 1912). For a good overview of the changing white perception of the American Indian at this time, see Robert F. Berkhofer, Jr., *The White Man's Indian: Images of the American Indian from Columbus to the Present* (New York: Alfred A. Knopf, 1978).

50. For a more detailed account of this shifting of ideals, see Lois W. Banner, *American Beauty* (New York: Alfred A. Knopf, 1983), 128–74.

51. Browne, "Lorado Taft: Sculptor," 191; "Art by Contract."

52. See photographs of "living sculpture" groups in Box 10, Taft Papers, University of Illinois.

53. "Nymph Group in Favor," 1; "Nymphs the Town Talk," I, 8.

54. " 'September Morn' " Pits Her Beauty against Censors," *Chicago Tribune*, 21 March 1913, 1, 4; "September Morn—'Not Guilty,' " *Chicago Tribune*, 22 March 1913, 6.

55. Mayor Carter H. Harrison to the Chicago City Council, 31 March 1913, *Journal of the Proceedings of the City Council of the City of Chicago for the Council Year 1912–13* (Chicago: City of Chicago, 1913), 4266; *Journal of the Proceedings of the City Council of the City of Chicago for the Council Year 1913–1914* (Chicago: City of Chicago, 1914), 59, 225–26.

56. "Will the Police Suppress Chicago's September Morn?" *Chicago Tribune*, 21 September 1913, VIII, 3.

57. Taft quoted in "There's Nothing the Matter with the Art Institute Which a Million Dollars Cannot Cure," 32.

58. Burnham to Taft, 2 May 1910, in "Letters, Business and Personal," Vol. 18, 1909–11, Frames 514–15, Daniel Hudson Burnham Collection, Ryerson Library, Art Institute of Chicago. Use of this collection permitted by courtesy of the Art Institute of Chicago.

59. "Midway to Be Dream in Marble," 5. For an early list of those Taft proposed for his Hall of Fame, see Wright, "Apotheosis of the Midway Plaisance," 346–48.

60. Roswell Field, "Why Not Localize That Midway Art?" *Chicago Examiner*, 8 May 1910, news clipping in Box 11, Taft Papers, University of Illinois.

61. Ibid.

62. Ibid.

63. Trustees may well have been worried about a renewal of public criticism in the final stages of negotiation of the *Fountain of Time* contract, for they instructed Taft to keep all news of their discussions away from the press. See Frank G. Logan to Taft (telegram), 9 December 1912, Box 12, Taft Papers, University of Illinois.

64. "One Hundred—Count Em!" *Chicago Tribune*, 2 February 1913, VIII, 4.

65. "Statues at a Discount," *New York Evening Telegram*, 9 February 1913, news clipping in Box 11, Taft Papers, University of Illinois.

66. Harriet Monroe, "Chicago Artist Wins Gold Medal at 'Old Salon' in Paris."

67. Harriet Monroe, "Chicagoans Face Vast Problem in Taft Exhibit," *Chicago Tribune*, 23 November 1913, VIII, 4.

68. Harriet Monroe, "Lake Monument Triumph in Art," *Chicago Tribune*, 14 September 1913, II, 5.

69. Monroe, "Chicagoans Face Vast Problem in Taft Exhibit," VIII, 4.

70. Ibid.

71. Harriet Monroe, "Some Opinions of Art Lovers on Taft's Midway Project," *Chicago Tribune*, 30 November 1913, VIII, 8.

72. Ibid.

73. Harriet Monroe, "The Ryerson Collection of Paintings Now Being Shown at the Art Institute," *Chicago Tribune*, 7 December 1913, VIII, 5.

74. Maurice I. Flagg, director of the Minnesota State Art Society, to Taft, n.d.; and Taft to Flagg, n.d. [handwritten draft of reply on back of Flagg to Taft], Box 12, Taft Papers, University of Illinois. Although undated, this correspondence quite obviously occurred during the late fall or early winter of 1913–14 as Monroe was waging her campaign against Taft's plans.

75. That Taft would have missed Monroe's column of 15 June 1913 carrying her description of the commission leading to his creation of a "full size plaster model" of the "Fountain of Time" seems especially unlikely given the efficiency of his clipping service at the time. A copy of this column still remains among his personal papers. See Monroe, "Chicago Artist Wins Gold Medal at 'Old Salon' in Paris," Box 12, Taft Papers, University of Illinois.

76. See Howard Van Doren Shaw to Taft, 18 December 1914, Box 12, Taft Papers, University of Illinois.

77. See Newton H. Carpenter to Taft, 4 June 1915, Box 12, Taft Papers, University of Illinois.

78. See Newton H. Carpenter to Taft, 29 March 1918, Box 12, Taft Papers, University of Illinois.

79. The trustees had originally specified that Taft's plaster model be prepared in such a way as to be "ready to be cut in marble," but the sculptor's wife later recalled that all his investigation of more traditional materials for the project went for naught when the time came to recreate the *Fountain of Time* on a permanent basis in the early twenties. See *The Art Institute of Chicago: Thirty-Fifth Annual Report for the Year 1913–14* (Chicago: Art Institute of Chicago, [1914]), 16; and Ada Bartlett Taft, *Lorado Taft, Sculptor and Citizen*, 36–37.

80. After consulting experts, Taft contacted Earley in late March, 1921. The contractor assured Taft he was capable of successfully casting the large *Fountain of Time* composition, and after bids and negotiations the contract was sent to Earley's office in November. See "Fountain of Time—Correspondence" Folder, Box 12, Taft Papers, University of Illinois. On Earley's process, see "Lorado Taft's Fountain of Time Done in Concrete by John J. Earley," *Concrete* [Detroit], 21 (December, 1922), 170–73; Williams, "Lorado Taft: American Sculptor and Art Missionary," 97–98; and especially Frederick W. Cron, *The Man Who Made Concrete Beautiful: A Biography of John Joseph Earley* (Fort Collins, Colo.: Centennial Publications, 1977). Examples of other "cast stone" work by Earley may be found at the Franciscan Monastery in Washington, D.C. See James M. Goode, *The Outdoor Sculpture of Washington, D.C.: A Comprehensive Guide* (Washington: Smithsonian Institution Press, 1974), 337–38.

Taft had employed cast concrete earlier in the fabrication of his colossal *Blackhawk* at Eagle's Nest, but that was a more private project designed for the less formal setting of his summer camp. Experiment was far more appropriate in the

woods of rural northern Illinois than at the terminus of the grand public parkway he hoped to make Chicago's new sculptural showcase.

81. "Taft Monument on Midway Is Dedicated," *Chicago Herald-Examiner*, 16 November 1922, news clipping in Box 12, Taft Papers, University of Illinois.

82. Taft's address quoted in "Lorado Taft's Masterpiece Is Dedicated," *Hyde Park Herald*, 17 November 1922, news clipping in Box 12, Taft Papers, University of Illinois.

83. d'Unger, "A Sculptor's Dream of the Chicago Beautiful," 162.

84. Dickerson, "The Art Movement in Chicago," 380.

85. See especially Robert M. Weiss, "The Shock of Experience: A Group of Chicago's Writers Face the Twentieth Century."

86. For a good expression of his distrust of modern American literature after the turn of the century, see Garland, *Daughter of the Middle Border*, 244–45.

87. See Ellen Williams, "Harriet Monroe and 'Poetry' Magazine," *Chicago History*, 4 (Winter, 1975–76), 209; and John Pilkington, Jr., *Henry Blake Fuller* (New York: Twayne Publishers, 1970), 83–84.

88. Lorado Taft, "Recent Tendencies in Sculpture," *Proceedings of the American Academy of Arts and Letters and of the National Institute of Arts and Letters*, 4 (1910–11), 46. Taft's most complete statement regarding his views on his field was made in 1917 when he delivered the thirteenth annual series of Scammon Lectures at the Art Institute of Chicago. The Scammon Lectureship had been established by a bequest of Mrs. Maria Sheldon Scammon in 1901. Taft's lectures were subsequently published in his second major book, *Modern Tendencies in Sculpture* (Chicago: University of Chicago Press, 1921). Although critical of some newer trends in sculpture, it should be pointed out that Taft's critique was far more moderate than those of some of his fellow sculptors. Perhaps most virulent was the view of New York sculptor Frederick Wellington Ruckstull, editor of *The Art World: A Monthly for the Public Devoted to the Higher Ideals*. By way of preface to a collection of his essays, Ruckstull boldly asserted that "anarchy reigns in the world of art today. The cause is: 'Modernism.'" See Frederick W. Ruckstull, *Great Works of Art and What Makes Them Great* (New York: G. P. Putnam's Sons, 1925), v.

89. See Warren I. Susman, "'Personality' and the Making of Twentieth-Century Culture," in *New Directions in American Intellectual History*, ed. John Higham and Paul K. Conklin (Baltimore: Johns Hopkins University Press, 1979), 212–26.

90. The classic account of the infamous 1913 Armory Show is Milton W. Brown, *The Story of the Armory Show* (Greenwich, Conn.: New York Graphic Society, 1963). Also helpful is the more recent collection of documents in *The Armory Show: International Exhibition of Modern Art*, 3 vols. (New York: Arno Press, 1972).

91. See "The Armory Show," in *The Emergence of Modernism in Illinois, 1914–1940*, exh. cat. (Springfield: Illinois State Museum, 1976).

92. "Chicago Artist Starts Revolt," *Chicago Tribune*, 26 March 1913, 15.

93. See Kenneth R. Hey, "Ralph Clarkson: An Academic Painter in an Era of Change," 184–86.

94. "Artists Give Cubist Play," *Chicago Tribune*, 27 March 1913, II, 15. Al-

though there is no evidence suggesting Taft participated in this unique event, it was staged by many of his friends, colleagues, and students.

95. Ibid.

96. Alson J. Smith, *Chicago's Left Bank* (Chicago: Henry Regnery Co., 1953), 160–61.

97. Taft, *Modern Tendencies in Sculpture*, 27.

98. Garland, *My Friendly Contemporaries*, 12–13. The Little Room party Garland reported on took place on April 13, three days before the Armory Show closed in Chicago.

99. Theodore Dreiser, *The "Genius"* (1915; reprint ed., New York: New American Library, 1967), 49.

100. "Lorado Taft and the Western School of Sculpture," *Craftsman*, 14 (April, 1908), 23.

101. Garland identified a perceptible decline in Little Room status occurring as early as 1907 and attributed it to the fact that the lure of New York had drawn off most of the more successful artists and writers working in Chicago. More recently, however, Weiss has suggested that recruitment of interested younger artists and writers to a club consisting of older, more staid personalities was the real problem. See Garland, *Companions on the Trail*, 336; and Weiss, "The Shock of Experience: A Group of Chicago's Writers Face the Twentieth Century," 212, n. 6.

102. For a more complete account of the careers and impact of Dawson, Szukalski, and Wisenborn, see Kenneth Robert Hey, "Five Artists and the Chicago Modernist Movement, 1909–1928" (Ph.D. diss., Emory University, 1973).

103. "More Pet Atrocities."

104. Field, "Why Not Localize That Midway Art?"

105. Ada Bartlett Taft, *Lorado Taft, Sculptor and Citizen*, 38.

106. Taft quoted in "The Society of Medalists Eleventh Issue," pamphlet, n.p., n.d., in "Medals" folder, Box 13, Taft Papers, University of Illinois.

107. Weller, *Lorado in Paris*, 9.

108. See Pomaranc, *Fine Arts Building*, 6; and Duis, " 'Where Is Athens Now?' " 74–75.

109. Taft to Don Carlos Taft, 9 March 1886, Box 6, Taft Papers, University of Illinois.

110. See Scudder, *Modeling My Life*, 52–68. Scudder recalled that Taft was instrumental in helping her obtain commissions to model a figure of *Justice* for the Illinois Building and a *Nymph of the Wabash* for Indiana.

111. Zulime Taft Garland, "Recollections of Lorado Taft," 7.

112. See Dickerson, "Evelyn B. Longman," 528; and Taft, "Women Sculptors of America," 2. The three former Taft students who had acquired membership in the National Sculpture Society by 1908 were Evelyn B. Longman, Julia Bracken Wendt, and Bessie Potter Vonnoh.

113. Floyd Dell, *Women as World Builders: Studies in Modern Feminism* (Chicago: Forbes and Co., 1913), 17. The biographies following this introduction had been published serially in the *Chicago Evening Post* the preceding year.

114. Henry Charles Payne, "Is There an American Type?" *World To-Day*, 8

(March, 1905), 256. In fairness to Taft, the sculptor did occasionally transcend his more traditional biases regarding the use of women as subjects. As a student in Paris, for example, Taft selected Molly "Pitcher" Hays, heroine of the Revolutionary War Battle of Monmouth, as an appropriately American subject for an early major work in 1884. See Weller, *Lorado in Paris*, 240–43.

115. Taft, "Why I Have Found Life Worth Living," 727.

116. Some additional measure of the sculptor's seriousness of intention here may be found in the fact that others later quoted this "creed" as evidence of Taft's religious faith. See Carl C. Mose, "Religion in Art: Lorado Taft," *Christian Register*, 116 (30 December 1937), 782; and Ada Bartlett Taft, *Lorado Taft, Sculptor and Citizen*, 85.

Bibliographic Essay: Literature on American Sculpture

Academic sculpture of the late nineteenth and early twentieth centuries has been a subject of considerable recent interest among scholars. Long ignored as a mere extension of existing practices and ideals, new studies have attempted to shed light on a variety of issues proving this an area ripe for reconsideration today. Although admittedly uneven in quality, the following are items useful in any attempt to address the history of American sculpture from this period.

Taft himself opened study of this subject in the twentieth century with his monumental *The History of American Sculpture* (1903; rev. ed., New York: Macmillan Co., 1917), still an important source for any wishing to work on the topic. There have been a number of subsequent efforts to develop broad chronicles of the period, but scholars have been best served more recently by another valuable survey in Wayne Craven, *Sculpture in America* (New York: Thomas Y. Crowell Co., 1968), easily the most complete source on American sculpture produced to date. Also valuable are essays in Tom Armstrong, et al., *Two Hundred Years of American Sculpture*, exh. cat. (New York: Whitney Museum of American Art, 1976). Generally comparable sources on French and English sculpture and sculptors may also be very helpful. See, for example, Ruth Mirolli, *Nineteenth Century French Sculpture: Monuments for the Middle Class*, exh. cat. (Louisville, Ky.: J. B. Speed Art Museum, 1971); Peter Fusco and H. W. Janson, *The Romantics to Rodin: French Nineteenth-Century Sculpture from North American Collections*, exh. cat. (Los Angeles: Los Angeles County Museum of Art, 1980); Benedict Read, *Victorian Sculpture* (New Haven: Yale University Press, 1982); and Susan Beattie, *The New Sculpture* (New Haven: Yale University Press, 1983). Broader surveys of the sculpture produced in several countries through this period include the extremely valuable H. W. Janson, *Nineteenth-Century Sculpture* (New York: Harry N. Abrams, 1985), organized by period and country; and a more idiosyncratic but still interesting Maurice Rheims, *Nineteenth-Century*

Sculpture, trans. Robert E. Wolf (New York: Harry N. Abrams, 1972), organized variously by style, period, artist, or subject.

Also helpful for providing rich information regarding public sculpture are the many recent studies (and guidebooks) documenting the existence of key works in individual cities across the country. Models of such sources are works like James M. Goode, *The Outdoor Sculpture of Washington, D.C.: A Comprehensive Guide* (Washington: Smithsonian Institution Press, 1974), an extensive and richly documented guidebook with valuable bibliography and appendixes; and Nicholas B. Wainwright, ed., *Sculpture of a City: Philadelphia's Treasures in Bronze and Stone* (Philadelphia: Fairmount Park Art Association, 1974), containing both valuable guide and expanded essays by specialists focusing on individual works. Other substantial surveys of this sort include James L. Riedy, *Chicago Sculpture* (Urbana: University of Illinois Press, 1981); Ira J. Bach and Mary Lackritz Gray, *A Guide to Chicago's Public Sculpture* (Chicago: University of Chicago Press, 1983); Dennis Alan Nawrocki, *Art in Detroit Public Places* (Detroit: Wayne State University Press, 1980); Joseph Lederer, *All around the Town: A Walking Guide to Outdoor Sculpture in New York City* (New York: Charles Scribner's Sons, 1975); and Marilyn Evert, *Discovering Pittsburgh's Sculpture* (Pittsburgh: University of Pittsburgh Press, 1983).

Dated or in some cases less substantial but still helpful are an assortment of other local surveys like William Sener Rusk, *Art in Baltimore: Monuments and Memorials* (Baltimore: Norman, Remington Co., 1924); Allan Forbes and Ralph M. Eastman, *Some Statues of Boston* (Boston: State Trust Co., 1946); Allan Forbes and Ralph M. Eastman, *Other Statues of Boston* (Boston: State Trust Co., 1947); Walter Muir Whitehill with Katharine Knowles, *Boston Statues* (Boston: Barre Publishers, 1970); Agnes Wright Spring, *Denver's Historic Markers, Memorials, Statues and Parks* (Denver: Colorado Historical Society, 1959); Fay L. Hendry, *Outdoor Sculpture in Kalamazoo* (Okemos, Mich.: Iota Press, 1980); *A Survey of Kansas City's Public Outdoor Art* (Kansas City, Mo.: Municipal Art Commission, 1975); Fay L. Hendry, *Outdoor Sculpture in Lansing* (Okemos, Mich.: Iota Press, 1980); *Statues and Monuments in Milwaukee County Parks* (Milwaukee: Milwaukee County Park Commission, n.d.); and Dennis Bolazina, *Special Report on Public Art to Alfonso J. Cervantes, Mayor, City of St. Louis* (St. Louis: St. Louis Beautification Commission, 1969). Finally, for a comparable survey of public sculpture throughout the state of Ohio, see Marianne Doezema and June Hargrove, *The Public Monument and Its Audience*, exh. cat. (Cleveland: Cleveland Museum of Art, 1977); and for a more general source covering the country, see Emma Lili Fundaburk and Thomas G. Davenport, comp., *Art in Public Places in the United States* (Bowling Green, Ohio: Bowling Green University Popular Press, 1975).

Also important for any study of public sculpture are recent monographs on individual sculptors. Worthy of special note in this category are a limited but helpful number of studies focusing on American sculptors, including James M. Dennis, *Karl Bitter: Architectural Sculptor, 1867–1915* (Madison: University of Wisconsin Press, 1967); Michael T. Richman, *Daniel Chester French: An Ameri-*

can Sculptor, exh. cat. (New York: Metropolitan Museum of Art, 1976); Sylvia E. Crane, *White Silence: Greenough, Powers, and Crawford, American Sculptors in Nineteenth-Century Italy* (Coral Gables: University of Miami Press, 1972); Hester Elizabeth Proctor, ed., *Sculptor in Buckskin: An Autobiography by Alexander Phimister Proctor* (Norman: University of Oklahoma Press, 1971); Millard F. Rogers, Jr., *Randolph Rogers: American Sculptor in Rome* (Amherst: University of Massachusetts Press, 1971); John H. Dryfhout, *The Work of Augustus Saint-Gaudens* (Hanover, N.H.: University Press of New England, 1985); Kathryn Greenthal, *Augustus Saint-Gaudens: Master Sculptor* (New York: Metropolitan Museum of Art, 1985); and Lewis I. Sharp, *John Quincy Adams Ward: Dean of American Sculpture* (Newark: University of Delaware Press, 1985).

Special studies involving close consideration of particular works in broader historical context are also helpful. An earlier example offering an interesting sample of such work by an historian is found in Gilbert C. Fite, *Mount Rushmore* (Norman: University of Oklahoma Press, 1952). More recently other even more useful models of such scholarship are available in Marvin Trachtenberg, *The Statue of Liberty* (1974; reprint ed., New York: Penguin Books, 1977); and Albert E. Elsen, *Rodin's "Thinker" and the Dilemmas of Modern Public Sculpture* (New Haven: Yale University Press, 1985). Both of these studies attempt to place the works in proper social context, the latter pushing even beyond this to a useful survey and discussion of several problems emerging in connection with modern public sculpture. For more on this last issue see also H. W. Janson, *The Rise and Fall of the Public Monument*, Andrew H. Mellon Lectures in the Humanities no. 3 (New Orleans: Graduate School, Tulane University, 1976); Michele H. Bogart, "The Importance of Believing in 'Purity,' " *Archives of American Art Journal*, 24 (1984), 2–8; Jane Mayo Roos, "Rodin's *Monument to Victor Hugo*: Art and Politics in the Third Republic," *Art Bulletin*, 68 (December, 1986), 632–56; and two of my own studies, "The *Jay Cooke Monument* as Civic Revisionism: Promotional Imagination in Bronze and Stone," *Old Northwest*, 9 (Spring, 1983), 37–57; and "From *God of Peace* to 'Onyx John': The Public Monument and Cultural Change," *Upper Midwest History*, 1 (1981), 4–26.

An assortment of recent essays have also attempted to address the role of the public monument as part of the physical and cultural landscape—often from different disciplinary and interdisciplinary perspectives. Most directly addressing the matter of site and sculpture is Margaret A. Robinette's critical survey *Outdoor Sculpture: Object and Environment* (New York: Whitney Library of Design, Watson-Guptill Publications, 1976). Beyond this, landscape architect James Brinkerhoff Jackson offers views on the meaning of monuments erected to celebrate or otherwise mark in "The Necessity for Ruins," in *The Necessity for Ruins and Other Topics* (Amherst: University of Massachusetts, 1980), 89–102; Yi-Fu Tuan, a cultural geographer, describes the place-marking role of monument in his chapter, "Visibility: The Creation of Place," in *Space and Place: The Perspective of Experience* (Minneapolis: University of Minnesota Press, 1977), 161–78; art historian Karal Ann Marling considers valuable lessons to be learned about both physical and cultural issues in connection with some extraordinary popular

monuments in *The Colossus of Roads: Myth and Symbol along the American Highway* (Minneapolis: University of Minnesota Press, 1984); and contemporary photographer Lee Friedlander working with writer Leslie George Katz also addresses both presence and meaning in an extraordinary volume, *The American Monument* (New York: Eakins Press Foundation, 1976). My own contribution to speculation on the relationships between public sculpture and cultural context is "Paul Manship, F. Scott Fitzgerald, and a Monument to Echo the Jazz Age," *Journal of American Culture*, 7 (Fall, 1984), 2–18.

Secondary literature on Taft and his career is limited, but certain sources do warrant mention. Allen S. Weller has long been one of the leading authorities on the sculptor, and two of his most valuable recent contributions are *Lorado Taft: A Retrospective Exhibition*, exh. cat. published as *Bulletin of the Krannert Art Museum*, 8 (1983); and *Lorado in Paris: The Letters of Lorado Taft, 1880–1885* (Urbana: University of Illinois Press, 1985). Other recent work includes Patrick Reynolds, " 'Fra Lorado,' Chicago's Master Sculptor," *Chicago History*, 14 (Summer, 1985), 50–63; and my own "Conferring Status: Lorado Taft's Portraits of an Artistic Community," *Illinois Historical Journal*, 78 (Autumn, 1985), 162–78. Somewhat dated but still useful are the *catalog raisonné* in Lewis W. Williams, "Lorado Taft: American Sculptor and Art Missionary," Ph.D. dissertation, University of Chicago, 1958; and the insights into an intriguing side of Taft's career provided in Genevieve Richardson, "Lorado Taft and Theatre," Master of Arts thesis, University of Illinois, 1948. Studies of other specific subjects related to the sculptor and his career include Icko Iben, "The Literary Estate of Lorado Taft," *American Archivist*, 26 (October, 1963), 493–96; and John Pilkington, "Fuller, Garland, Taft, and the Art of the West," *Papers on Language and Literature*, 8, Supplement (Fall, 1972), 39–56. Also interesting for the personal insights offered are the recollections of the sculptor published by his wife in Ada Bartlett Taft, *Lorado Taft: Sculptor and Citizen* (Greensboro, N.C.: Mary Taft Smith, 1946); and those of a studio assistant in Trygve A. Rovelstad, "Impressions of Lorado Taft," *Papers in Illinois History and Transactions for the Year 1937*, 44 (1938), 18–33.

Index

Note on the Author

Timothy J. Garvey did his graduate work in art history and American studies at the University of Minnesota. Since 1980 he has been on the faculty at Illinois Wesleyan University where he is presently an associate professor of art history and coordinator of the American studies program. In addition to the current study of Lorado Taft and his Chicago sculpture, Garvey has published articles on other public sculpture, including that of Lee Lawrie, Paul Manship, Carl Milles, and Henry Merwin Shrady.